The Renaissance Rediscovery of Linear Perspective

THE
RENAISSANCE
REDISCOVERY
OF LINEAR
PERSPECTIVE

Samuel Y. Edgerton, Jr.

ICON EDITIONS
Harper & Row, Publishers
NEW YORK, EVANSTON, SAN FRANCISCO, LONDON

Library of Congress Cataloging in Publication Data

Edgerton, Samuel Y 1926–
 The Renaissance rediscovery of linear perspective.

 Includes bibliographical references and index.
 1. Perspective—History. 2. Visual perception—
History. I. Title.
NC748.E33 742 73–91086
ISBN 0–06–430069–2

DESIGNED BY VINCENT TORRE
75 76 77 78 10 9 8 7 6 5 4 3 2 1

Dedicated to my wife, Dorothy,
and our children,
Perky, Sam, and Mary
and especially, to the
memory of our dear
son
Peter Martineau Edgerton
April 23, 1954–May 12, 1974

Contents

Contents

Illustrations

Illustrations

Illustrations

Illustrations

Acknowledgments

DURING the many, many years it has taken to write this book, I have piled up such debts of gratitude I hardly know where to begin. Perhaps, in chronological order, I owe my first and greatest thanks to Frederick Hartt, who originally urged me to undertake the project and who has been my faithful supporter ever since. His good words and prestigious help when I needed it most will be a memory I shall never forget. Next, my thanks go to Charles Peterson, who, although never approving my Renaissance interest, first taught me the stern principles of sound historical research. In this regard also, I owe much to the wisdom and tolerance of my professors and friends at the University of Pennsylvania: David Robb, Robert Smith, George Tatum, Malcolm Campbell, Richard Brilliant, and John McCoubrey.

Next in order of time, I am ever grateful to William Jewell, my department chairman and colleague at Boston University, who allowed the greatest latitude to my consuming studies, and who used his influence to obtain for me two generous financial grants, one from the Mervyn Bailey Fund and the other from the Graduate

Acknowledgments

School of Boston University, in order that I might travel abroad. My next "break" came when Millard Meiss interested himself in the project and invited me to spend a year at the Institute for Advanced Study in Princeton. My gratitude to the Meisses knows no end, for they too have proved loyal to me throughout the long years it has taken to complete this book.

I was furthermore fortunate in receiving additional grants from the National Endowment for the Humanities and from the Harvard University Center for Renaissance Studies at the Villa I Tatti in Florence. The wonderful year my family and I spent at the latter hardly needs elaborating. I am most thankful for the kindnesses received there from Myron and Sheila Gilmore, Florence and Mason Hammond, Fiorella Superbi, Anna Terni, and fellows Marcia Hall, Lars Larssen, Miklós Boskovits, James Beck, and George Hersey. Penultimately, I must single out those friends and colleagues of long standing who have consistently, over many years, offered me criticism and encouragement whenever I asked —and I asked often: James Ackerman, James O'Gorman, Anthony Molho, Alessandro Parronchi, Creighton Gilbert, and David Lindberg. There are so many others who added a little piece to the puzzle at one time or other, sometimes even inadvertantly. If I forget the names of some, I hope I shall be forgiven (indeed, I hardly dare call this book my own): Julia Keydel, Howard Saalman, John Spencer, Richard Lamoureux, Ulrich Krause, Ulrich Middeldorf, Moshe Barasch, Marshall Clagett, Harold Cherniss, O. Neugebauer, Carl Nordenfalk, Ivan Galantic, Renée Watkins, Hellmut Wohl, Cecil Grayson, A. I. Sabra, David Rosand, Nina Laserson, and Jamelia Witwer. Of course, all those good and patient people in so many museums and libraries, particularly the staffs of the Sopratendenza alle Gallerie in Florence, the Biblioteca Laurenziana, the Map Room of Harvard University, and the John Carter Brown Library in Providence.

Finally, I owe overwhelming gratitude to David Grambs whose remarkable writing skills have at last made this book readable. How I could have used his talents earlier!

SAMUEL Y. EDGERTON, JR.

Chronological Outline of the History of Linear Perspective

c. 300 B.C. Euclid's *Optica;* first written application of the laws of geometry to problems of how people see. Definition of the rectilinear "visual ray" and the "visual cone" as geometric constructions.

c. 25 B.C. Vitruvius' *De architectura;* reference to antique stage designs which implies understanding of the "vanishing point" notion of linear perspective in ancient Greek and Roman art.

c. 140 A.D. Ptolemy's *Optica;* application to Euclid's *Optica* of the geometric laws of refraction. Definition of the unrefracted and therefore crucial "centric visual ray."

Ptolemy's *Geographia;* application of the laws of optics to the projection of the spherical form of the earth onto a two-dimensional surface. Earliest

known linear perspective construction for drawing a map of the world.

c. 175 A.D. Galen's *De usu partium;* early effort to define the physiological structure of the eye. Definition of the lens, called by him the *crystallinus,* as the first image-receiving surface within the eye—erroneous, but accepted until the sixteenth century, and therefore an important concept in the development of linear perspective.

c. 1000 A.D. Alhazen's *Perspectiva;* great Arab compendium of optics. Based on an integration of Euclid, Ptolemy, and Galen with new ideas on visual psychology and the mechanics of how images get into the eye and thence to the brain. Most influential optics treatise to reach Europe after the twelfth-century renascence.

c. 1260 A.D. Roger Bacon's *Opus Majus;* containing an important section on optics, adapting Alhazen's, Euclid's, Ptolemy's, and Galen's ideas to the Christian notion of how God spreads His grace throughout the universe.

c. 1270 A.D. John Pecham's *Perspectiva communis;* most popular treatise on optics to circulate in Europe for the next three hundred years. Distilled from ideas of the Greek geometric opticians, the Arabs, and the Christian theorists such as Bacon and Robert Grosseteste. Copies in most European libraries during the fourteenth and fifteenth centuries.

c. 1390 A.D. Blasius (Biagio Pelacani) of Parma's *Quaestiones perspectivae;* popular adaptation of Bacon's and Pecham's optics which circulated in Italy during the early fifteenth century. Copy known in Florence in 1428.

c. 1400 A.D. Arrival in Florence for the first time anywhere in

Western Christendom since classical antiquity of Ptolemy's *Geographia*.

c. 1424 A.D. Return to Florence of Paolo dal Pozzo Toscanelli, medical doctor, mathematician, geographer, possible author of a treatise on optics, and friend of Filippo Brunelleschi.

c. 1425 A.D. Filippo di Ser Brunelleschi (1377–1446), with possible coaching by Toscanelli, makes the first linear perspective pictures since classical antiquity, the now-lost panels showing the Baptistery of Florence and the Palazzo Vecchio.

Masaccio paints the *Trinity* fresco in Santa Maria Novella, Florence, the first surviving picture constructed according to clear-cut linear perspective rules.

c. 1427 A.D. Masaccio and Masolino paint the Brancacci Chapel frescoes in Santa Maria della Carmine, Florence; early adaptation of Brunelleschi's linear perspective rules to problems of artistic composition.

c. 1434 A.D. Leon Battista Alberti (1404–1472) comes home to Florence after a lifetime of exile.

1435/6 A.D. Alberti writes his treatise on painting, the first written recording of how to draw a linear perspective construction, and dedicates it to Brunelleschi, Masaccio, Donatello, Ghiberti, and Luca della Robbia.

The Renaissance
Rediscovery of
Linear Perspective

I

The Western Window

MORE THAN FIVE centuries ago, a diminutive Florentine artisan in his late forties conducted a modest "experiment" near a doorway in a cobbled cathedral piazza. Modest? It marked an event which ultimately was to change the modes, if not the course, of Western history. Yet for its perpetrator it was all in a few mornings' work, or not much more. His tools included an easel, a miniaturist's paintbrush, one or two small flat mirrors, a little wooden panel, and his own, unquestionably prodigious, "mind's eye."

If we are to point to a crystallizing moment for the postmature birth of geometric linear perspective, it has to be this nameless day of Filippo Brunelleschi's out-of-doors demonstration in 1425. Brunelleschi's "subjects," however, could not have fully realized the implications of what they were seeing, and the artist no doubt preceded his final effect with a voluble lecture on optics, among other things. In modern-day terms, his Baptistery-view experiment could be called "the production of the vanishing point." And to the fifteenth-century Florentine citizen, the result was almost magical.

3

The Western Window

Brunelleschi, of course, was no mere sidewalk painter. This was the man—sculptor, architect, "artisan-engineer"—who gave Florence numerous architectural masterpieces, above all the magificent dome (1420–1436) over the Cathedral of Santa Maria del Fiore. Yet how many of us know that he was the midwife, if not the father, of linear perspective in the Western world? That his most far-reaching contribution to modern civilization was a twelve-inch-square panel painted from the portal of the Duomo—with his back to his model? His mirror experiment was a feat, not just of aesthetic marksmanship, but of perceptual upheaval and theological reinforcement. Directly or indirectly, it had implications which extended irreversibly to the entire future of Western art—and to science and technology from Copernicus to Einstein.

In terms of his own times, Brunelleschi's pocket perspective demonstration was the crucial event—if one taken in stride by the precocious Florentines—in several decades of fitful, teasing progress in optics by the artists, mathematicians, and cartographers of that remarkable, fervent city. Others played their part, too, in the "rediscovery" of linear perspective, some of them centuries earlier. Brunelleschi owed much to his learned friend Toscanelli, about whom history deserves to know more. There was also a bit of good luck involved, in the form of a single book brought to town by a member of what we might today call an "adult study group." A decade after Brunelleschi's mirror painting of the Florence Baptistery, an exiled aristocrat returned to that city and put into writing, for the first time in history, the method for making a linear perspective construction in painting.

How curious that an understanding of the mathematics of human pictorial representation occurred so late—and so locally—in history. And how regrettable that Brunelleschi and Alberti have received so little credit for the perceptual revolution that they fostered! Today we are the tired children of their discovery; the magic of perspective illusion is gone, and the "innate" geometry in our eyes and in our paintings is taken for granted. Linear perspective has been part and parcel of psyche and civilization for too many centuries, which is perhaps far less astonishing than the fact that it eluded men of all civilizations for a thousand years prior to the Quattrocento. We think of perspective no more than we think consciously of our extraordinary, mindless doodles on handy telephone scratch pads. And we think of it considerably less than

we do of Columbus' discovery of America—on which, as we shall see, it had some bearing.

W E SPOKE ABOVE of the "rediscovery" of linear perspective with Brunelleschi's experiment in 1425. Who, prior to the fifteenth-century Florentines, came upon the principles which Alberti was to give directly to painters?

So far as we have been able to ascertain, no civilization in the history of the world prior to the time of the ancient Greeks and Romans ever made pictures according to this procedure. There is even some doubt as to whether these classical artists themselves knew perspective rules as such. We do know that certain of the classical mathematicians, in particular Ptolemy (Claudius Ptolemaeus) of Alexandria in the second century A.D., knew about geometric perspective, although they apparently applied their formulations only to practical maps and stage designs.

But whatever the ancients may have known of perspective constructions vanished into oblivion during the Middle Ages in Western Europe. Nor did any of the other great cultures of the world—and here we may include the Chinese, Persian, Indian, Arab, and Byzantine civilizations—which classical learning influenced, seem to have been interested in this geometric-optical way of picture making.

Suddenly—or perhaps not so suddenly—linear perspective burst on the scene again, in Florence, Italy, around 1425. There Filippo Brunelleschi conducted his ingenious mirror demonstration, showing that he had managed to work out the complex geometry of "realistic" painting; the original pictures in which he accomplished this, alas, have been lost. Although he wanted his feat to come to the notice of his townsmen, it appears that Brunelleschi did not personally try to capitalize on his breakthrough. Rather, he passed the rules on to his friends, the painters Masaccio and Masolino and the sculptor Donatello, who, with a few other Florentine artists, became the first men to apply the principles of linear perspective since classical antiquity. About a decade later, in 1435, the humanist Alberti, returning to Florence after a lifetime of exile, formally

recorded these principles. Alberti's treatise, specifically on painting, thus became the first document ever—anywhere in the world—to relate the optical laws of vision to the aims and aspirations of artists.

We cannot help wondering why it was the artists of the Italian Renaissance who, unlike any of their fellow craftsmen outside Western Christendom, discovered or invented—once more—the geometric laws of pictorial representation. The distinction between the words "discover" and "invent" here is intentionally provocative. "Discover" implies that linear perspective is an absolute scientific truth, universal to all men regardless of cultural background or historical period. "Invent," on the other hand, suggests that linear perspective is only a convention, the understanding or adoption of which is relative to the particular anthropological and psychological needs of a given culture. The issue is moot, and the question as to whether perspective is revealed or imposed continues to stir debate among cultural historians and perceptual psychologists (at present, the "discover" side seems to be carrying the day).

From the scientific standpoint, it is clear enough that if one takes for granted that a picture should present itself as an illusionistic open window, with the viewer standing centrally before it, then the perspective configuration of the objects in such a picture will indeed approximate the way the same objects would look in "reality." This is not to say, however, that *all* pictures should be conceived in terms of windowlike frameworks—a notion which only the peoples of classical antiquity and those of the European Renaissance (and after) have ever entertained.

Florence, of course, had unique qualifications to become the matrix of modern pictorial perspective, as we shall consider at greater length in Chapters III and IV. On the other hand, any definitive "causes" to account for the peculiar time and place of this development remain as elusive as the "vanishing point" did for thousands of years. That the lightning rod for linear perspective lay so exclusively in the West may not be unrelated to the singularly Western propensity never to resolve the ancient conflict between the secular and the spiritual. We shall be exploring a number of coincidences between events stemming out of this conflict and the advent of perspective. Indeed, the fresh geometrical discoveries became "hot" with late medieval artists at the very moment when new mercantile and urban political ideas were beginning

to challenge traditional Christian spiritual and moral authority in Europe.

In any case, the intricacies of windowlike perspective could not long remain exclusively an artist's concern. It was almost inevitable that the developing sciences of geometry, optics, and cartography —along with generous doses of theology—would also play a role. Yet the Renaissance "rediscovery" of perspective was not immediately heralded as a victory of objective reality over medieval mysticism. To the contrary, the early users of the new art-science thought of it as a tool which might help restore the moral authority of the Church in a world becoming progressively materialistic. In this sense, the advent of the new perspective represented not a revolt but a recrudescence.

To APPRECIATE exactly what transpired in Florence at this time, we have only to consider two topographical views of the city (Illustrations 1–1 and 1–2). What they reveal, uniquely, is the "before" and "after" not of a town but of the artist's eye. The earlier map is a detail from a larger fresco painted about 1350 for the old Loggia del Bigallo. In the second illustration we have a large woodcut (and painting) from about 1480 known as the *Map with a Chain*. Very little actual change had taken place in the topography of Florence between the above dates; the only significant new feature in the *Map with a Chain* is Brunelleschi's majestic dome over the Cathedral. Yet the two views of the city are strikingly different.

In the *Map with a Chain* we can see clearly what happened to human pictorial orientation after the advent of linear perspective. This new Quattrocento mode of representation was based on the assumption that visual space is ordered a priori by an abstract, uniform system of linear coordinates. The artist need only fix himself in one position for the objective field to relate to this single vantage point. He can then represent the objects in his picture in such a way that the viewer can apprehend the scene exactly as if he were standing in the same place as the artist. Most people raised

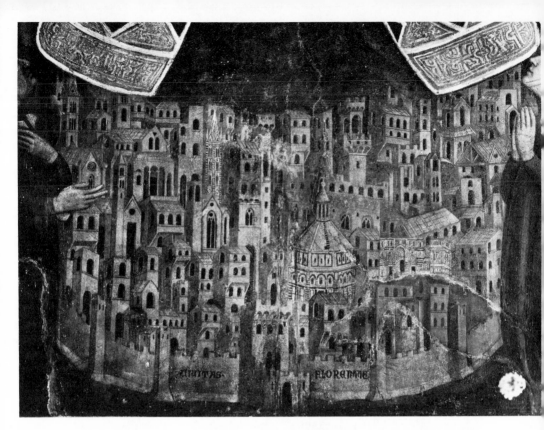

Illustration 1–1: Unknown Italian artist, detail showing the *Civitas Florentiae* (City of Florence) from a fresco in the Loggia del Bigallo, Florence, c. 1350. Courtesy, Alinari-Art Reference Bureau.

Illustration 1–2: Unknown Italian artist, *Map with a Chain*, woodcut copy after a painting now in the Museo Firenze com'era, Florence, c. 1480. Courtesy, Alinari-Art Reference Bureau.

in this perceptual tradition since the Renaissance have come to accept linear perspective as producing greater "realism." In contrast to this, the uncentralized representation in the Loggia del Bigallo fresco seems childlike or "naive," suggesting that its fourteenth-century creator was either pitifully ignorant or deliberately distorting what he saw in order to achieve a particular aesthetic effect. Many present-day historians of science, in fact, tend to view the advent of linear perspective in the same way they do Columbus' discovery of America or Copernicus' apprehension of the heliocentric universe: as a definitive victory over medieval parochialism and superstition.

On the other hand, the attitudes of modern art have persuaded art historians today that the artist of the Loggia del Bigallo fresco was scarcely "naive." Was he not raised in the sophisticated age of Dante, Petrarch, and Giotto? Nor was he any less "faithful" in rendering the city of Florence than the designer of the *Map with a Chain*. The painter of the earlier picture did not conceive of his subject in terms of spatial homogeneity. Rather, he believed that he could render what he saw before his eyes convincingly by representing what it felt like to walk about, experiencing structures, almost tactilely, from many different sides, rather than from a single, overall vantage. In the *Map with a Chain* the fixed viewpoint is elevated and distant, completely out of plastic or sensory

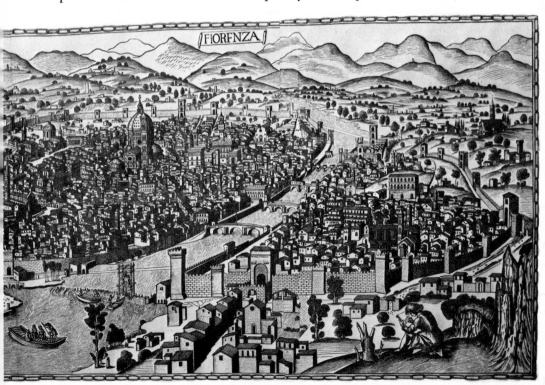

reach of the depicted city. In the fresco, on the other hand, jutting building corners, balconies, and rooftops are thrust out and huddled toward the viewer from both sides of the picture. If we do not get a keen thumb's-eye notion of the layout of Florence, we do get a feeling for the sculptural impact of an encompassing medieval city. Just ask any modern tourist, arriving for the first time in Florence with heavy baggage and unfamiliar *pensione* address in hand, which of the two views is more true!

Could it be possible that the "naturalism" of the Loggia del Bigallo fresco is just as valid a part of human—and artistic—visual experience as the "realistic" linear perspective of the *Map with a Chain?*

Perceptual psychologist James J. Gibson has recently advanced a theory that lends support to such a view.[1] According to Gibson, sight is not merely a specific, autonomous sense but is interrelated with the other senses in a highly complex sensory system (Gibson rearranges these senses into a new order of "perceptual systems"). Moreover, this visual system involves at least two kinds of perception: the "visual world" and the "visual field." The visual world, according to Gibson, is what we experience in the broadest sense of seeing, that is, as we move about, orienting ourselves to objects from all sides. In the visual world phenomena are experienced in their three dimensions and with cognizance of their complete form, as perceived by other senses (like that of touch). The visual field, on the other hand, is what we perceive when we fixate with the eyes, whether we are standing still or moving. It is in the visual field that we become aware of linear perspective, that is to say, the distortion of shape, size, and distance in the aspect of the seen objects according to the viewer's single eyepoint. In the absolutism of the visual world, we are conscious of the invariant size and form of things and of their substantiality in their own right, without relation to other objects. In the more relative visual field, we are aware of how things change in shape, size, and proportion with respect to position and distance from the fixed eyes (and from each other).

Whereas in the visual world we see what Professor Gibson calls "depth shapes," in the visual field we see "projected shapes." The depth shape of an object is its total three-dimensional form, the impression of the object as a solid geometrical entity as we observe it from different viewpoints while moving about or turning it over

in our hands. The projected shape of an object, however, presents a more limited aspect, as our vision in this case is limited to seeing it from a single vantage point. The forms of things seen in the visual field are distorted in perspective, seldom appearing according to their actual size and shape. Thus the ordinary dinner plate is recognized as quite circular in the visual world but as being an ellipse in the visual field.

Thus, we may consider these two sets of visual experience as being mutually complementary: one gives more information about the nature of separate objects themselves, while the other reveals more about their relative size and locus and the spatial separations between them.

LET US LOOK at two more illustrations, both of which violate accepted norms of linear perspective. The first is a detail from a Byzantine Yugoslavian fresco in the King's Chapel at Studenica. It was painted in the early fourteenth century and shows the infant Virgin Mary in her cradle (Illustration 1–3). The second is a modern cartoon by Robert Weber from a recent issue of *Esquire* magazine (Illustration 1–4). In the traditional, formalized Byzantine style of the first picture, we notice that the background buildings are shown as if seen from above and below at the same time. Similarly, the cradle in which the infant Virgin rests is drawn with its two presumably parallel ends in "reverse perspective"—that is, with the rockers, which should be perpendicular to the front side, diverging rather than converging, as we have come to expect in familiar perspective articulation. One hardly needs reminding that this picture, as originally conceived, deals with an indisputably sacred subject in Christian art. Not the slightest hint of humor was intended in the representation of this intimate and holy scene. Yet to modern eyes, such a reversal of the expected converging lines is at the very least ingenuous, if not—as in Weber's cartoon—arrestingly droll. Most of us today are so removed from old medieval pictorial attitudes that the obvious sincerity of the Studenica painting seems quaint.

Reverse perspective, as a means of rendering the illusion of the

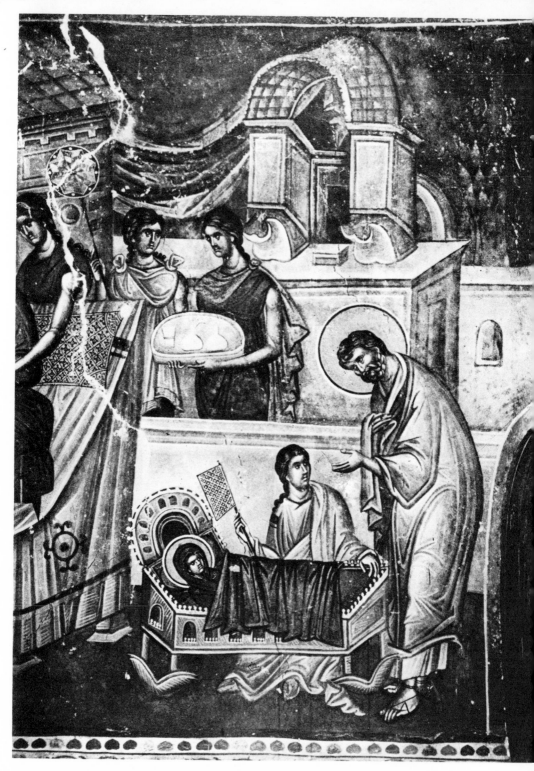

Illustration 1-3: Unknown Byzantine artist, Detail showing the *Birth of the Virgin* from a fresco in the King's Chapel, Church of Sts. Joachim and Ann, Studenica, Yugoslavia, c. 1310–15.

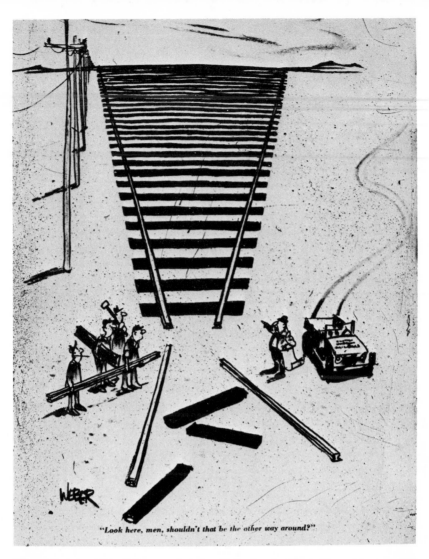

"Look here, men, shouldn't that be the other way around?"

Illustration 1–4: "Look here, men, shouldn't that be the other way around?" Reproduced by permission of Esquire Magazine, copyright © 1966 by Esquire, Inc.

third dimension, is by no means unique to the Studenica painting. There are innumerable examples of it in pictures from all over the ancient and medieval worlds, including the works of the most sophisticated painters of the fourteenth century both south and north of the Alps, among them the great Giotto. It is seen to this day in the art of non-Western societies which have remained outside the influence of Renaissance perspective. Reverse perspective has also been related to the phenomenon of split representation, observed by anthropologists and social psychologists among so-

called primitive peoples, and especially among children.[2] This is the propensity to represent three-dimensional objects as if split apart and pressed flat, so that the picture shows more sides and parts of the object than could possibly be seen from a single viewpoint.

While more study of this phenomenon is needed, it seems to be implicitly related to the artist's desire to depict what is experienced in the visual world. This propensity, moreover, seems to be innate; cultural history shows it to be at least more "natural" for human beings to begin making pictures in this way. The pictorial attitude of the visual field, on the other hand, is not innate and is quite unnatural until it is learned. Why have we in the post-Renaissance West become so insensitive to the nonperspectival pictorial conventions of our own early Middle Ages? Indeed, why did the devout Christians of the fourteenth and fifteenth centuries abandon such time-honored, understood conventions for the more mathematical terrain of linear perspective?

In fact, a tendency toward centralized composition, if not precisely toward linear perspective, was beginning to work its way into Western European art a century and a half before the decisive inceptions of Brunelleschi and Alberti. We have a graphic example in the late thirteenth-century fresco cycle, probably by Giotto, in the upper church of San Francesco at Assisi. These paintings on the lower nave walls epitomize, it may be said, the end of the Middle Ages and the dawn of the Renaissance. One sees clearly that the painter planned his frescoes in groups of three for each stretch of surface between the nave piers, with each group of pictures having a painted frame (Illustration 1–5).[3] This painted framework (which was certainly planned at the time the frescoes were begun) gives the illusion of an open architectural loggia, through which the viewer is to regard the various St. Francis scenes as if they were outside, beyond the fictive openings. It is evident that the artist constructed this illusionistic loggia so that the edges of all the painted modillions at the top and of the dentils at the bottom converge toward the center of the middle picture; those on the left converge toward the right, while those on the right converge left.

It is also clear that the St. Francis master anticipated the viewer's positioning himself centrally before the frescoes. Still, we do not have a precise perspective system here, since the lines converge not on a single vanishing point—a term with which we shall be dealing

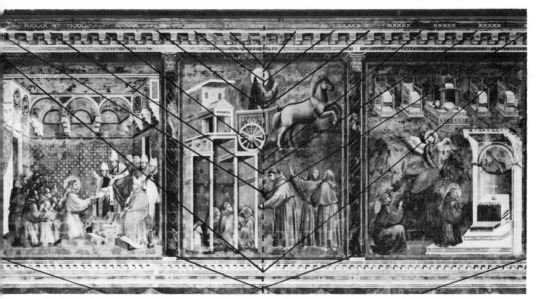

Illustration 1-5: Giotto (?), Scenes from the *Life of St. Francis*, Upper Church of San Francesco, Assisi, late thirteenth century. Courtesy, Fototeca Berenson, Villa I Tatti, Florence.

in some detail—but on a vertical axis running through the center-most picture of each group. Although the painter seems to have had a premonition of Quattrocento linear perspective here, he does not go further and apply it consistently in the individual scenes themselves. Whether or not conceived of as events happening beyond a window, none of the scenes depicted in the fresco cycle has any perspective unity whatever; this obtains whether they are viewed individually or as tripartite units. In each fresco we see the general medieval "encircling eye" propensity for projecting cor-ners and split views, a propensity for literally—to borrow from our most unmedieval modern idiom—"letting it all hang out."

There are also inklings of destined perspective in the Loggia del Bigallo Fresco (Illustration 1-1), done about seventy years later. One notices, for example, that all the buildings in the depiction of Florence are illuminated from the right and shaded on the left. In spite of the fact that the artist relied on multiple viewpoints for depicting various parts of these buildings, there is the feeling that he wanted to assume a single *moment*, if not a single viewpoint, for all the lighting.

II

Pictures in the Service of God

THE COMING of linear perspective to the Western world was heralded by more than a few isolated precursors, and by more than developments in the craft of painting. Well before the fifteenth century, the foundations for a changing pictorial attitude in Europe were laid in scholastic writings. During the 1260s the Franciscan monk Roger Bacon (c. 1220–c. 1292) composed the *Opus majus*, a long treatise which he intended as a compendium of all knowledge. He dedicated it to the pope, with the fervent hope that it might benefit His Holiness in overseeing Christendom. As we shall see, Bacon included a section on optics, whose geometric laws—he wished to show—reflected God's manner of spreading His grace throughout the universe.

In addition, and most importantly for the present argument, Bacon wanted to demonstrate in his section on mathematics proper that painters should also become skilled in geometry. With this knowledge, Bacon argued, they could truly "make literal the spiritual sense." Here he was referring to the scholastic method of scriptural exegesis, whereby the events of the Bible are interpreted literally, allegorically, morally, and mystically (anagogically).

Pictures in the Service of God

Churchmen were usually quite skillful concerning the last three levels of interpretation, but they had not been very convincing, Bacon thought, in getting the literal message across. Accordingly, he hoped that the pope might exert his influence on artists to master geometry in order that they might better illustrate the works of God.

This deliberative plea, lengthy as it is, deserves our reading because it is so revealing of a time and spirit remote from us today but very much relevant to the events in Florence less than two centuries later. More than this, it is a singularly moving document. Certainly nowhere else in the Middle Ages will we find a more earnest, precocious call to artists to bring an ambitiously geometric composition to sacred pictures. Bacon's *Opus majus* is invaluable in helping us to understand the evolution of Western realism:

Now I wish to present the . . . [purpose], . . . which concerns geometrical forms as regards lines, angles, and figures both of solids and surfaces. For it is impossible for the spiritual sense to be known without a knowledge of the literal sense. But the literal sense cannot be known, unless a man knows the significations of the terms and the properties of the things signified. For in them there is the profundity of the literal sense, and from them is drawn the depth of spiritual meanings by means of fitting adaptations and similitudes, just as the sacred writers teach, and as is evident from the nature of Scripture, and thus have all the sages of antiquity handled the Scripture. Since, therefore, artificial works, like the ark of Noah, and the temple of Solomon and of Ezechiel and of Esdras and other things of this kind almost without number are placed in Scripture, it is not possible for the literal sense to be known, unless a man have these works depicted in his sense, but more so when they are pictured in their physical forms; and thus have the sacred writers and sages of old employed pictures and various figures, that the literal truth might be evident to the eye, and as a consequence the spiritual truth also. For in Aaron's vestments were described the world and the great deeds of the fathers. I have seen Aaron thus drawn with his vestments. But no one would be able to plan and arrange a representation of bodies of this kind, unless he were well acquainted with the books of the *Elements* of Euclid and Theodosius and Milleius and of other geometricians. For owing to ignorance of these authors on the part of theologians they are deceived in matters of greatest importance. . . . Oh, how the ineffable beauty of the divine wisdom would shine and infinite benefit would overflow, if these matters relating to geometry, which are contained in Scripture, should be placed before our eyes in their

physical forms! For thus the evil of the world would be destroyed by a deluge of grace, and we should be lifted on high with Noah and his sons and all animate creatures collected in their places and orders. And with the army of the Lord in the desert we should keep watch around the Tabernacle of God and the table of the shewbread, and the altar, and the cherubim overshadowing the mercy seat, and we should see as though present all the other symbols of that ancient people. Then after the unstable tabernacle swaying to and fro had been removed, we should enter the firm temple built by the wisdom of Solomon. And with Ezekiel in the spirit of exultation we should sensibly behold what he perceived only spiritually, so that at length after the restoration of the New Jerusalem we should enter a larger house decorated with a fuller glory. Surely the mere vision perceptible to our senses would be beautiful, but more beautiful since we should see in our presence the form of our truth, but most beautiful since aroused by the visible instruments we should rejoice in contemplating the spiritual and literal meaning of Scripture because of our knowledge that all things are now complete in the church of God, which the bodies themselves sensible to our eyes would exhibit. Therefore I count nothing more fitting for a man diligent in the study of God's wisdom than the exhibition of geometrical forms of this kind before his eyes. Oh, that the Lord may command that these things be done! There are three or four men who would be equal to the task, but they are the most expert of the Latins; and rightly must they be expert, since unspeakable difficulty lurks here, owing to the obscurity of the sacred text and the contradictions of the sacred writers and difference of the other expounders. . . . And for the sake of all things in general let us recall to mind that nothing can be known concerning the things of this world without the power of geometry, as has already been proved. Also a knowledge of things is necessary in Scripture on account of the literal and spiritual sense, as has been set forth above. For without doubt the whole truth of things in the world lies in the literal sense, as has been said, and especially of things relating to geometry, because we can understand nothing fully unless its form is presented before our eyes, and therefore in the Scripture of God the whole knowledge of things to be defined by geometrical forms is contained and far better than mere philosophy could express it. . . .[1]

To be sure, Bacon was not advocating linear perspective per se. He certainly had never seen a perspective picture, and it is conceivable that he wouldn't have fully appreciated one if he had. Here he never once alluded to anything on the order of a vanishing point, the key to linear perspective (as we shall see). What seems to have been on his mind, rather, was the lack of *any* system or clear-cut geometric order in the painting of his own day.

Pictures in the Service of God

An energetic scientist in spite of his deep religious calling, he was obviously not satisfied with the piecemeal imagery and symbolism we of the more agnostic twentieth century have come to associate with "naive" medieval religious faith. Bacon wanted the sacred stories illustrated in "literal truth," according to the laws of optics and geometry, which he believed underlay God's masterplan for the universe.

It is by no means unlikely that Bacon personally compared paintings by his contemporaries with mirror reflections. In his *Opus majus*, he also devotes a long essay to the geometric theory of mirrors, that is, on how to use Euclidian rules to locate the mirror image in relation to the object before it. One cannot help wondering whether or not the "three or four Latins" he mentions in his treatise might possibly have been Italian painters, just then preparing to reveal an extraordinary new and revolutionary style on the walls of his own mother church at Assisi. Among these might have been Cimabue, Giotto's teacher, or the so-called Isaac Master.

During Bacon's thirteenth century, the emerging secular world was expanding to an extent unknown since classical antiquity. New, international avenues of trade had opened and people were on the move about the Continent. Above all, learning, since the great influx of classical literature in the century previous, was in a state of glorious renascence. The feudal cement which had served to hold the medieval world together was beginning to crack.

Late in the century, controversy surrounded the hitherto unassailable teachings of Aristotle. Finally, in 1277, Aristotle was banned altogether by the bishop of Paris on the grounds that the philosopher had described the universe as finite. According to Aristotle, all the planets and stars revolved in fixed spheres around the earth, but beyond the last sphere there was nothing, only void. To this the bishop of Paris now raised the proposition that God could, if He would, make the universe move off from its earth-bearing location to some other place; or God could create as many universes as He wished. There can therefore be no such thing as a void in which God cannot operate; to believe otherwise denies His omnipotence. This episcopal edict was to have far-reaching effects. However ingenuous such a theological argument may seem to us today, what is important is that it helped prepare the way for

a modern scientific concept of infinite and homogeneous space, and therefore for the advent of linear perspective in art.

The science historian Alexandre Koyré has made an interesting examination of the scholastic dispute over Aristotle, particularly of the witings of the bishop's numerous defenders.[2] Of these several commentators, the most interesting for us was the brilliant English mathematician and theologian Thomas Bradwardine (c. 1290–1349), archbishop of Canterbury and Oxford scholar. Bradwardine argued that before the Creation, some kind of infinite space existed *within* which the universe was established, and that God himself presided from within this space in His act of creating. The Creator, if He so willed, could expand the universe to any extent and in any direction. "God" wrote Bradwardine, "is an infinite sphere whose center is everywhere and whose circumference nowhere" (*Deus est sphaera infinita cuius centrum est ubique et circumferentia nusquam*).

We have here, in official theological language, a recognition that nothing stands in the way of union between mathematical logic, on the one hand, and God's divine grace, on the other. This was (as we shall see in Chapter V) a fundamental principle in the optical thought of Robert Grosseteste and Roger Bacon. Bradwardine's remarks reflect a notion held not only by his fellow English opticians, but also increasingly by Italian painters: namely, that the theoretical, infinite space of the mathematician and the physical space one sees before the eyes are one and the same thing. Perhaps it is no coincidence that in Italian art at this very time, skies were less often painted in the symbolic colors of purple or gold, but frequently in blue. The notion of uniform and infinite space was beginning to take hold.

Bradwardine, quoting from St. Augustine, also observed that God created the universe in the manner of the artisan (*quomodo artifex regens quod fecit*).[3] While we cannot be quite sure exactly what Bradwardine or St. Augustine understood by *artifex*, the relevant passage does seem to distinguish God as *artifex* and not as *faber*, the stoneworker responsible for (among other things) the building of an arch. The latter works only from outside his edifice; his handicraft depends on extrinsic materials and is accomplished in a place different from that where the mason stands himself. God, however, creates entirely from within Himself. He is infused totally with the universe He creates (*Deus autem infusus*

mundo fabricat . . .). Bradwardine's analogy is briefly put. Nevertheless, he appears to have sensed something quintessential: the ubiquitous nonwindow character of medieval painting about which Bacon expressed such concern.

Unlike the Renaissance painter depicting his scene in perspective, the medieval artist viewed his world quite subjectively. He saw each element in his composition separately and independently, and thus paid little attention to anything in the way of a systematic spatial relationship between objects. He was absorbed within the visual world he was representing rather than, as with the perspective painter, standing without it, observing from a single, removed viewpoint. It was only later, as we have seen, that people were taught to think of painting as the mason builds his arch: from the outside looking in, as if the picture were a window between the painter and the subject he would depict.

Professor Gibson has used the example of railway tracks to express this distinction in another way. The post-Renaissance artist, he points out, will see the rails as forever converging. But what about the railroad engineer? He is "infused" with the tracks, as it were, and hence sees the rails as parallel. The "reality" of the tracks for the engineer, as with the medieval artist, depends on quite a different viewpoint from that of the linear perspective painter.[4]

H OW "NAIVE," then, is preperspective art? Modern scholars have seen a distinct parallel between the manner of painting of the medieval artist and that of young children in our own times. (While this observation has always been made with some hesitation, it would be a mistake to imagine that such a comparison in any way denigrates the special genius of the craftsmen of the Middle Ages.) The similarities that come out of such a relating of art history to human development are interesting, for children, like the medieval artists, imagine themselves as completely infused with the world they wish to depict. Instead of looking at things from a single, detached vantage, the young artist tends to see everything egocentrically. An object attracting a child's attention is seen only from its most advantageous and descriptive viewpoint. The

sky, for example, is usually rendered as a blue streak at the top, because the child sees the sky as being "up." The ground becomes a green stripe at the bottom, because it is most conveniently seen by looking down. The main or middle part of the picture is generally left neutral in color by the child, as that is where he sees the people and other things which really interest him. Because he knows his own house from walking all around it, he will often draw it with the two ends showing as well as the main front side.

In recent years Swiss psychologist Jean Piaget has been studying the change in children's perceptual development from an egocentric, nonperspectival viewpoint to a growing understanding of "space structuration" after the age of about eight. He has related this developmental change to the history of mankind generally: phylogenesis recapitulates ontogenesis. Admittedly, Piaget has only experimented with Western children in this regard (in fact, his own), and the parallel he draws between the growth of the child's perception and that of the human race as a whole necessarily reflects his own Western values and predispositions. The phylogeny-ontogeny notion is one which does not rest easy with the cultural historian, but it should not be dismissed out of hand. Within the history of Western civilization, at least, the "phylogeny" of linear perspective from the Middle Ages through the Renaissance has clear enough parallels to the "ontogenetic" mental growth of a modern child learning to perceive an abstractly structured visual space and to think of pictures in linear perspective.[5]

Most importantly, however, Piaget does not characterize the acquisition of knowledge as a pyramid, that is, as a pile of progressively refined information derived empirically through the senses and then narrowed toward an apex of understanding. Rather, he characterizes the growing process of the human mind as a spiral with a perpetually changing but never disappearing radius. Each level or turn of this self-extending spiral is a completion in itself. At every growth stage of the human being there is a new loop, as it were, and therefore a special self-regulating wholeness, unique to each stage. As Piaget explains, the mind of the young child—and I would include here the mind also of the medieval European Christian—is not to be thought of as a mere preliminary or deficient version of the adult in modern Western society. Instead, it is a *qualitatively* different and homogeneous entity. The process of acquiring knowledge consists less in the

discovery of external truths than in the changing internal structuring process of the mind itself. This evolving aptitude cannot be summed up in terms of an inferior-superior ratio. Rather, it is a matter of considering one set of perceptions of "what is" against another set—equally valid, autonomous, and complete.

Particularly relevant to our inquiry here are Piaget's ideas concerning the development in young children of the ability to perceive spatial relationships, and to make what he calls "logico-mathematical" judgments about them. As Piaget believes, the process of perception is fundamentally linked with an innate ability to order sensory information into such logico-mathematical patterns, but this ability is not manifest until the child, at about eight or nine, begins to venture more forthrightly into the world beyond his securely self-oriented universe. Piaget's experiments show that the child's abstract comprehension of space, as a vertical-horizontal reference system, occurs at about the same time that he begins to relate himself to a wider range of experiences in the sensory world.

Could one not also say that the peoples of the Middle Ages began to exercise their own innate seeing and structuring capacities in much the same way? Did they not also begin to apply logico-mathematical perspective only after beginning to experience the secular world outside their borders?

BUT LINEAR PERSPECTIVE was not simply the outgrowth of an expanding secular world. Certainly the remarkable determination of Christian teachers, such as Bacon, to make casuistic relationships between the various applications of mathematics and moral doctrine played as important a role. Indeed, the new capitalism of Italy lived, at least until the late fifteenth century, in an extraordinary symbiosis with traditional medieval religious faith. In our modern attempts to see the unfolding Renaissance as a forerunner of contemporary individualism, rationalism, and agnosticism, we often forget, as David Herlihy reminds us, that the era of civic humanism in the early fifteenth century was also a period of intense civic Christianity.[6] The desire of the donors or patrons to atone for personal sins and foster in others service to

Pictures in the Service of God

God had as much to do with the flowering of fresco and panel painting in Trecento and Quattrocento Italy as any secular force.

Whatever we may mean by the catchall term "realism" today, for the average Italian citizen in early fifteenth-century Florence the word had metaphysical as well as physical connotations. Holy images such as the famous *Nostra Donna*, a Byzantine-style painting at the Church of Santa Maria at Impruneta outside Florence, continued throughout the century to attract a huge following; among them were members of the Florentine government, who believed that this particular picture could invoke divine favor in time of crisis.[7]

Initially, the new perspectival constructions by the contemporaries of Brunelleschi and Alberti were intended not only to objectify the physical environment but also to enhance the allegorical, moral, and mystical message in scripture and the lives of the saints. Indeed, all of the early paintings in linear perspective, by Donatello, Masaccio, Masolino, and Fra Angelico, were of religious subjects only; the empirical naturalism of Trecento painting apparently seemed to these first perspective artists too beguiling, an enticement which might distract the viewer from proper Christian contemplation. Linear perspective, then, with its dependence on optical principles, seemed to symbolize a harmonious relationship between mathematical tidiness and nothing less than God's will. The picture, as constructed according to the laws of perspective, was to set an example for moral order and human perfection.

IT IS INTERESTING that most of the Italian artists during the first half of the fifteenth century did not suddenly adapt to linear perspective, and the new art-science was never applied either to scientific drawings or architectural models until the time of Leonardo da Vinci (1452–1519). Rather amusingly, there was a propensity, continuing right through the sixteenth century, to illustrate scientific manuals with pictures in split-view or reverse perspective, long after the rules of Brunelleschi and Alberti had

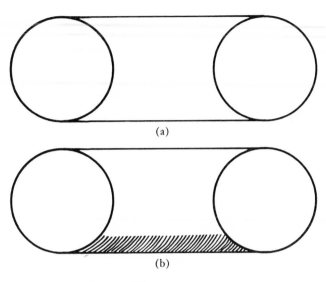

(a)

(b)

Diagram II–I

been acknowledged by artists generally. Diagram II–Ia, for example, is a reproduction of a cylinder figure that was to be found in nearly all European geometry textbooks published from classical antiquity through the 1500s.[8] To the learned geometer, the salient property in the cylinder's "reality" was always its oblong length with parallel sides and equal circles on each end. This, of course, the diagram showed him quite graphically without the help or need of linear perspective. In the seventeenth century, however, the ever-increasing impact of perspective pictures prompted conservative textbook printers to "improve" the old cylinder—by the incongruous addition of shading (Diagram II–Ib)![9]

However cautiously, linear perspective did find its way, panel by panel, fresco by fresco, into the painting styles of Continental Europe. At the heart of this revolution lay the germinal contributions of Brunelleschi and Alberti, whose rules spawned an increasingly complex mass of textual guidelines and constructions. Their crucial discovery unquestionably was the definition of the so-called vanishing point. This refers to the illusion in ordinary vision that the parallel edges of objects stretching away from the eyes seem to be converging at an infinite point on the horizon. Brunelleschi, as all evidence here will suggest, was not only the first artist but also the first scientist in history since antiquity to

grasp the geometrical and optical principles by which this appears to happen. In spite of the intense interest in the science of vision by Greek, medieval Christian, and Arab scholars, and despite the scrutinous observation of nature by the European painters of the fourteenth century, no one before Brunelleschi seems to have satisfactorily elucidated this phenomenon in ordinary sight—much less shown how to recapitulate it in pictures.

THE TERM *vanishing point*, used for convenience throughout this book, was not coined until modern times. We do not know what epistemological significance, if any, either Brunelleschi or Alberti gave to the phenomenon; that is, whether they thought of it as a mathematical point, a distinct place, or a symbol of infinity. Alberti simply referred to it as the "centric point." Although he understood its relation to infinity, his only expressed concern was that it be placed by the artist in the center of the drawing space and operate as the single locus for all converging architectural lines.

Corollary to the vanishing point principle were the notions of the *distance point* and what I have called, perhaps too ponderously, *horizon line isocephaly*. The distance point has to do with working out a construction, ancillary to that of the vanishing point, in order to determine geometrically, not only the apparent convergence of receding parallels, but the diminishing depth of pictorial elements. Horizon line isocephaly describes the phenomenon whereby, if we see other persons standing on the same plane as ourselves, the apparent diminution in the size of more distant figures begins with the feet; the heads of all figures standing on the same level as the viewer are always seen aligned with his own head on the common horizon. Alberti wrote down very explicit instructions for constructing both the distance point and horizon line isocephaly. But the ideas were certainly inherent in the earlier demonstrations of Brunelleschi.

Pictures in the Service of God

I T IS DURING and shortly after the year 1425 that we can date the first pictures to show such features. The young Florentine artist Masaccio seems to have been the earliest painter, and Donatello the first sculptor, to employ linear perspective. They were both good friends of Brunelleschi, and the latter must have imparted his ideas to these two shortly after his own demonstrations. Consequently, Masaccio tried out Brunelleschi's rules in his large fresco of the *Trinity* in the Church of Santa Maria Novella (Illustration II–1). In the same year Donatello applied perspective rules on a smaller scale, and somewhat less forthrightly, in his little bronze panel, the *Feast of Herod*, for the Siena Baptistery font.

In painting the *Trinity*, Masaccio fixed the vanishing point of the fictive architecture exactly five feet nine inches off the floor, the height of an "average" viewer standing before the painting. He thus wished to prove Brunelleschi's observation that the illusionary convergence of edges of objects, parallel to the ground plane in nature, always occurs at a point level with the viewer's eyes (see Chapter IX).

A year or two thereafter, Masaccio was working with his partner Masolino in the Brancacci Chapel of the Santa Maria della Carmine church in Florence. In two of the frescoed scenes from this famous mecca of Western art, the *Tribute Money* and the *Raising of Tabitha and Healing of the Cripple* by Masaccio and Masolino respectively, we can observe how sophisticated the painters had become in their handling of Brunelleschi's rules (Illustrations II–2 and II–3). The two artists were now able to use linear perspective principles as a means of giving compositional unity to all the many pictures in the chapel. For instance, by applying the rule of horizon line isocephaly, aligning the heads of all standing figures both in the foreground and far distance along a common horizon line, they provided a unifying link and a structural harmony between all the frescoes; from the practical standpoint, they made it easier for the viewer to follow the depicted stories from one scene to the next. As far as I can determine, these two pictures are the first in the entire history of art to illustrate the scientific-artistic principle of horizon line isocephaly.

Brunelleschi's two recorded perspective demonstrations, in which he constructed pictures of the Florentine Baptistery and the

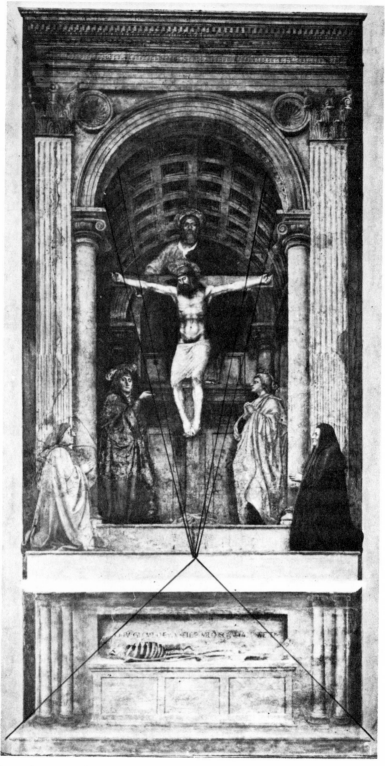

Illustration II–I: Perspective reconstruction: Masaccio, *Trinity*, Santa Maria Novella, Florence, c. 1425. Courtesy, Soprintendenza alle Gallerie, Florence.

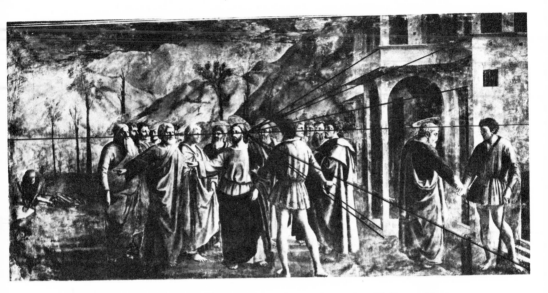

Illustration II–2: Perspective reconstruction: Masaccio, *Tribute Money*, Brancacci Chapel, Santa Maria della Carmine, Florence, c. 1427. Courtesy, Soprintendenza alle Gallerie, Florence.

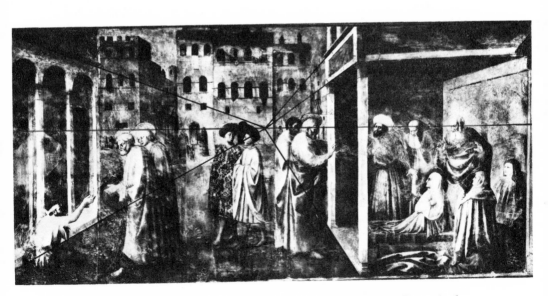

Illustration II–3: Perspective reconstruction: Masolino, *Healing of the Cripple and Raising of Tabitha*, Brancacci Chapel, Santa Maria della Carmine, Florence, c. 1427. Courtesy, Soprintendenza alle Gallerie, Florence.

Palazzo Vecchio, are no longer extant. In all likelihood, however, they were not intended as works of art in the aesthetic sense, but rather as optical experiments. Brunelleschi was trying to create the ultimate illusion in representational painting in his perspective view of the Baptistery (we shall later see to what extent he succeeded). This self-educated architect, sculptor, and painter, who belonged to the late-medieval profession which Lynn White has termed "artisan-engineer" (Leonardo being the most famous), was of middle-class origins.[10] His educational opportunities, which we shall examine in the next chapter, no doubt ended with the *abacco*, that is to say, with grammar school training that fitted him for a commercial or technical career—what in America might be called vocational school. He was not exposed, at least not formally, to philosophy or classical history. Nor would his family background and training have ingrained in him any particular desire to relate the aim and composition of a picture to the philosophical ideals of classical antiquity.

But for Leon Battista Alberti, much more was at stake than a technological tour de force. While his own perspective method was certainly derived from Brunelleschi's, he thought it out from quite another position. Unlike Brunelleschi, Alberti was a patrician intellectual, born of one of the noblest families in Italy and the product of an elitist university education. While admiring Brunelleschi's pragmatic outlook and competence as an artisan, he understood linear perspective in more theoretical terms. As Cecil Grayson has observed, Alberti always retained a "conviction that the beauties of the . . . arts correspond to a moral and spiritual equilibrium of human existence."[11] He was interested in providing a standard means for painters to fashion a plausible and unified pictorial space—more a stage than a space, actually—within which painted figures could be presented gracefully, according to the harmonious rhythms of geometry. His perspective construction was intended to copy no specific place. It provided a purely abstract realm which the viewer would discern as a world of order: not the beguiling, undisciplined world of the late Gothic International Style painters, but *real* space in the sense that it functioned according to the immutable laws of God.

From classical times through the Renaissance, the purposes of history were always deemed to be twofold: the chronicling of events and the interpreting of them with rhetorical elegance. Al-

berti wished, above all, for painting to serve the cause of rhetorical history. His whole system of perspective and his exhortations about learning geometry were seen as being in service to the art which he called *istoria,* or history painting.[12] Alberti's *istoria* entailed the depiction of human figures according to a code of decorous gesture. It called for the representation of a higher order of *virtù, onore,* and *nobilità.* The perspectival setting itself was to act as a kind of visual metaphor to this superior existence, for Alberti believed the world functioned best when everything in it obeyed the laws of mathematics. Hence, *istoria* implied more than verisimilitude or "realism." Its major function was didactic: the improvement of society by placing before the viewer a compelling model based on classical ideals and geometric harmony.[13]

During his service in Rome, just prior to his return to Florence, Alberti was a composer of Latin letters (*abbreviatore apostolico*) for the pope, a situation which gave him ample cause and opportunity to study classical monuments and literature. While it was surely the vigorous art of Florence that catalyzed his desire to write the treatise on painting, he mentions only one postclassical artist in the body of his text—Giotto, the first painter in more than a thousand years to sense the need for a pictorial world governed by geometric order.

Because Alberti's perspective system was so obviously related to the ancient and medieval science of optics, this history first considers his treatise on painting, written in Florence in 1435–1436. Brunelleschi's doorway demonstration, which actually occurred some ten years earlier, is better understood and appreciated if viewed through the wrong end of the historical telescope. Equally important, we can gain a richer insight into both of our central characters if we first turn our attention to the abundant city which nourished them.

III

Alberti's Florence

HOW DID PEOPLE in early fifteenth-century Florence "see"? Was it different from the way we conceptualize our physical surroundings in the mind's eye today? What was the peculiar "mental set" at that time which made certain citizens of Florence so amenable to pictures constructed according to the cold logic of optical geometry?

The various interrelated areas of modern Renaissance scholarship, particularly those focusing on the art, politics, economy, demography, science, and theology of the early Quattrocento, tell us enough to give us at least an inkling of a plausible Florentine "psychological profile" during the years between 1400 and 1435. Above all, it is worth giving some attention to certain aspects in the busy life of that commune on the Arno which had to be formative influences on both Alberti and Brunelleschi.[1]

The miracle of Renaissance art and thought, including the advent of linear perspective, owed in large measure to the unique institution of the Italian city-state, with its republican form of government. The relatively small size of these Italian states itself

encouraged individuality by making possible frequent and easy communication between the lowliest citizens and the top-level governmental administrators, for new ideas to find reception and reward, and for unorthodox opinion to enjoy tolerance. Indeed, the city-state society fostered a general feeling that any citizen could make his fame and fortune through the exercise of pure intelligence.

The Florence which Alberti saw for the first time in his life in 1434 was just coming under the sway of the Medici oligarchy. Alberti's family, once one of the richest and most powerful in the city, had been banished before he was born because of their political opposition to the ruling Albizzi. Conceived out of wedlock while his father was trying to reestablish himself in Genoa, he was shunted from one relative to another as a child. He nevertheless managed to gain an education *par excellence*, first in the grammar school of the splendid humanist teacher Gasparino Barsizza in Padua, and then at the University of Bologna, where he studied canon law and the "liberal arts." In the meantime, his native city was undergoing a series of critical wars with the neighboring states of Milan and Naples, which were threatening her precious *libertà*. Rising to power in the wake of these events was a canny banker named Cosimo de' Medici. When he seized the reins of government in 1434, all former enemies of the old regime, including the Alberti, were invited to return.

The Medici dynasty went on to rule for the better part of three hundred years. In spite of the princely excesses of his descendants, Cosimo's staying power was originally based on "low profile" conservatism, a philosophy which stressed traditional moral values and decorum in social behavior and public appearance. The arts, as well as commerce, were encouraged to carry on in a straightforward and orderly way. Cosimo's success was in large measure based on his appeal to the ethical code of the still feudal family structure of Florentine society, and on his gift for assimilating this with the new humanist interest in Ciceronian civic service and with the traditional modes of Christian piety.

The rich patrons of the arts in Cosimo's Florence, heretofore inclined to favor the decorative manner of late Gothic painting (e.g., Gentile da Fabriano's *Adoration of the Magi*, Illustration III-1), were now increasingly admonished to show less public ostentation. The accent in the works of Masaccio, Masolino, Fra

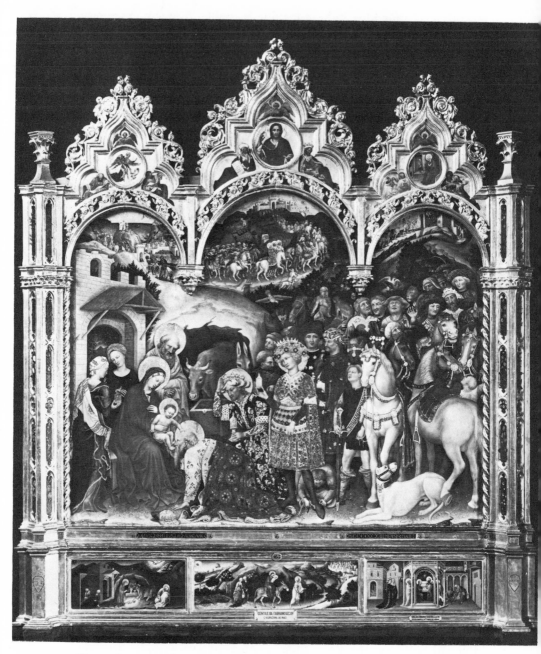

Illustration III–1: Gentile da Fabriano, *Adoration of the Magi*, Uffizi Gallery, Florence, 1423; formerly in the Strozzi Chapel, Santa Trinita, Florence. Courtesy, Alinari-Art Reference Bureau.

Angelico, Fra Lippo Lippi, Domenico Veneziano, and other masters of the 1420s, 1430s, and 1440s, was now not on sensuous charm of pictorial surface, but rather on compelling the viewer to a more intellectual contemplation of the picture's holy subject; here Brunelleschi's new perspective rules played their part. One can be sure that in these sumptuary years of Cosimo's rule, and in the eyes of such a conservative community, the patrons of civic works of art did not allow any new idea to be used by their artists which would not uphold their family prestige. Alberti himself, as he sat down to write his treatise on painting in 1435, was doubtless not unaware that the rich banker Palla Strozzi (the patron of Gentile's hedonistic *Adoration*) was now in exile, sent thither by the same Medici power that had allowed the Alberti to return.

We can only imagine what Alberti's feelings and anticipation must have been as, his exile ended, he traveled through the countryside of Tuscany on the way to the city of his fathers. Since the early fourteenth century, the *mezzadria* system of agriculture, with its centralized land management and emphasis on economical crop distribution, had replaced the old subsistence manorial farming which had led to so much famine and depression. The carefully striated terraces on the Tuscan hillsides, with their neat rows of olive trees and parallel strings of grape vines, doubtless impressed Alberti, as they still charm the modern tourist. For the intellectual and businessman in Alberti's time, such geometricization of the land was appreciated, not only for beauty, but also for the assurance that such mathematical order yielded increased profits. The well-regulated *contado* or countryside around Florence, like the reticulated "pavement" in Alberti's later perspective instructions, was yet another testament to the harmony between mathematical order and God's providence to man on earth.

And with what excitement must this returning son have beheld the city itself as he explored it in the first few days! The awesome, heralded hoisting machinery Brunelleschi had invented was clustered around the cathedral where the great new dome was going up. There were the fabulous frescoes in the Brancacci Chapel by the recently deceased but already legendary Masaccio. There were the vivid sculptures of Donatello at Orsanmichele and on Giotto's Duomo *campanile*, the magnificent new singing gallery by Luca della Robbia, and the Baptistery bronze doors by Lorenzo Ghiberti. Alberti was to meet these extraordinary creative artisans,

to whom he dedicated his treatise on painting the following year. He can only have felt wonder at the miraculous surge of Florentine art, at places such as Ghiberti's open workshop, where artists from all over the city came to meet and discuss their daily activities.

There were many humanists in Florence who did think in terms of a visual world ruled by mathematical law. For many of them, the city of Florence was nothing less than an elect microcosm of God's divine order. Leonardo Bruni, for example, one of the most important of the early civic humanists and chancellor of the Florentine republic, wrote, almost devotionally, in his *Laudatio Florentinae urbis* in about 1404:

Just as harpstrings . . . attuned to each other so that, when they are twanged, a single harmony arises from all the different tones . . . just as this farsighted city has so adapted all her parts to each other that there results a harmony of the total structure of the republic. . . . Nothing in this state is ill-proportioned, nothing improper, nothing incongruous, nothing left vague; everything occupies its proper place which is not only clearly defined but also in the right relation to all others.[2]

To be sure, Bruni's vision here derives from conventionalized encomiums (to Athens, Rome, and St. Augustine's City of God) in classical and medieval tradition. But in this case the analogy reflects a passionate interest among Florentines not only in the moral but the *practical* application of arithmetic and geometry in all walks of the city's life. Mathematics was becoming a kind of social lingua franca, linking upper and lower classes, creating a bond among humanist intellectuals, bankers, artisans, and shopkeepers.

A remarkable testimony to the growing admiration certain humanists had for the quantitative skills of the artisan class is Nicolaus Cusanus' *Idiota*, written about 1450. Cusanus was a German-born cardinal, a frequenter of Florence, and a friend of Paolo dal Pozzo Toscanelli, of whom we shall have more to say. In this book Cusanus imagines a Socratic conversation between Idiota, a deceptively "ignorant" artisan, and a pedantic scholar called Orator (humanists were frequently referred to as "orators") who believes that all knowledge must come from books.

"How can you, being an illiterate (*idiota*), be led to knowledge of your ignorance?" asks Orator.

"Not from your books," answers Idiota cannily, "but from God's."

"And what are they?"

"Those He wrote with His own finger," says Idiota.

Idiota then goes on to explain that true knowledge is found in everyday experiences in the market place, for, as he says, "wisdom cries out in the streets!" [3]

Orator now gets the message and replies, "I see in one place money being counted, in another merchandise being weighed, and opposite to us oil is being measured. . . ."

Idiota—Cusanus' Socrates, at this point—goes on to say that the ability to measure is God's greatest gift to man and therefore the root of all wisdom. God's infinite knowledge is contained in the simple units of measurement. The argument continues to the effect that God's ideal form and design for things is inherent in the laws of geometry. His infinite goodness is expressed by the *recta linea*—the straight line.

WHILE EDUCATION in Alberti's Florence was generally limited to the upper classes, there was a wider opportunity than in feudal times for children of lesser families to obtain schooling. This was because of the need for trained clerks and accountants in the rising mercantile life of the city. The schools for such training were called *abacchi*, and their curricula generally focused on instruction in reading and writing the Italian language and *algoritmo* or arithmetic. Giovanni Villani, writing in his own *Historia Fiorentine* before the Black Death, noted that there were six such *abacchi* schools in Florence in his time, where more than a thousand students learned arithmetic.[4] A textbook used in one of these schools has recently been published, giving us a good idea of what such arithmetic lessons were like. It is a reprint of a fifteenth-century manuscript based on Paolo dell' Abbaco's *Trattato d'aritmetica*, written originally about 1360.[5] As his name implies, Paolo was himself a schoolmaster, and taught until his death in 1374 in a building just opposite the church of Santa Trinita in Florence. Paolo's text, in Italian, is filled with charming illustra-

tions of money being exchanged at bank counters, goods being weighed in a market, towers being measured, and land being surveyed. Indeed, the whole thrust of the book is toward the practical application of arithmetic and geometry and simple algebra. The *Trattato* is also filled with "story problems"—the kind which are still the bane of grammar school pupils today.

The teachers at the *abacchi* were also expected to perform certain municipal tasks like land surveying and civil engineering on the city walls.[6] The schools thus provided a good foundation for practical engineering, a profession of rising importance in the fifteenth century.[7] Brunelleschi, Filarete, Il Taccola, and Francesco di Giorgio Martini most likely received their early training, and a good deal of their inspiration, through studying books such as Paolo's *Trattato*. Such craftsmen were essentially freelance jack-of-all-tradesmen who hired themselves out to rich patrons for all sorts of ambitious projects, designing buildings, fortifications, weapons, waterworks, and machinery of all kinds. They were highly respected even early in the Quattrocento, as we know from the career of Brunelleschi. Leonardo da Vinci was only the most illustrious practitioner of what had long since been regarded as a proud calling in Italy and throughout Renaissance Europe. Like Leonardo, many of these artisan-engineers kept notebooks filled with drawings. Besides possessing a rich imagination, they were called on for two other requisite talents: skill in mathematics and the ability to draw. In addition—and what is most important to us here—they had to have an unusual sense of what is today called "depth perception," for it was their job to imagine complex mechanical devices completely in the abstract, and then commit these designs to paper with a convincing illusion of three dimensions. It is scarcely surprising, in view of this, that it was an artisan-engineer who gave the Western world its first linear perspective system.

Of great relevance to the changing pictorial attitudes in Florence of this time was the rise and increasing sophistication of banking and commerce. Even double-entry bookkeeping, according to some economic historians, originated in Florence during the thirteenth century.[8] Certainly it was a Tuscan, Leonardo Fibonacci of Pisa, who first introduced to the West the Hindu number system we use today; he had learned it in Arab Algeria and described the system in his *Liber abaci* of 1202. How much easier it was

to compute with these simple figures than by the clumsy old method of Roman numerals! Significantly, Fibonacci devoted a part of his text to matters of business accounting. By the fifteenth century, the merchants and bankers of Florence (as well as of Venice and Genoa) were keeping the best-ordered books in Europe, and controlled far-flung business empires through an intricate system of debit and credit accounting.[9]

Did not these tight-fisted, practical-minded businessmen find themselves more and more disposed to a visual world that would accord with the tidy principles of mathematical order that they applied to their bank ledgers? In fact, the definitive treatise on double-entry bookkeeping, part of *Summa arithmetica geometria proportioni et proportionalita* (1484), was written not by a businessman but by the mathematician Luca Pacioli, who was a friend of Alberti, Piero della Francesca, and Leonarda da Vinci. Pacioli was also the author of the *Divina proportione*, in which he designed a handsome Roman-style alphabet. Here he not only praised linear perspective but included it among the mathematical arts, along with arithmetic, geometry, astrology, music, architecture, and cosmography. While music pleases the ear, he wrote, perspective pleases the eye, which is the more intellectual sense.[10] The painters in Florence came from the same artisan class and received whatever training they got at the same *abacco* school as accountants, shopkeepers, and craftsmen in general. The best evidence we have of their attitudes, aside from their pictures themselves, is expressed in three treatises of the period: the *Libro dell'arte* of Cennino Cennini (c. 1370–c. 1440), whose training was in the International Style-late Giottesque manner of Agnolo Gaddi; the *Commentari*, or memoirs, of the sculptor Lorenzo Ghiberti (1378–1455); and Alberti's own treatise on painting. Cennini's book consists mostly of technical recipes and shop methods; it is an artist's manual which only obliquely hints at the visual psychology of the time. While Ghiberti's book is much richer, the author, a self-made humanist, as it were, seems more interested in impressing posterity with his own accomplishments and *nouveau riche* learning than with providing honest insights into the science of visual perception and pictorial communication.

Alberti's Florence

THE OUTSTANDING literary document of the three is, of course, Alberti's, the first book ever to treat of painting as more than an artisan's craft. In the view of this gifted patrician, painting was a profound intellectual exercise, involving not only traditional technical skill and observation of nature but an understanding of an ideal world: a world as expressed in the ideals of ancient Rome, one which goes hand in hand with the order, harmony, and proportion exemplified in the mathematical sciences. His book is also the first literary work ever to treat of linear perspective as a device for painters.

Why, we may ask, did Alberti choose to make a point of linear perspective in his treatise, after his friend and dedicatee Brunelleschi had already established the essential rules? Alberti's invaluable contribution here was, of course, that he put perspective construction methods down on paper for the first time—the acceleration of mass communication in the Renaissance took care of the rest. But the two men also had different intents. Brunelleschi carried out his unprecedented demonstrations as technological feats, not as acts of artistic composition.

Alberti's treatise on painting was written in two languages and possibly three versions between 1435 and 1436. Arguments still exist as to whether he wrote the Italian edition, *Della pittura*, or the Latin, *De pictura*, first (the latter seems to have been later revised), but he did apparently intend his vernacular text to be read by artists, and appropriately dedicated it to Brunelleschi.[11] Before coming to Florence, however, Alberti had studied mathematics and presumably optics at the university in Bologna.[12] He also suffered a nervous breakdown, and in order to relax his mind, took up painting. He was thus unique among his peers, not only in being one of the rare humanists of his day to have university training in the sciences, but in being the only scholar actually to have put his hand to the artisan's craft of making pictures, if without any formal training.

While the content of the Latin and Italian versions of Alberti's treatise is generally the same, the Latin edition contains certain passages omitted from the vernacular text.[13] These all have to do with references to the science of optics, of which we shall hear more in Chapters V and VI. In both versions, however, the

treatise was divided into three books, the first having to do with the geometry and optics of painting, including directions for a linear perspective construction; the second with Alberti's ideas on *istoria* or history painting; and the third with the intellectual and moral preparation of the painter himself.

In spite of his thorough grounding in mathematics, Alberti took pains, even in Book One, to play down the purely geometrical aspect of painting; the purpose of this section was rather to have his artist-readers know just enough geometry and optics for them to comprehend what he meant by *proportione*, a concept essential to *istoria* painting. Alberti felt strongly that painting should serve the cause of rhetorical history. Out of this conviction he developed his theory that painting should not merely be pleasing to the eye but, more importantly, should be instructive and edifying to the mind. Only great events, as in the lives of classical heroes, should be depicted by painters, since they provide the best models for conveying the virtues of honor, nobility, and selfless service to one's family and state (it is implicit that he also intended his notion of *istoria* to be applied to religious pictures). In a properly edifying painting, he suggests, there is a manifest mathematical rationale. The number of painted figures are to be restricted and shown only in decorous, carefully prescribed attitudes, arranged in a geometrically ordered pictorial space, almost as on a stage. This arrangement must pay careful attention to proportion, evincing measured relationships between large and small, near and far objects. The elements are to be in harmony, even as real things in this world are in harmony with the divine masterplan.

Alberti believed his fellow painters to be generally deficient in understanding geometry, since the *abacco* education provided little in the way of theoretical applications of mathematics. Accordingly, he urged his artisan readers to give special study to matters of proportion (a subject on which he went so far as to write a separate treatise, *Elements of Painting* [14]). He admonished painters to construct their perspective not according to abstract arithmetical ratios, as some contemporaneous artists were doing, but only according to the geometric proportions derived from the laws of optics.

Alberti's Florence

THE ONCE-EXILED patrician also believed that the ancients had never realized the proper importance of authentic perspective principles. As he wrote in *De pictura:*

This method of dividing up the pavement pertains especially to that part of painting which, when we come to it, we shall call composition; and it is such that I fear it may be little understood by readers on account of the novelty of the subject and the brevity of our description. As we can judge easily from the works of former ages, this matter probably remained completely unknown to our ancestors because of its obscurity and difficulty. You will hardly find any *istoria* of theirs properly composed either in painting or modelling or sculpture.[15]

So far as the specifics of linear perspective were concerned, Alberti's approach to the problem was to divide his construction into two separate operations, which we may refer to as the vanishing point and distance point operations. The following passage describes this first step, the establishment of the vanishing point (Diagram III–1):

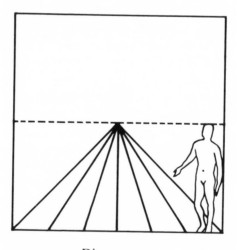

Diagram III–1

First of all, on the surface on which I am going to paint, I draw a rectangle of whatever size I want, which I regard as an open window through which the subject to be painted is seen; and I decide how large I wish the human figures in the painting to be. I divide the

height of this man into three parts, which will be proportional to the measure commonly called a *braccio;* for as may be seen from the relationship of his limbs, three *braccia* is just about the average height of a man's body. With this measure I divide the bottom line of my rectangle into as many parts as it will hold; and this bottom line of the rectangle is for me proportional to the next transverse equidistant quantity seen on the pavement. Then I establish a point in the rectangle wherever I wish; and [as] it occupies the place where the centric ray strikes, I shall call this the centric point. The suitable position for this centric point is no higher from the base line than the height of the man to be represented in the painting, for in this way both the viewers and the objects in the painting will seem to be on the same plane. Having placed the centric point, I draw lines from it to each of the divisions on the base line. These lines show me how successive transverse quantities visually change to an almost infinite distance. . . .[16]

In other words, Alberti would first outline his quadrangular drawing space, which he wanted to think of as a window or, more scientifically, as an intersection through the visual pyramid. He would then draw in the figure of a man, presumably standing on the base line, and would divide him into three parts or *braccia* (a Florentine unit of measurement equivalent to just under two feet); Alberti would use this unit of measurement to mark off the base line of his drawing space. Next he would locate a *centric point*, level with the top of the head of his depicted man. From this centric point he would draw diagonals to each division of the base line. These lines represent what are today called *orthogonals* in perspective parlance.

Further on, Alberti mentions that the artist should draw a horizontal through the centric point, which he calls the centric line and which we now refer to as the horizon:

This line is for me a limit or boundary, which no quantity exceeds that is not higher than the eye of the spectator. As it passes through the centric point, this line may be called the centric line. This is why men depicted standing in the parallel furthest away are a great deal smaller than those in the nearer ones, a phenomenon which is clearly demonstrated by nature herself, for in churches we see the heads of men walking about, moving at more or less the same height, while the feet of those further away may correspond to the knee-level of those in front.[17]

Here Alberti describes what I referred to earlier as horizon line isocephaly. This optical phenomenon was first utilized by the early fifteenth-century painters, and was probably corollary to Brunelleschi's first perspective experiments. It is never, to my knowledge, seen in pictures anywhere before about 1425. Thereafter it appears frequently, and with particular distinctness, as in the Brancacci Chapel frescoes of Masaccio and Masolino (Illustrations II–2 and II–3).

In his second step, treating his distance point operation, Alberti's vaunted gift for clarity falters somewhat. For years the obscurity of his explanation of this has owed much to the fact that the surviving texts of both *De pictura* and *Della pittura* are incomplete. Fortunately, Cecil Grayson has recently brought to our attention a heretofore unnoticed five-word phrase tucked away in a number of Latin copies of the treatise. This seemingly minor phrase goes a long way toward revealing exactly what Alberti intended, not only in regard to his distance point operation but also in relation to the larger intent of his linear perspective procedure. Curiously, these key words are not found in extant Italian editions:

I have a little space in which I describe a straight line. This I divide into parts like those into which the base line of the quadrangle (the picture space) is divided. Here I place a single point above and *perpendicular to one end of this line* [*ad alterum lineae caput perpendicularem*] and as high as the centric point is above the base line of the quadrangle. From this point I draw single lines to the individual divisions of this same line. Then I establish how much distance there is to be between the eye of the spectator and the picture, and here at the established place of the intersection, I establish an intersection of all lines it meets, by means of a perpendicular, as the mathematicians say . . . this perpendicular line gives me by means of its coordinates the limits of each distance which should be between the transverse and equidistant lines of the pavement. In this way, I have drawn all the parallels. A parallel is the space between two equidistant lines, of which we spoke at length above. It can be proven that they were correctly described if a single and continuous straight line be (drawn) as the diagonal of the conjoined squares in the depicted pavement. . . .[18]

Alberti has, as this text discloses, "a little space" (*picciolo spatio* in the Italian version, *areola* in the Latin), which seems to have been an extra piece of paper with a wide margin at the side

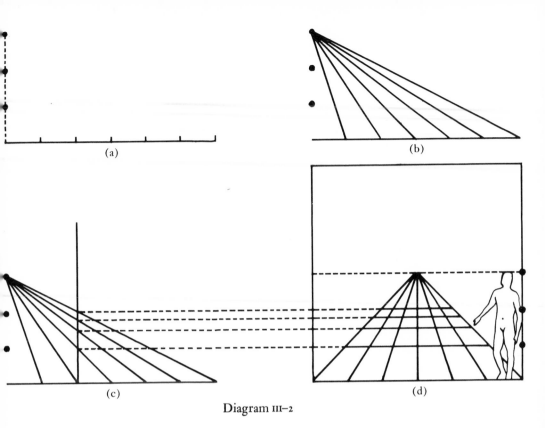

Diagram III–2

of his regular ruled drawing space.[19] In this "little space" he would draw another line and divide it into parts of the same length as those along the base line of his quadrangular drawing space in the vanishing point view (Diagram III–2a). Next he would locate the "single point," which for all intents and purposes is a distance point, and from there draw diagonals to the line divisions in the "little space" (Diagram III–2b). According to Grayson's interpretation, Alberti probably intended this distance point to be placed right over one end of the line in the "little space" and as "high as the centric point is above the base line of the quadrangle."

Then, the text continues (Alberti is emphatic about the word "then"), he would "establish how much distance there is to be between the eye of the spectator [the distance point] and the picture," and at such a proper distance he would insert a vertical intersection through the diagonal (Diagram III–2c). Presumably, although Alberti does not tell us exactly how, the results of his distance point operation would be transferred to the vanishing point operation, and the perspective construction would then be complete. The lines thus passed on to the vanishing point view are called transversals (Diagram III–2d). They seem to be grow-

45

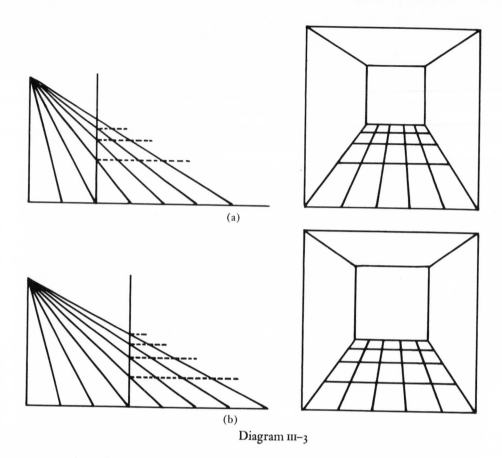

(a)

(b)

Diagram III-3

ing closer and closer together and give the illusion that we have before us a floor composed of checkerboardlike squares receding in the distance.

From Grayson's textual find, it is clear that the distance point was intended to be fixed immutably first, after which the distance to the vertical intersection was to be established.[20] This sequence of steps is most important if we are to interpret Alberti's intentions correctly. In other words, the distance point itself is *not* variable in Alberti's construction, but the intersection *is*. The artist following these instructions regulates his degree of depth illusion simply by sliding the intersection back and forth from the distance point across the diagonals linking the ground line (Diagram III-3). Thus Alberti's diagrammatic representation of the visual pyramid demanded a fixed ratio between the apex (the painter's eye) and the base (the surface of the object seen), with the desired degree of perspective determined solely by the placement of the intersection.

How will the artist know if his final drawing is correct? He

46

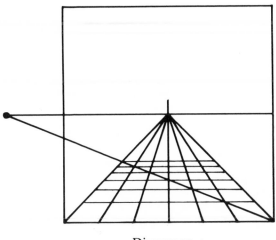

Diagram III–4

can make a final test of his perspective construction, Alberti says, by drawing a diagonal across the corners of his projected squares (Diagram III–4). In the portion of the projected floor plane which is a perfect square itself (that is, where it is as many squares deep as it is across), a diagonal intersects the corners of all the squares it traverses. *This can only occur when the squared plane has been foreshortened by geometric means.* It does not occur, for instance, when use is made of an arithmetical method for creating the illusion of a diminishing squared surface.[21]

But what is happening to the overall composition of the actual picture? Alberti must have observed that by moving the intersection closer to the stationary distance point, the floor plane of his drawing would rise and seem steeper (Diagram III–3a); when he moved the intersection further away, the floor plane would appear lower, the back or facing plane larger, and the depicted "room" correspondingly more shallow (Diagram III–3b).

In an earlier article in which I attempted to trace the roots of Alberti's perspective system, I suggested that our patrician hero, whose scholarship tended to be most comfortable in the ivory tower of theory, wished at one time or another to weigh his own theoretical findings against those of the everyday, practical workshop. Assuming this, it is possible that Alberti became acquainted with a handy protoperspective structuring method, one hypothesized by several art historians today and called by them the "bi-

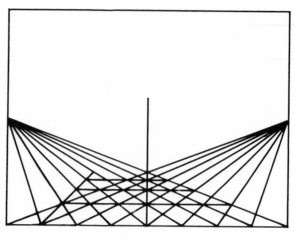

Diagram III–5

focal method" (Diagram III–5). We can only conjecture as to the existence or prevalence of this method. No such quasi-perspective underpinnings have ever been discovered *in situ*, either as a *sinopia* drawing beneath a fresco painting or incised on a panel before the mid-fifteenth century—that is, before the advent of Brunelleschi's and Alberti's linear perspective rules.[22]

But let us suppose, nonetheless, that painters in the Italian workshops of the Trecento and early Quattrocento did possess an imperfect means by which they could, in the initial layout and preparation of their pictures, render convincing relationship between depicted figures and their surrounding space. Indeed, before true perspective, a favorite convention of artists was to show their scenes as occurring on a checkerboardlike floor or under a similarly squared ceiling. Such pictures, although they were optically illegitimate, could show some guiding geometric principle and some degree of spatial unity.

In Diagram III–5, for example (assuming it reflects true workshop practice), the artist need only set out two "bifocal" points, one on either side of his picture space (and on the same level). Then he would mark off a number of equal segments along either the base or top margin of the picture, depending on whether he wanted to paint a squared floor or ceiling. From each of the two lateral points he would then rule lines, perhaps by snap strings, to each of the marks on the bottom or top margins. He could then note where each set of diagonals from the lateral points

crossed each other. At each level of these intersections he would draw horizontal lines, observing that these transversals automatically came closer as he proceeded toward the middle of his picture. He would also draw another set of lines upward or downward from the base or top margin through the same intersections of the diagonals from the lateral points. These lines, he would observe, also seemed to converge inexorably toward a single, more or less centric locus. The end result of all this is a perspectivelike matrix or outline, one which an artist could set out on his picture surface to facilitate his final composition. He need have no knowledge at all of the underlying geometric logic of vanishing and distance points.

Alberti never mentioned such a bifocal method, although he discussed and dismissed as incorrect another protoperspective workshop method whereby artists constructed a diminishing squared floor by means of an arithmetical formula. There are, however, some fourteenth- and early fifteenth-century Italian paintings which could, at least, have been laid out from two lateral points; Alberti may have detected principles in common between these ersatz methods and his own perspective system.[23] Indeed, one advantage of his method in this respect was the fixed distance point which could also be positioned on the very lateral margin of the picture. Such a device would be of great help in the painting of a fresco on a constricted wall space, where the setting out of distance points wide of the margins might be impractical. Conceivably, Alberti proved to himself the underlying kinship of bifocal construction to his. How? By showing that the lateral loci of the diagonals in the former were in actuality distance points, while the lines coming up toward the center automatically met—at a vanishing point.

IV

Alberti's *Compositione*

HOW WERE ALBERTI'S rules for stately compositional perspective followed by his fellow Florentine artists?

There will be a necessary exactitude about any treatise involving geometry, and hence we have now and then refered to the constructions in Alberti's epochal treatise on painting as "rules." But it should be emphasized that his elaborations were designed mainly to be *rules of thumb*, with a view to his artist readers improving upon them.[1] In fact, Alberti's discussion of linear perspective per se takes up only a fractional part—roughly one-twentieth—of the whole treatise. The rules, far from being meant as rigid precepts, were offered plainly to help the individual painter with the main business at hand: the decorous enhancement of his figures and compositions, the lending of spatial order to his *istoria*. (Unfortunately, Alberti's humble intent has been misunderstood in certain quarters of the abstract art world, where "Albertian perspective" has a decidedly pejorative ring.)

How, then, did his rules of thumb come out in actual paintings by his contemporaries?

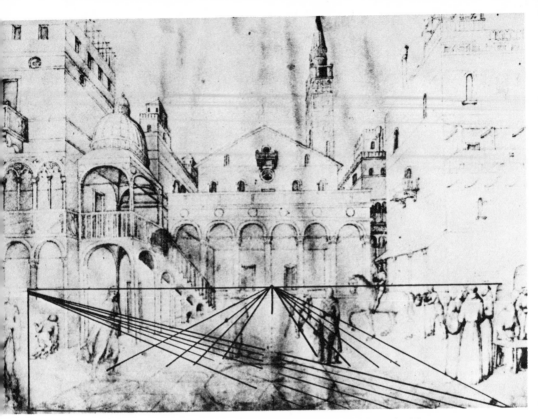

Illustration IV–I: Perspective reconstruction: Jacopo Bellini, *Architecture*, from the notebook of his drawings in the Louvre, Paris, c. 1450. Courtesy, Musées Nationaux, Paris.

Illustrations IV–I and IV–2a are drawings, one by Jacopo Bellini and the other by Pisanello, which can be dated in the 1440s, the period when these two artists served as court painters to Leonello d'Este, Duke of Ferrara. Alberti was also a close friend of Duke Leonello. We know that his treatise on painting and certain other writings made a considerable impression on Leonello's circle, and it is thus quite conceivable that his ideas on perspective influenced Pisanello and Bellini.

Of particular interest in these drawings, for our purposes, is the fact that the original perspective layout constructions can still be seen under the finishing ink (in the Bellini sketch these lines have been darkened by overlay to make them more visible). Both artists followed the same perspective construction. Indeed, they seem to have followed Alberti's instructions to the letter—to the best of their understanding; where Alberti's directions were less than clear, as in the matter of the "little space" and the variable intersection, Bellini and Pisanello made interesting modifications.

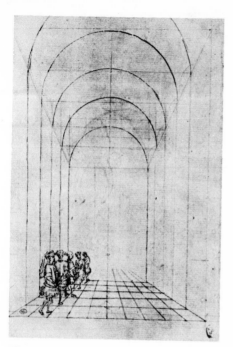

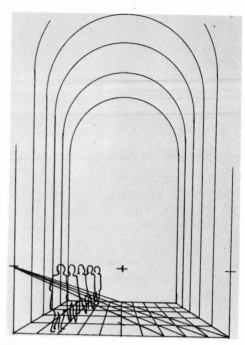

Illustration IV–2: (a) Pisanello, *Perspective*, drawing from the Vallardi Collection, Louvre, Paris, c. 1445. Courtesy, Musées Nationaux, Paris.

Illustration IV–2: (b) Edgerton, "Rejected" perspective layout for the Louvre Pisanello drawing.

The Bellini drawing shows an exterior courtyard, while the Pisanello is of an interior space. But in both examples, Alberti's centric point operation is scrupulously followed. In the Bellini drawing, the foremost standing figure at the left measures just three pavement squares, as does the first of the five figures advancing toward the center in the Pisanello sketch. Both drawings have tessellated ground planes defined by orthogonals and transversals. Each transversal of Pisanello's squared floor joins, at either end, verticals which define the wall height and are spanned by an arch form (drawn in by compass). In both sketches the heads of all their figures are on a precise line with the centric point. Pisanello even drew in the centric line; it is still visible where it crosses the outermost verticals at left and right.

At this intersection of the centric line with the leftmost outer vertical, and directly over one end of the ground line, Pisanello placed his distance point. Bellini placed his distance point in the same position in his drawing—also over one end of the base line. From these points the artists then measured diagonal lines to the separate divisions of the ground lines. Where these diagonals crossed their respective center orthogonals, the artists made marks

which can still be seen (as small oblique dashes in the Pisanello and as dots in the Bellini). In each case, the artist treated the center orthogonal as the vertical intersection; the markings were to denote the diminishing spaces for drawing in the transversals. Thus, insofar as Alberti's distance point operation was concerned, the two artists kept to the rule of placing the point "above and perpendicular to one end" of the base line. But ignoring the step involving the "little space," they instead combined the distance point operation with that of the vanishing point in a single, super-imposed construction. Moreover, they did not bring into play the variable intersection—Bellini was content to have it in the center, and Pisanello began his own construction in the same way.

Yet we can see that Pisanello instinctively followed Alberti's intent. The reader will already have observed that the artist, after having marked where the diagonal lines crossed the center ortho-gonal, did not then employ these marks as divisions for his trans-verse distances. (Theoretically, each mark should have indicated to him the depth of each of the five floor squares projected on the picture surface. These depths would diminish from bottom to top on the vertical line, thus presenting the illusion of receding space.) Why did Pisanello ignore the markings and draw in freehand each transverse line a little higher than indicated in his original distance point preparation? The reason is obvious if we compare Pisanello's composition to my own reconstruction (Illus-tration IV–2b) of how the drawing would have looked if he had finished it according to his first perspective markings. It must have occurred to Pisanello that his floor plane, if drawn according to his original marks, would have been too low (the uppermost mark on the center orthogonal would have been the top line of the extended floor) and not at all conducive to the feeling of deeply projected space he was trying to create. Such a low-lying floor plane (as compared with that in Pisanello's own drawing) forces the figures standing on it to be more equivalent in size, thus de-creasing the effect of their dynamic movement into distance. The arch forms and wall verticals would consequently be closer to-gether, that is, nearer to the margins of the picture, leaving an obtrusively large open space in the illusionary background; this, of course, would have limited the visible pictorial stage.

Pisanello therefore decided to abandon his original determina-tion of the floor plane in order to relieve the feeling of shallow-

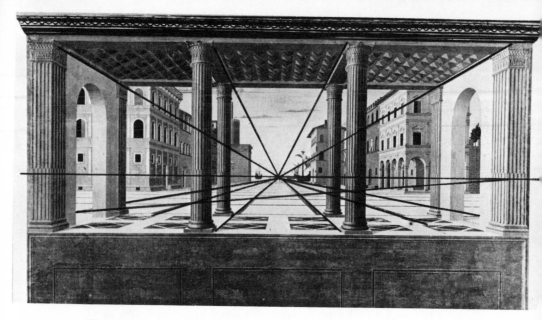

Illustration IV–3: Perspective reconstruction: Unknown Italian artist, *Architectural view*, c. 1470. Staatliche Museum, Berlin.

ness, improve his composition, and increase the sensation of depth all at the same time. He then "fudged" his transversals, aptly enough for them to appear convincingly legitimate even though geometrically in error. This error is proven by the fact that the traditional Albertian check—the diagonal—*will not pass through the corners of all floor squares on line with it.* But by his free-hand improvisation, Pisanello obtained virtually the same result he would have if he had moved the intersection closer to the distance point.[2]

These modifications notwithstanding, we can see what Pisanello and Bellini owed to Alberti's perspective theory. Such steps as may have seemed vague to them (the variable intersection) or even unnecessary (the "little space") were either simplified or ignored. If these two drawings are the earliest offspring of Alberti's *De pictura*, they are certainly not the last. In numerous subsequent Italian paintings extant (see, for example, Illustrations IV–3 and IV–4), we can clearly discern the linear tracks of Alberti's influence, as well as a degree of individual improvisation.

It should also be noted that such modifications borrow more than Alberti's original method from the so-called bifocal construction. Pisanello's and Bellini's resort to this makeshift layout formula thus seems—given Alberti's more sophisticated methods—a retrogressive rather than a progressive application. Although

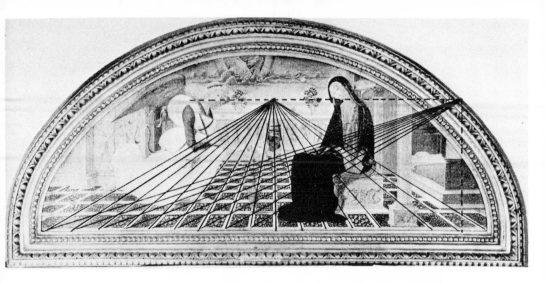

Illustration IV–4: Perspective reconstruction: Neroccio de'Landi, *Annunciation*, c. 1475. James Jackson Jarves collection, Yale University Museum, New Haven, Conn.

Alberti's distance point operation was his most fecund contribution (and an improvement over Brunelleschi's own cumbersome construction), I know of no example of Italian art in the wake of the *De pictura* which shows unequivocally a conscientious application of the variable intersection. Of the many invaluable insights Alberti passed on to the painters of his century, his distance point operation is the one most consistently modified or ignored altogether.

EXACTLY WHAT were the painters of this time attempting to demonstrate in applying Alberti's perspective principles? Certainly it was not the relationship of specific place to specific viewpoint, which Brunelleschi's earlier experiments had elucidated for them. Nor was it an "abstract arrangement" of lines and shapes, as modern aesthetics would like us to believe. Rather, Alberti's *compositione* seems to have provided a special compromise for the fifteenth-century artist—between his traditional, still-medieval studio practices and his increasing desire to infuse geometric (divine) harmony into his various pictorial situations.

Indeed, the modern notion of "aesthetic experience" tends to make us forget how differently a fifteenth-century audience would have understood Alberti's perspective rules in a painting. Aesthetics in fact is only of eighteenth century origin, when European intellectuals began to wonder how such diverse artistic objects as an Egyptian mummy case, a Ming vase, and a Renaissance altarpiece could have anything in common. Certainly it is true that in the antiseptic halls of the art museum where such objects are indiscriminately mixed together with little acknowledgement of their original context, the viewer can only experience them aesthetically. In this situation linear perspective has come to be regarded as unaesthetic, since it implies the primacy of objective realism over true artistic subjectivity.

As we have already argued, however, perspective was not embraced by its first practitioners for any such reason. "Realism" in fifteenth century eyes was as metaphysical as it was physical. Therefore perspective rules were accepted by these early artists because it gave their depicted scenes a sense of harmony with natural law, thereby underscoring man's moral responsibility within God's geometrically ordered universe. Was this not in itself conducive to aesthetic experience, different only in kind from that produced by the modern abstract painter who seeks also to reach the inner "spirit" of his viewers?

Let us therefore attempt to reconstruct a fifteenth century, post-Albertian aesthetic experience, that is, insofar as we can show the options available to an artist wishing to apply Alberti's perspective rules to the painting of an altarpiece, to be seen not by a modern museum audience but by a still devoutly religious, medieval church congregation.

The picture in mind is the *Madonna and Child Adored by Saints* by Domenico Veneziano (c. 1410–1461) for the main altar of Santa Lucia de'Magnoli from about 1445 (Illustration IV–5) now in the Uffizi Gallery, Florence. The original purpose of this painting was to serve as an icon, a sacred image of the Blessed Virgin to inspire the greatest devotion on the part of the worshipers. Every aesthetic thought the artist had concerning this holy scene was formed out of his desire to enhance this didactic objective. Linear perspective rules themselves had to be modified or even abandoned if they conflicted with the picture's true purpose in this sense. We will observe now how Domenico Veneziano followed

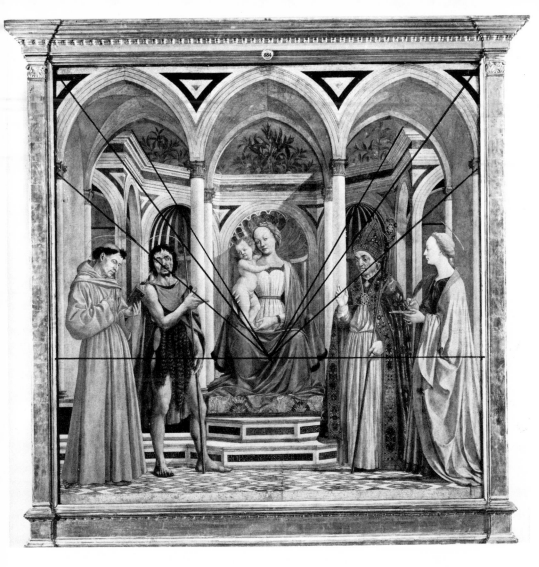

Illustration IV-5: Perspective reconstruction: Domenico Veneziano, *Madonna and Child Enthroned with Standing Saints* (St. Lucy Altarpiece), Uffizi Gallery, Florence, c. 1445. Courtesy, Galleria degli Uffizi, Florence.

the spirit of Alberti's instructions even as he violated the letter. The reasons why, however, are especially revealing of fifteenth-century aesthetic taste in contrast to our own.

First we see here the Virgin Mary holding the Infant Jesus surrounded by four saints in symmetrical arrangement. She sits in majesty before an open loggia. Behind this, Domenico painted an open pentagonal exedra which, even though it appears smaller, is exactly the same size and of one architectural piece with the middleground loggia. Between the exedra and the loggia, we ob-

serve an open sky and a number of leafy plants in the background whose organic intrusion nicely mitigates the otherwise solemn stolidity of the architecture itself. Of particular note is the fact that the pentagonal exedra, even though perspectively rather far back in the fictive depths, seems almost paradoxically to be enframing the foreground figures. Each arched opening in this backgound appears just above the heads of the four standing saints, and the Virgin herself, the central iconic figure in the composition, seems almost enshrined within an escalloped niche that in "reality" must be many yards behind. Indeed, this niche looks almost like a halo, combining its symbolic circular shape with the shell motif, the traditional Christian metaphor of Resurrection.

What is of particular interest now is that the artist did not achieve this "realism" by following Alberti's rules exactly. In fact, as can be seen in the overlay on Illustration IV–5, he positioned the vanishing point not in the center at head level with the standing figures, but lower down on the picture surface, actually between the Virgin's knees! Why did he violate this basic Albertian tenet, that the centric vanishing point and the centric line demarking the heads of all standing figures in the picture be synonymous?

I think the reason becomes clear if we now examine, in Illustration IV–6, another version of the same painting. This one is a reconstruction of the picture I made, showing how it would look if the artist had followed Alberti's rules to the letter, that is, if he had raised the vanishing point to the center and on the same level as the heads of the four saints standing on the ground plain.

What happens now is striking. While there is no appreciable difference in the appearance of the iconic personalities themselves, the enhancing background becomes changed dramatically. Instead of strongly amplifying each figure, as did the exedra arches in the original, these now are forced by the unsympathetic laws of geometry to climb toward the top of the picture where they no longer complement the figures at all. Whether more "realistic" or not, the background architecture becomes completely detached from the picture's meaning, perhaps even antagonistic since it detracts from the viewer's contemplation of the spiritual message.

Certainly it is not to Domenico's discredit that he failed to follow Alberti's rules in order to fulfill the mandate of this

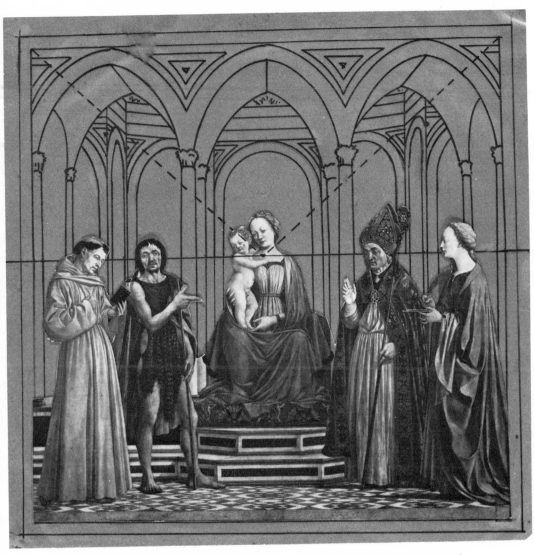

Illustration IV–6: Edgerton, Alternative perspective reconstruction of Domenico Veneziano's St. Lucy Altarpiece.

specific commission. In this case he exercized "originality" in the best Renaissance sense. He created in his Saint Lucy altarpiece one of the finest examples of Albertian *istoria* by deliberately modifying Alberti's perspective rules. Indeed, Alberti himself would probably have approved. I think Alberti understood, as we now should ourselves, that linear perspective remains the servant not the master to the artist, and that visual truth in a picture does not depend upon correct perspective per se, but upon the basic moral and philosophical priorities of the civilization itself. These are the "realities" appropriate to pictures in any given culture.

It just so happened that linear perspective enhanced these values during the Renaissance. During the early Quattrocento at least perspective proved a loyal valet; it was not until relatively modern times that the servant became jealous of his master's wardrobe.

BEFORE THE MIDDLE of the fifteenth century, the term *perspectiva* (or *prospectiva*) never referred to artistic attempts to represent illusionary space. Alberti, in fact, never uses the word in his treatise. In his time, *perspectiva* referred exclusively to optics, and Dante once called *perspectiva* the "handmaiden of geometry." Since ancient Greek times, optics had been considered a branch of mathematics. Throughout the Middle Ages and increasingly so during the fourteenth century, optics were taught in nearly all the major universities of Europe. Alberti had probably studied the science himself during his own residence at the University of Bologna from 1421 to 1428.

WHILE OPTICS WAS a science, it was also a branch of the Faith. The initial impetus to study it in medieval Europe was that its geometric concept of light-filled space provided some kind of rationalization of how God's grace pervaded the universe. Meister Eckhart, the early fourteenth-century German mystic, noted that the soul "sees" God just as the eye itself beholds a picture on the wall. As the image in the picture seems to diminish in size as it "filters" through the intervening atmosphere in order to enter the tiny pupil of the eye, so also the soul—the "eye" which receives God—must not have on it the slightest "mote" of sin, lest it block the "image" of God's grace coming into it.[3] Even St. Antonine, the ascetic archbishop of Florence (1446–1459), adapted ideas from optics for the purposes of moral allegory throughout his *Summa theologica*. In one whole chapter, entitled "Concerning These Things Which are Required for Good

Seeing Both Corporeally and Spiritually" (*De his, quae requirunter ad bene videndum corporaliter et spiritualiter*), he drew liberally from the science in order to make earnest correlations between spiritual "seeing" and visual pathology.[4]

Further evidence of the important influence of optics on the thinking of Florentine artisans is found in the *Commentari* of Lorenzo Ghiberti (written about 1450), famous sculptor and friend of Alberti. The third of this three-book memoir is filled with glosses lifted verbatim from the optical writings of Alhazen, Witelo, Bacon, Pecham, Avicenna, Averröes, and Vitruvius. These passages are completely unedited and poorly translated into Italian, but they do show that the science of *perspectiva*, whether through Alberti's direct influence or not, was filtering down to the level of the informally educated artisan.[5]

ONE OF THE MOST FAMOUS scholars in early Renaissance Florence (who could well be the crucial figure in this book if only more hard evidence existed about his implicit contributions) was Paolo dal Pozzo Toscanelli (1397–1482). This extraordinary man was a medical doctor, mathematician, geographer, cartographer, and optician; a friend of Brunelleschi, a friend of Alberti (and the man to whom the latter dedicated *Intercoenales,* one of his poetic writings), and correspondent with Christopher Columbus. Above all, it may have been Toscanelli's advice which was instrumental in the success of Brunelleschi's historic perspective experiments. (We shall have more to say about his role in this in Chapters IX and X.) Toscanelli received his own university training at Padua, where he seems to have begun studies with the medical faculty in about 1418.[6] In those days, medical students were required to study mathematics in order to comprehend astrology; in fact, the faculty of mathematics was itself under the chair of astrology, and at Padua the latter was also a medical school post. The occupant of the astrology chair at Padua was thus expected to be conversant on all aspects of the mathematical arts, including geography and optics.[7] For many years the chair of astrology at Padua was occupied by Blasius of

Parma (Biagio Pelacani), who wrote a renowned book on optics called *Quaestiones perspectivae*. Although the professor had died by the time of Toscanelli's residence there, Toscanelli was undoubtedly influenced by Blasius' book.

According to Ugolino Verino, who toward the end of the fifteenth century wrote a long poem treating the lives of eminent Florentines, Toscanelli himself wrote "perspective books." [8] Unfortunately, we have no further record of just what these books contained or whether they were about perspective for painters or just optical *perspectiva*. Curiously, for a Florentine scholar, Toscanelli wrote very little, and almost nothing of his writing survives. Like the humanist Niccolò Niccoli, he became a leading and influential intellectual in his city even without a long list of "publications." The fact of particular interest to us is that he was also a good friend of Brunelleschi. Giorgio Vasari, culling from several sources that attest to this friendship, wrote the following in his 1568 biography of Brunelleschi:

Maestro Paolo dal Pozzo Toscanelli, who returned at that time from his studies [at Padua, c. 1424], was having dinner with certain of his friends at a place, and invited Filippo. Filippo, having listened to Toscanelli argue on the arts of mathematics, showed such familiarity that he learned geometry from him. Filippo did not even have advanced education but did everything so rationally with the naturalness of practical experience that he often confounded Toscanelli.[9]

Vasari goes on for several more lines, saying how much Toscanelli admired Brunelleschi, how they discussed the scriptures and "sites and measurements" from the geography of Dante's *Divine Comedy*, and how Toscanelli considered Brunelleschi a "new Saint Paul" because he was so articulate. Toscanelli was apparently in a position to be of aid to Brunelleschi with his first linear perspective experiments, and the "mathematics" the two discussed may well have had to do with practical applications of geometric optics.

In the ensuing pages we take up this matter of optics and its development as a science from antiquity to the time of Alberti. More than any other area of scholarship, this old and hallowed pursuit stimulated new notions about pictorial illusion that took root in the Renaissance. For this science lay at the disposal of European craftsmen at precisely the moment when their culture

became interested in having pictures become like windows or intersections of the visual pyramid.

When the Paduan scholar Michele Savonarola (granduncle to the more famous Fra Girolamo) came to write the praises of his native city around 1445, he noted that *perspectiva*, as now studied by painters, was truly a "part of philosophy." It had become, as far as he was concerned, the fifth subject after the traditional quadrivium—the "eighth" member of the liberal arts.[10]

V

The Fathers of
Optics

Indeed among the ancients there was considerable dispute as to whether these rays emerge from the surface or from the eye. This truly difficult question, which is quite without value for our purposes, may here be set aside.[1]

So WROTE ALBERTI in Book One of the Latin version of his treatise on painting, hoping to spare his readers from a confusing point of controversy among the ancient Greeks who studied οπτικα. Greek optics, as a matter of fact, were a topical subject in Alberti's humanist circles, especially since the science was alluded to so often in the recently translated (from Greek to Latin) *Lives of the Philosophers* by Diogenes Laertius.[2] Alberti made frequent reference to this newly available classical source in his treatise, wanting his readers to know that he was quite conversant with the arguments of the old philosophers.[3] His Book One is entirely devoted to the subject of optics, and as such is the first text to deal with linear perspective for painters.

The Fathers of Optics

Yet Greek optics was at best only the grandfather to the science with which Alberti had been familiar since his school days. The medieval optics of Western Europe had actually been sired more directly by the Arabs before the turn of the second millennium, and the science was specifically referred to as *perspectiva*. As we have already noted, craftsmen and writers on *perspectiva* prior to Alberti were never seriously interested in the problems of illusory visual effects in pictures. Nevertheless, *perspectiva* assumed what could be called a stepfatherly role in the emergence of artificial linear perspective.

Medieval *perspectiva* had to do essentially with how people see, either by geometry, which the Greeks introduced to show how vision could be diagramed on paper according to the theorems of Euclid, or by empirical observation, which the Arabs and medieval Christians had developed to a scientific method (thereby laying the groundwork for modern experiments in perceptual psychology). Important corollaries to the study of optics in antiquity and the Middle Ages were the medical treatises of Galen and Avicenna, which provided the first rational—if erroneous—understanding of optical anatomy. Indeed, throughout the no less than two thousand years before the scientific breakthroughs of the seventeenth century, when Kepler, Descartes, Newton, and others reshaped optics in the form we know it today, *perspectiva* had stood firm, built as it was on the most mathematical and empirical of foundations. For all its errors, medieval optics was a completely rational and mechanistic science, relatively uncluttered by theological mystery. It cemented together the best scholarship and talents of three great civilizations: the Greco-Roman, the Arab, and the medieval Christian. No wonder, then, especially as the science reached a wider audience during the fourteenth and fifteenth centuries, that people not only took for granted these explanations, but also tended more and more to "see" the natural world according to these Euclidian or geometric rules.

THIS FALLIBLE but useful school, though not of itself concerned with painters' problems, thus formed at least the threshold from which an applicable theory could develop in Renaissance

painting—namely, one of *perspectiva artificialis.* Nevertheless, certain assumptions about optical phenomena, never before spelled out in the old optics texts, begged serious attention, particularly those concerning the nature of the vanishing point. These concepts had not been explicitly discussed in the traditional science because the old philosophers were not concerned with pictures.

The problem alluded to in the quotation beginning this chapter has to do with whether the force of vision comes into or issues from the eyes. The dispute "among the ancients," as Alberti well knew, had already undergone some very sophisticated modification, especially by the Arab Alhazen and the English scientists Robert Grosseteste and Roger Bacon. In another passage, Alberti raises—and again dismisses—certain other complexities of *perspectiva naturalis:*

This is not the place to argue whether sight rests at the juncture of the inner nerve of the eye, or whether images are created on the surface of the eye, as it were in an animate mirror. I do not think it necessary here to speak of all the functions of the eye in relation to vision.[4]

Again Alberti wants to impress upon his readers his knowledgeability. But it is also clear that he wants to forego quiddities and get, as it were, to the eye of the storm. He was concerned chiefly with what the artists of his time could possibly *apply.* He was not interested in the complexities of binocular vision, for example, a problem which had been of great import to the medieval opticians. Why? Because Alberti insisted that painting performed best when seen from a monocular and centric viewpoint.

A comprehensive account of the history of optics in the Western world is well beyond the scope of this book, but we cannot fully escape its glance if we are to have some understanding of the evolution of linear perspective. Our theme here is not only pictorial objects but the eyes which view them, and, above all, the forces—and directions of those forces—linking the two. Both Brunelleschi and Alberti had much to sort out from the optics bequeathed them by Greek, Arab, and medieval Christian scholars. Our cursory attention in this chapter to relevant optical theories should, hopefully, give us a better appreciation of what these two Florentines accomplished for Western civilization within ten years of each other.

The Fathers of Optics

TWO THOUSAND YEARS before the Quattrocento, Greek optics were concerned basically with the physical explanation of seeing, of explaining the essences of visual energy. The "atomists," for example, held that all objects in nature gave off *eidola*, or picturelike effluxes which penetrated the air and then somehow impregnated the surface of the viewer's eye with an exact image.[5] This concept was the basis of the so-called intromission theory of sight subsequently propounded by the Epicurean philosophers.[6] But other philosophers, notably the Pythagoreans, objected that such effluxes of things so large as, say, a camel or a mountain could not very well pass through the tiny pupil of the eye. They proposed instead that the visual force was emitted primarily by the eyes, and their viewpoint was elaborated in the so-called extromission theory. The Stoics also contributed to optics by suggesting that visual forces leave the eyes in the form of a cone, the apex of which was at the eyes and the base at the object seen (Diagram v–1). The cone hypothesis was to become, we shall see, indispensable in the history of optics.

Diagram v–1

The two preeminent Greek philosophers, Plato and Aristotle, had rather ambiguous views on optics. Plato believed that a kind of "fire" emitted from the eyes touched a certain other force given off by the objects themselves, thereby transmitting back to the eyes a sensation of sight. Aristotle, on the other hand, held that objects of sight somehow activated the medium (whether air or water) between themselves and the observer whenever light was present. This activation was then sensed by the eyes, which projected a perceiving force of their own from the "soul"

67

or cognitive center of the brain. According to Aristotle, some transparent but material medium must always exist between viewer and object seen; vision could not occur in a void.

Aristotle's surviving writings on the nature of vision outnumber those by all other philosophers up to his time, yet they do not together form a consistent theory. It remained for the geometer Euclid in the fourth century B.C. to give the then inconclusive science of optics its first uniform mathematical model. Euclid's *Optica* is almost entirely an exercise in geometry. He believed that the force of vision always proceeded from the eyes as "visual rays" which could be diagramed as straight lines. These visual rays diverged to form an imaginery cone, with the apex in the observer's eye. Since the visual cone can be diagramed, he reasoned, must it not therefore fall under the same laws which govern that abstract figure in geometry?

Euclid proceeded from this assumption to various postulates. Only those things on which visual rays fall are seen by the eyes. Things seen under larger visual angles appear larger; those under a smaller angle appear smaller; those under equal angles appear equal in size; and so on.

All of these propositions Euclid demonstrated by geometrical proofs. He was not concerned, of course, with problems of pictures, so there are no theorems in his *Optica* having to do with the vanishing point phenomenon. In fact, his basic rule, that the illusion of diminishing size of distant objects is determined by the visual angle, is meant not to explain the apparent convergence of parallels but rather to insist on just the opposite—that they really do not converge at all.[7]

While Euclid bequeathed the science of optics a much-needed geometrical structure, his numerous propositions still did not explain some of the most basic physical and physiological—much less psychological—aspects of human sight. What, for instance, was the nature of the visual rays? Were they material entities, or simple abstract lines without width or thickness? How could such rays convey a "solid" impression to the eyes when they were supposed to have blank spaces between them? How was an image actually received by the eye and then passed on to the brain?

After Euclid, the most important Greek studies to attempt to answer some of these questions were the *Optica* of Claudius Ptolemaeus or Ptolemy, written in Alexandria in the second cen-

tury A.D.,[8] and the optical sections of Galen's *De usu partium,* written about fifty years later.[9]

Ptolemy's optical treatise, while it includes geometric demonstrations, is conceived more from the point of view of a physicist. He was particularly interested in the perceptual problems of color and atmospheric perspective. Painters, he notes, when they wish to show something close by, paint those parts in bright colors, while elements understood as being farther away they render more darkly. Ptolemy also probes the problems of binocular vision, optical illusions and "accidents," and perception of magnitudes. On this latter point, Ptolemy was not entirely in agreement with Euclid about the sole importance of the visual angle. Location of different objects in respect to one another, as well as their relative distance from the eye, were also important considerations, he felt. His *Optica* also contained separate sections on catoptrics, the science of mirror reflection, and dioptrics, the science of refraction.

So far as linear perspective theory is concerned, Ptolemy's major contribution for future painters was his explanation of the centric visual ray principle. (This idea had apparently occurred to other Greek optical scientists following Euclid, but their treatises have not survived.) Whereas for Euclid the rays fanning out from the observer's eyes were undifferentiated, Ptolemy (as well as Galen and other post-Euclidian Greeks) stressed that those rays near the center of the visual cone were shorter; hence they carried back clearer and more precise impressions of the objects seen. Thus the centermost visual ray, following the axis of the visual cone and making right angles with the surface of what is seen, would be the most distinct ray of all (Diagram v–2). Alberti was eventually to refer to this as the "prince of rays."

Diagram v–2

The Fathers of Optics

Galen, the Greek doctor who followed Ptolemy in the third century A.D., described for the first time in his *De usu partium* the anatomy of the eye. He also extrapolated a mechanical means to account for how the visual image passes into the optical organ for transmission to the brain. His anatomical diagram, which was generally accepted by optical scientists for the next thirteen hundred years, showed the lens in the forepart of the eye behind the pupil as the sensitive membrane in the seeing process. The image, he said, was transferred to the brain by visual spirit or *pneuma* through the "hollow" optic nerve, which Galen considered as being on an exact axis with the center of the pupil (Diagram V–3).

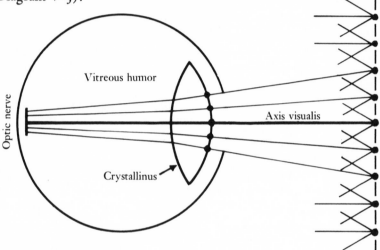

Diagram V–3: The human eye as understood in the Middle Ages and Renaissance following Alhazen's theory of vision. Rays of light are given off from every point on the object seen and travel in straight lines. Only those rays striking the surface of the eye perpendicularly, however, may enter, where they then reproduce the image in miniature scale on the anterior surface of the *crystallinus*. At the posterior surface of the *crystallinus*, these same rays are refracted in the vitreous humor, through which they then travel nearly parallel toward the optic nerve.

But the Greeks were interested in more than the anatomy of vision. Their optical findings had a practical side. Considerable attention seems to have been paid to *scenographia*, the science of painting theater backdrops in what apparently was a form of linear perspective.[10] There are no surviving texts describing this branch of optics, although many are alluded to in other classical

manuscripts. Similarly, we have no extant example of classical painting, either from Greece or Rome, to show us a linear perspective construction like that of the Renaissance Italians. There is some evidence, however, that the ancients worked out some kind of vanishing point system for painting stage backdrops, as was attested to by the Roman architect Vitruvius in his famous *De architectura* of the first century B.C.:

Scenography also is the shading of the front and the retreating sides, and the correspondence of all lines to the center of a circle. . . .

For to begin with: Agatharchus at Athens, when Aeschylus was presenting a tragedy, was in control of the stage, and wrote a commentary about it. Following his suggestions, Democritus and Anaxagoras wrote upon the same topic, in order to show how, if a fixed center is taken for the outward glance of the eyes and the projection of the radii, we must follow these lines in accordance with a natural law, such that from an uncertain object, uncertain images may give the appearance of buildings in the scenery of the stage, and how what is figured upon vertical and plane surfaces can seem to recede in one part and project in another.[11]

Unfortunately, there are enough uncertainties in the original Latin texts to make a definitive translation impossible. When Vitruvius mentions the "fixed center" (*centro constituto*) or the "center of a circle" (*circini centrum*), is he referring to the same vanishing point concept as that of Brunelleschi and Alberti? Similarly, when he refers to the "projection of the radii . . . lines in accordance with a natural law" (*ad aciem oculorum radiorumque extentionem . . . ad lineas ratione naturali respondere*), is he claiming that a picture can be an extension of the real space of the viewer's world? And that the viewer's eye level should correspond to the painted horizon in the picture? These are questions yet to be answered. In a later chapter we shall see how Ptolemy, in his *Geographia* (but never in his *Optica*), worked out for cartographers a linear perspective system similar to that of *scenographia*.

Ghiberti, one of the five artists to whom Alberti dedicated his treatise on painting, copied down verbatim the second of the above Vitruvian passages—without further comment—in his own autobiographical *Commentari*.[12] Whether Alberti knew Vitruvius' writings or not, the ancients had not yet perfected linear perspec-

tive for painters, and he charged as much in a strong statement of his own in Book One of the treatise.[13]

With the demise of classical civilization, the scholarship of the Greek scientists was absorbed into the language and learning of the Arab, and thereby began its circuitous route back to the West. Galen's works showed up as early as the eleventh century A.D. at Salerno, then a great medical center. But it was in the next hundred years, especially in the courts of Moorish Spain and in that of Norman Sicily, that the revival of classical scholarship flourished by way of the translator's pen. In Sicily the Emir Eugene rendered Ptolemy's *Optica* from Arabic to Latin. At the Norman court, the Englishman Adelard of Bath translated Euclid's *Elementa* from Arabic into Latin. At about the same time, although the translator remains unknown, the *Optica* and *Catoptrica* were rendered into Latin from both Arabic and Greek manuscripts.[14]

It was the Arabs themselves, however, who were the greatest contributors to the science of optics as Western Europe passed through its so-called Dark Ages. Their work, which often combined highly original experimentation with the old groundwork of classical theories, was to have a profound effect with its revival in Europe. Three Arab scientists were particularly seminal: the ninth-century writer Alkindi [15] and, in the late tenth and early eleventh centuries, Avicenna [16] and Alhazen (Ibn al-Haytham).[17] The latter two were contemporaries but probably remained unknown to each other in spite of the fact that their optical theories were often quite similar. Alkindi's optical treatise, called *De aspectibus* in Latin, was particularly influential in Western Europe during the early thirteenth century. Along with his other treatise, *De radiis*, it made its way even to England, where both were read by Grosseteste and Bacon. Whereas *De aspectibus* was essentially a supporting critique of Euclid's extromission optics, Avicenna and Alhazen were both believers in intromission.

The writings of the Persian Avicenna eventually became popular in European medical schools—among them Alberti's University of Bologna.[18] According to Avicenna, Galen's understanding of the crystalline lens as the seat of visual power was correct, but his extromission explanation was not. The crystalline lens, he argued, was a receiver rather than a transmitter of the visual force. It acts like a "mirror," receiving the "form" of things on its

flattened anterior surface before transferral to the "soul." Significantly, Alberti also referred to the eye as a "living mirror" in his *De pictura*.[19]

But by far the greatest and most influential of the Arab optics treatises was Alhazen's *Kitab al-Manazir* or simply *Perspectiva*, as it was entitled in Latin. Written in Cairo during the early eleventh century, the work was introduced to the West about 1200 and became the prime source for thirteenth-century optical investigators such as Witelo, Bacon, and John Pecham. It was translated into Italian during the fourteenth century, and a version of it was extracted and copied by Ghiberti in his *Commentari*.[20]

Alhazen's great contribution was that he effectively blended the old Greek mathematical attitude toward the visual cone with the physicist's appraisal of how sight works. The result was a model which explained how the "form" (*sura*) of things passes into the eyes and thence to the brain. His mechanistic theory of sight is as simple as it is ingenious, and it was to prevail in the West until the time of Kepler.[21]

Alhazen first established, as had Avicenna, that the visual force emanated not from the eyes but from the objects seen. "We find," he wrote in his opening statement, "that when the eye looks into exceedingly bright lights, it suffers greatly because of them and is injured. . . ."[22] From every body of the universe, he went on, whether luminous, nonluminous, or reflecting, light radiates *from every point*. Each point on an object's surface sends forth rays in all directions and always in straight lines. Alhazen thought of these rays as corporeal entities, yet at the same time believed them to obey precisely the laws of geometry, including the laws of refraction within the eye itself.

But if these rays of light coming to the eyes are overwhelming in number, striking the surface of the eye in a completely fortuitous way, how is the eye, under such a barrage, to discern individual shapes and subtle distance relationships? Furthermore, how could such voluminous visual stimuli from the vast visible world enter the tiny pupil of the eye?

Alhazen's answer was based on an ingenious application of Ptolemy's dioptrics. Ptolemy had already shown that light rays bend or refract when striking a transparent surface. He had observed that refracted rays always lose some of their intensity and strength, while those rays striking a surface at right angles pass

through unrefracted and thereby retain their intensity. Thus, Alhazen postulated, only those rays that strike the curved cornea at a right angle will pass through.

Concerning the eye itself, Alhazen said that the curve of the cornea and that of the crystalline lens were concentric. Because of this, a single ray from each of the infinite and infinitely radiating points of the objects seen could be perpendicular to both of these parts of the eye; all the rest would be refracted and their stimulation unrecorded. Hence every point on the surface of every object seen in nature was able to pass or convey its form to the seat of vision within the eye—in an exact one-for-one, place-for-place proportionate way.[23] By this elucidation, Alhazen made Euclid's theorem (Twenty-one) concerning proportionate smaller triangles physically feasible in intromission optics. The objection raised against the ancient atomists concerning how a mountain could get "into" the eyes was now overcome. From here, Alhazen explained scientifically and anatomically how the object's form—he never quite says "image"—reaches the brain through the sensitized crystalline lens.

It is also worth noting that Alhazen's theory of vision preserved the integrity of the centric ray or *axis visualis*, which travels unrefracted through the vitreous humor to the optic nerve. Hence it is the rays nearest to this axis which elicit the greatest visual acuity *to what is seen in the center of the field of view*. In such insights by this, the greatest of the Arab optical theorists, can be seen the foreshadowings of the ultimate and true perspective which was to come forth in Italy centuries later.

The propitious link between the mechanistic optical theories of the Arabs and the eventual demonstrations of linear perspective by Brunelleschi and Alberti was made possible by three thirteenth-century English monks with close connections to the Franciscan order: Robert Grosseteste (c. 1168–1253), Roger Bacon (c. 1220–1292), and John Pecham (c. 1235–1292). Why should the mathematical science of optics hold such fascination for these faraway, northern men of the cloth? Bacon gives us the answer in his own *Opus majus*:

Since the infusion of grace is very clearly illustrated through the multiplication of light, it is in every way expedient that through the corporeal multiplication of light there should be manifested to us the

properties of grace in the good, and the rejection of it in the wicked. For in the perfectly good the infusion of grace is compared to light incident directly and perpendicularly, since they do not reflect from them grace nor do they refract it from the straight course which extends along the road of perfection in life. . . . But sinners, who are in mortal sin, reflect and repel from them the grace of God. . . .[24]

In other words, optics seemed the model by which God spread his grace to the world. To understand the physical laws of optics meant that one might gain insight into the very nature of God! We must also wonder how distant from one another England and Italy really were. Did the Italian Franciscans know the work of Bacon, Grosseteste, and Pecham? It may not be entirely coincidental that the basilica of San Francesco, the home of the Franciscan order at Assisi, was at that very moment being readied for the great cycles of painting which were to transform it into a new Mecca of optically rational Christian art and a palpable cornerstone of the oncoming Renaissance. In the mid-fifteenth century, St. Antonine, the Dominican archbishop of Florence and spokesman for the prevailing theology of his city at the time Brunelleschi and Alberti were active there, expounded on this same idea: on how *lux gratiae* pervades the universe according to optical principles derived from the theories of Grosseteste, Bacon, and Pecham.[25]

The most interesting new optical concept fathered by the English Franciscans was the notion of *species*, developed largely by Grosseteste and Bacon. The former was actually a generation older than Bacon and Pecham and served during the 1230s as a lecturer at Oxford. His thoughts on optics, it should be noted, do seem to have emerged independently of Alhazen's direct influence. Grosseteste was first concerned with defining the nature of light. Since *lux* was created by God on the First Day, he reasoned, this had to be the basic force for the divine energizing of the universe. Light was therefore synonymous with God's grace, and Grosseteste then postulated that light was to the natural world what abstract space was to geometry. The laws governing the geometry of optics could be applied to the nature of light in the universe, and optics therefore became the key to understanding the metaphysical as well as the physical world.[26]

Grosseteste proposed that all things in nature give off certain

elements of energy called *species*, and these were also capable of producing vision. *Species* radiate or project in straight lines, in all directions, from every point on every object in the universe, he asserted, and hence the *species* themselves behave according to the laws of geometry and optics (thus *species* differ from Alhazen's intromitted rays in that they issue both from the object and the eyes). With this line of reasoning, Grosseteste neatly synthesized the neo-Platonic doctrine of light, with all its deep implications for Christian theology, with the basic geometry of Greek optics and the Aristotelian notion of a physically rational universe.[27]

Grosseteste's species theory was given fuller treatment by Bacon, who wrote a treatise on it called *De multiplicatio specierum*. But Bacon's greatest work, the *Opus majus* which we have discussed earlier, also included a long section on optics.[28] This section was divided into the usual three subsections of optics proper, catoptrics, and dioptrics. Bacon, too, noted how *species* were "multiplied" or propagated from every point on an object's surface, and how they fanned out indefinitely in the form of expanding pyramids. Furthermore, *species* had corporeal existence; they interacted in a corporeal medium and produced a corporeal result. For Bacon there was nothing mystical about either visual or metaphysical *species*. Either from human eyes or from God himself, *species* travel in straight lines, acting on similar *species* coming from all other objects, the more "active" body (*agens*) influencing the more "passive" (*patiens*). In this way eyes see, the sun heats, and God spreads his Divine Grace:

Everything in nature completes its action through its own force and species alone, as for example, the sun and the other celestial bodies through their forces sent to the things of the world cause the generation and corruption of things; and in a similar manner inferior things, as, for example, fire by its own force dries and consumes and does many things.[29]

There are aesthetic foreshadowings here. In fact, Bacon's description of *species* could well be a commentary on a painting of Giotto in which, for the first time in Western art since antiquity, we observe solid, substantially material-looking bodies interacting upon one another in palpable three-dimensional space. Similarly, Bacon's theory seems to prefigure the starkly physical aura and

"cause-and-effect" consciousness of Dante's *Divine Comedy*. As we have said, Ghiberti incorporated passages from Bacon's work in his own *Commentari* in the mid-fifteenth century. Alberti's ambiguousness about the direction of his own "visual rays" and his characterization of them as corporeal entities is in keeping with Bacon's ideas.

Probably no other optics book ever written, including that by the great Alhazen himself, attained the widespread circulation and general popularity of the *Perspectiva communis* (c. 1265) by the English Franciscan John Pecham, who became Archbishop of Canterbury in 1279. What was particularly noteworthy about the *Perspectiva communis* was its brevity, which effectively assured its wide circulation. While Pecham incorporated some of Bacon's and/or Grosseteste's ideas in his treatise, his main source was certainly Alhazen—whom Pecham referred to reverently as the *auctor perspectivae*. Pecham really wrote his book as a succinct review of Alhazen, and he thereby deserves the credit for being the chief promulgator of Alhazen's optical ideas in the West. Today there are at least sixty-two known and extant manuscripts of Pecham's book (as compared to only nineteen extant manuscripts of Alhazen and eighteen of the thirteenth-century Thuringian optician Witelo).[30]

More important to our purposes here, there is every likelihood that Alberti first became acquainted with optics through the *Perspectiva communis*. Whatever other sources Alberti may have consulted in writing his treatise on painting, nearly all references to optics can also be found in Pecham's little book.

Nevertheless, there were two other optical treatises available in Florence when Alberti was there that should not go unmentioned. One of these was called, after the dialectical method of teaching in medieval universities, *Quaestiones perspectivae*, and was written by Blasius of Parma.[31] We have already mentioned him in connection with Toscanelli. Blasius' treatise was written about 1390, and a copy of it was in the university of Florence at least by 1428, apparently being lectured on by the professor of surgery and astrology.[32] The other treatise is unusual because it was originally written in Italian, as *Della prospettiva*, around the early 1420s. Its author is unknown, but there is good reason to suspect that it was by no less than Toscanelli himself, one of the "perspective books" he is credited with having written.[33] What is note-

worthy about both these optical treatises is that they are also thoroughly indebted to the prior work of Bacon and Pecham. While in no way addressing themselves to any issues of painting or "artificial" perspective, these texts are filled with a number of empirical insights that, as we shall see in Chapters IX and X, may have been influential on Brunelleschi—and even perhaps Alberti.[34]

VI

Alberti's Optics

IN HIS *DE PICTURA*, Alberti clearly wanted to establish a new, autonomous subbranch of optics for application specifically to painting. Moreover, he was so intent on being identified as a painter in his writing that he took pains to declassify himself as a mathematician on the first page of the book. While quite aware that painters needed to know more geometry, he was also mindful that he not be condescending. Thus he introduced the subject of painting almost as if it were a branch of the physical sciences; he approached his intended artist-readers as if they were already fellows to the ancient argument between the physicists, who would know the essences of things, and mathematicians, who thought only in abstractions:

In writing about painting in these short books, we will, to make our discourse clearer, first take from mathematicians those things which seem relevant to the subject. When we have learned these, we will go on, to the best of our ability, to explain the art of painting from the basic principles of nature. But in everything we shall say I earnestly wish it to be borne in mind that I speak in these matters not as a

mathematician but as a painter. Mathematicians measure the shapes and forms of things in the mind alone and divorced entirely from matter. We, on the other hand, who wish to talk of things that are visible, will express ourselves in cruder terms [*pinguiore . . . Minerva*].[1]

Alberti commenced his discussion in Book One with a series of definitions of geometrical terms to be used, as had Euclid and all other geometricians before him. As was proper to the Aristotelian approach to science, Alberti began with a definition of the most elemental figure, the point, proceeding then to the line, the plane, and (in Book Two) the body. He also discussed the qualities of planes, such as shape and color, and the nature of visual rays and of the visual pyramid:

> The first thing to know is that a point is a sign [*signum*] which one might say is not divisible into parts. I call a sign anything which exists on a surface so that it is visible to the eye. No one will deny that things which are not visible do not concern the painter, for he strives to represent only the things that are seen. Points joined together continuously in a row constitute a line. So for us a line will be a sign whose length can be divided into parts, but it will be so slender in width that it cannot be split. . . . If many lines are joined closely together like threads in a cloth, they will create a surface.[2]

Alberti's definitions here are generally the same as those in all the Euclidian geometries available at the time—but with a subtle distinction.[3] As Leonardo Olschki has shown, Alberti may have had on his desk the popular *Practica geometria* of Leonardo Fibonacci. Below is the Latin statement from the latter, defining a point, followed by its counterpart in *De pictura*:

> *Punctus est id quod nullam habet dimensionem, id est quid non potest dividi.* (Fibonacci) [4]
> *Punctum esse signum, ut ita loquar, quod minime in partes queat dividi.* (Alberti) [5]

The key word in Alberti's definition is *signum*. Whereas Euclid and other geometers traditionally thought in abstractions, Alberti wanted his geometry for painters to be absolutely *concrete*. *Signum* (*segnio* in *Della pittura*) means "figure" or "mark"—in other words, something tangible, like a dot on a piece of paper.

But this presented a problem for Alberti. Against the strict language of geometry, *signum* is a contradictory term since points, lines, and planes, lacking all or some dimensions, can exist conceptually but not "really." [6] In order to make a case for his specialized approach for painters, Alberti wrote a separate tract of one paragraph, called *De punctis et lineis apud pictores:*

Points and lines among painters are not as among mathematicians, [who think that] in a line there fall infinite points. From our definition, a point is a mark [*signum*] because the painter perceives it as if it were somehow a kind of thing between the mathematical [concept of a] point and a quantity which can be defined by a number, such as finite particles like atoms. Then from nature which is imitated [in the picture], the painter takes lines and angles, then lights and colors of surfaces, whatever of which can be measured and stands clear as to parts, that is to divisions not established artificially but by nature. And who would say that there be as many rays of light in a one-foot line as there are in a line two feet long? In sum, possibilities are presented because of this which need not be infinite and beyond rationality. Here let it be sufficient that I have answered my detractors in a few words. [7]

The words *punctus, linea*, and *superficies* which Alberti used in *De pictura* were, of course, common Latin geometrical expressions and directly translatable into Italian. He avoided the word *figura*, however, employing *signum* instead because *figura* was usually used by geometers to mean something totally abstract. While the Latin language possessed an adequate mathematical vocabulary, Alberti found himself having to manufacture many of his own expressions in order to give a tangible, concrete feeling to his "applied" optics. We see this particularly in his efforts to find a suitably physical word to be used in lieu of *extrema*, the stock geometric expression for the edge of a plane:

One [property of surface] we know from the outer edge [*ambitus*] in which the surface is enclosed. Some call this the horizon [*horizon*]: we will use a metaphorical term from Latin and call it the brim [*ora*], or the fringe [*fimbria*]. This fringe or outline will be composed of one or more lines. . . . [8]

The Latin words *ora, fimbria*, and *ambitus* all mean the edge of something tangible. *Fimbria* can specify the edge of a piece of cloth or a garment or refer to a thin hair or filament, and Alberti

settled on it in *De pictura* to denote the edge of the painter's tangible plane.[9] In *Della pittura* he used the equivalent word *orlo*, again avoiding more abstract Italian expressions such as *contorno* or *intorno*, used by Cennino Cennini to describe the outline of a figure.

It was Alberti's practice to employ not only single words but whole metaphorical phrases for familiar visual experiences. He described the plane, for example, not in the usual mathematical jargon but as being composed of "many lines . . . joined closely together like threads in cloth." A concave surface, he noted, is like "the inner surfaces of egg shells." [10] The mode of expression is that of an earthy craftsman and contrasts markedly with the dry idiom of the standard optics texts, such as Pecham's *Perspectiva communis:* "Concavity is perceived when the distance to the middle is greater than that to the extremes, and convexity vice versa." [11] We cannot help but be affected by what Alberti is attempting to do here. Blowing away the dust of abstraction, he borrows the familiar things of everyday life to lure the enterprising painter to the keyhole of a higher aesthetic order. To the black and white of Euclid, he brings the poetry of real—and artistic—life.

BEFORE ALBERTI could set out his linear perspective construction, he first had to establish his own, more sensate version of the fundamental visual cone. The original Greek term for this cone was κῶοστής ὄψεως. Apparently these words were rendered into Latin by the Christian translators of the twelfth century as *pyramis visibilis*. In medieval Latin the word *conus* referred to the point or apex of any conical or pyramidal shape. *Pyramis*, on the other hand, was understood as a "pyramid" of any possible number of sides, and the medieval writers even spoke of a *pyramis rotundis* to denote a rounded cone. Alberti, however, employed this ambiguous mathematic meaning to his own advantage. The *pyramis visibilis* of medieval optics, generally understood as implying a circular visual field, would now become in his own *perspective artificialis* the *pyramis radiosa* of the artist's concentrated vision, implying a quadrangular base—like a picture.

Alberti's Optics

Alberti's description of the visual pyramid began with its simplest form, the Euclidian visual triangle:

It is usually said that sight operates by means of a triangle whose base is the quantity seen, and whose sides are those same rays which extend to the eye from the extreme points of that quantity. It is perfectly true that no quantity can be seen without such a triangle. The sides of the visual triangle, therefore, are open. In this triangle two of the angles are at the two ends of the quantity; the third is the one which lies within the eye and opposite the base.[12]

While Alberti claimed to take no side in the extromission-intromission controversy, it would seem from the above that he clearly favored the latter. But it must have occurred to him that the illusion of linear perspective involved some activity of the eyes themselves. At any rate, he preserved his ambiguity by continuing to use the term "visual ray," implying a source point in the eyes:

The philosophers . . . say that surfaces are measured by certain rays, ministers of vision as it were, which they therefore call visual rays, since by their agency the images of things are impressed upon the senses. These rays, stretching between the eye and the surface seen, move rapidly with great power and remarkable subtlety, penetrating the air and rare and transparent bodies until they encounter something dense or opaque where their points strike and they instantly stick. . . . Let us imagine the rays, like extended very fine threads gathered together tightly in a bunch at one end, going back together inside the eye where lies the sense of sight. There they are like a trunk of rays from which, like straight shoots, the rays are released and go out towards the surface in front of them.[13]

Once again Alberti demonstrates how vividly he could translate difficult scientific concepts into literally picturesque language for artists.

Alberti's next step was to show how the visual pyramid was constructed. Its outside, he began, is formed of what he called "extrinsic rays": "The extrinsic rays, which hold on like teeth to the whole of the outline, form an enclosure around the entire surface like a cage." [14] The center of his visual pyramid was dominated by the centric ray, which Alberti called the "prince of rays," and the rest by "median rays" (Diagram VI-1).[15]

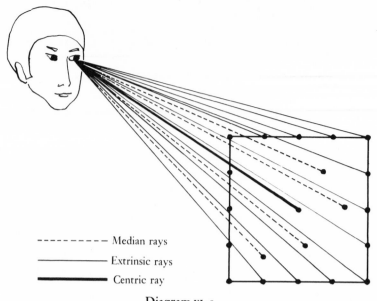

Diagram VI–I

The "median rays," he went on to point out, were those which bore color sensations, and Alberti makes a comparison with the chameleon:

We must now speak of the median rays. These are the mass of rays which is contained within the pyramid and enclosed by the extrinsic rays. These rays do what they say the chameleon and other like beasts are wont to do when struck with fear, who assume the colors of nearby objects so as not to be easily discovered by hunters. These median rays behave likewise; for, from their contact with the surface to the vertex of the pyramid, they are so tinged with the varied colors and lights they find there, that at whatever point they are broken, they would show the same light they had absorbed and the same color. We know for a fact about these median rays that over a long distance they weaken and lose their sharpness. The reason why this occurs has been discovered: as they pass through the air, these and all the other visual rays are laden and imbued with lights and colors; but the air too is endowed with a certain density, and in consequence the rays get tired and lose a good part of their burden as they penetrate the atmosphere. So it is rightly said, that the greater the distance, the more obscure and dark the surface appears.[16]

This remarkable passage provides us with one of the many refreshing human touches in Alberti's work: the wit of his personification—the "tired" visual rays (*fessis* in the Latin, *straccare* in the Italian)—is best appreciated only after toiling through the unrelievedly sterile optics of Alhazen, Witelo, Bacon, or Pecham. The idea, briefly expressed as it is, is nevertheless quite profound,

84

for it explains in essence what classical, medieval, and Renaissance opticians thought about the phenomenon of atmospheric perspective, a point which I have expanded upon at length elsewhere.[17]

ALBERTI DEVOTED special attention to the centric visual ray:

It remains for us to speak of the centric ray. We call the centric ray the one which alone strikes the quantity in such a way that the adjacent angles on all sides are equal. As for the properties of the centric ray, it is of all the rays undoubtedly the most keen and vigorous. It is also true that a quantity will never appear larger than when the centric ray rests upon it. A great deal could be said about the power and function of this ray. One thing should not go unsaid: this ray alone is supported in their midst, like a united assembly, by all the others, so that it must rightly be called the leader and prince of rays. Further comment would be more appropriate to a show of learning than to the things we set out to treat, and may therefore be omitted here. Besides, much will be said about rays more suitably in their proper place. Let it suffice here, as the brevity of these books requires, to have stated those things that will leave no one doubting the truth of what I believe I have adequately shown, namely, if the distance and position of the centric ray are changed, the surface appears to be altered. For it will appear either smaller or larger according to the relative disposition of the lines and angles. So the position of the centric ray and distance play a large part in the determination of sight.[18]

The peculiar imprimatur of the *axis visualis,* reflected in the work of both Pecham and Bacon, was even carried into literature by Dante in his *Convivio.* The soul-searching poet cited the same principle in order to sustain his argument that virtue was communicated by direct visual exchange with his *Donna pietosa:*

It should be known that, although more things than one can enter the eye at one time, that which comes in a straight line into the point of the pupil is truly seen by it, and alone is stamped on the imagination. And this is so because the nerve along which the visual spirit travels runs straight to that part, and, therefore, in truth one eye cannot look at another without being seen by it, because as the eye which

beholds receives the form on the pupil along a straight line, so also, its own form goes along by that same line into the eye which it beholds.[19]

Dante's optical explanation, in other words, upholds the wisdom of looking someone "straight in the eye," with all its overtones of detecting another's truthfulness and communicating one's own sincerity. In view of this, it is more than possible that the Trecento and particularly the Quattrocento artists saw a moral dimension in the concept of the centric ray and visual axis: the shortest, clearest distance between two points was also the most Christian.

As interest in both natural and artificial perspective grew during the fifteenth century, there was a corresponding predilection, particularly among Italian painters, to construct their hieratical pictures in precise frontal views—that is, with the predominant plane of the pictorial space (or facing background) perpendicular to the artist's visual axis. During the fourteenth century there had been a temporary favoring of charming oblique views. Thereafter it was as if painters wanted to recapture the solemn spirit of the old traditional Christian messages, to eschew the happy visual delights of the Trecento, and thus they took seriously the moral imprimatur of the centric ray. Brunelleschi insisted, in his own first experiment with artificial perspective, that his picture be seen from a single point, the same as that determined by his own *axis visualis* when he painted the picture.

Likewise, Alberti, ten years later, expressed a preference for one "centric point" to be placed in the middle of the painted panel as the locus for all orthogonal lines. There can be no doubt that he believed the didactic force of his *istoria*, with its idealized figures and *virtù*, would be enhanced by the godly properties of the "prince of rays."

Europeans came more and more to believe that things planned or seen from a central viewpoint had greater monumentality and moral authority than those which were not. While such a notion was not unusual in the Middle Ages (and is fundamental to the psychology of practically every human culture), it received particularly strong emphasis in the Renaissance, reinforced by the writings on optics. About 1455, the humanist Gianozzo Manetti, in his description of Pope Nicholas V's aborted plan for the Borgo Leonino, mentioned that a wide, straight avenue was to connect the Castle Sant'Angelo with St. Peter's, and that this

street was to be reserved for the rich, while angular side streets were to be used by the lower classes.[20] Alberti expressed similar ideas about straight, point-to-point avenues in his *De re Aedificatoria*.[21]

FINALLY, IN THE TREATISE on painting, Alberti turned his attention to how the artist's picture should be conceived relative to the structure of the visual pyramid. One should imagine that the picture was

transparent and like glass, that the visual pyramid passed right through it from a certain distance and with a certain position of the centric ray and of the light, established at appropriate points nearby in space. Painters prove this when they move away from what they are painting and stand further back, seeking to find by the light of nature the vertex of the pyramid from which they know everything can be more correctly viewed. . . . Therefore a painting will be the intersection of a visual pyramid at a given distance, with a fixed center and certain position of lights, represented artistically with lines and colors on a given surface.[22]

Thus Alberti's "intersection" is the key concept in his art-science of linear perspective. The picture becomes exactly proportional to the object to be depicted because of Euclid's Theorem Twenty-one from the *Optica*, which Alberti paraphrased:

And to what we said about extrinsic, median, and centric rays, and about the visual pyramid, should be added the mathematical proposition that if a straight line intersects two sides of a triangle, and this intersecting line, which forms a new triangle, is equidistant from one of the sides of the first triangle, then the greater triangle will be proportional to the lesser.[23]

For this same reason, as we have already seen, the medieval optical scientists presumed, according to the intromission theory, that the crystalline lens in the eye intercepted and reduced to scale the form of the object seen; the visual rays each touched a minute but measurable point on the object's surface, transmitting each point to the *crystallinus* as the rays converged on the center of

the eye. As Alberti himself remarked, the visual rays "should be found lighted and colored in a definite way wherever they are broken." Since all the rays pass through the *crystallinus,* the accumulation of points upon it theoretically makes up an exactly proportionate but smaller image—the same one, so the opticians thought, that then passed into the brain via the optic nerve. Bacon described the process thus:

The species of a thing, whatever be its size, can be arranged in order in a very small space, because there are as many parts in a very small body as there are in a very large one, since every body and every quantity is infinitely divisible, as all philosophy proclaims. Aristotle proves in the Sixth Book of the *Physica* that . . . there are as many parts in a grain of millet as in the diameter of the world.[24]

Alberti's own statement is quite similar:

To all these remarks should be added the belief of philosophers that if the sky, the stars, the seas, the mountains, and all living creatures, together with all other objects, were, the gods willing, reduced to half their size, everything that we see would in no respect appear to be diminished from what it is now.[25]

This concept of proportion or scale which we so casually take for granted today may not have been so easy to grasp, even in the late Middle Ages, and Alberti's little homily above may have been intended as more than a literary flourish. Indeed, the whole theory of linear perspective rests on a fundamental assumption by the viewer that large things can be represented smaller and in exact proportion. Since the science of optics also made use of this same assumption, Alberti's Book One intended to prove to artists that they could paint pictures not only of what the eye sees but *as* the eye sees.

IN ADDITION to writing about this phenomenon, Alberti himself devised certain related experiments. We know from the *Vita anonima,* an anonymous fifteenth-century biography—perhaps autobiography—of Alberti, that he built some sort of appara-

tus to show off certain "miracles of painting," these apparently being pictures or "images" which he had painted while living in Rome, prior to his return to Florence:

By looking into a box through a little hole one might see great plains and an immense expanse of sea spread out till the eye lost itself in the distance. Learned and unlearned agreed that these images were not like painted things, but like nature herself. These demonstrations, as he [Alberti] called them, took place by night and day. In the former you saw Orion, Arcturus, the Pleiades and other shining stars, and the moon rising above high mountains; by day you saw the blaze of dawn as Homer describes it. Certain Greeks, famous men and skilled seafarers, were astonished when he showed them, in his little world, a ship far out to sea. "Now it labors in the tempest," he said, "But tomorrow you will find it in harbor." [26]

Exactly what was this device? It was technically not a *camera obscura* since the image viewed was not projected outside the box but remained within it. Some years ago, William M. Ivins, Jr., worked out an elaborate reconstruction based on strings and a sliding template which, while presenting a reasonable model of Alberti's optical geometry, still does not correspond to what the author of the *De pictura* was supposed to have achieved in the *Vita anonima* account above.[27] Ivins' reconstruction, unfortunately, ignores all the painterly aspects of the illusionistic picture described in the account, such as the effects of the atmospheric perspective, how the eye "lost itself in distance," or how he depicted the color effects of "reflected rays." There is a brief reference to the same experiments in Alberti's treatise on painting:

Rays that are intercepted are either reflected elsewhere or return upon themselves. They are reflected, for instance, when they rebound off the surface of water onto the ceiling; and, as mathematicians prove, reflection of rays always takes place at equal angles. But these are matters that concern another aspect of painting. Reflected rays assume the color they find on the surface from which they are reflected. We see this happen when the faces of people walking about in the meadows appear to have a greenish tinge.[28]

Most of the passage above is a straight rephrasing of similar observations to be found in Aristotle, Ptolemy, Galen, Avicenna, and Witelo.[29] However, the reader must draw his own conclusions about the mechanics of Alberti's curious device. I can offer nothing

except to say that it may have related in some way to the demonstration Brunelleschi set up before the Baptistery of Florence (Chapters IX and X). Could Alberti's reference to "certain Greek seafarers" be a cryptic reference to Ptolemy's *Geographia?*

Perhaps the best explanation, suggested some time ago by Georg Wolff, is that Alberti constructed a *Guckkasten* or *camera ottica,* as distinct from the *camera obscura.*[30] In the former the viewer does not observe an exterior object by looking through a box, but rather looks into the box itself. One might very well imagine that Alberti rigged up a *camera ottica* whereby his viewers saw a reflection of a painted picture rather than the picture itself— in the same way Brunelleschi employed a mirror in his first perspective demonstration. Does Alberti's reference above to "reflections" hint that he used a mirror in just such a way?

In Book Two of *De pictura,* Alberti reports his devising of another practical device which would make the scale recapitulation of images even more assured. This was his famous *velo* or "veil," the use of which, he claimed, "I was the first to discover." [31] Alberti would have the artist hang out a reticulated net of colored strings in front of the object to be painted so that the parts of the things seen could be properly proportioned in a smaller picture.

In the following chapter we shall see how this very notion of reticulation was paralleled by the advent of another tool that played a role in linear perspective: Ptolemy's cartographic system for mapping the surface of the globe by means of a network of horizontal and vertical lines. In the Florentine mind's eye, all was becoming a matter of scale. Today the painting—and tomorrow the world.

VII

Enter Cartography

IN THE YEAR 1493, at the very time Christopher Columbus was back in Spain touting the successes of his first voyage, the Florentine artist Antonio Pollaiuolo cast an allegorical figure of Prospectiva as one of the *artes liberales* surrounding the bronze tomb of Pope Sixtus IV, in the Roman church of San Pietro in Vincoli (Illustration VII–1).[1]

We should hardly be surprised at this time, the dawn of the sixteenth century, to find the science of optics included among the liberal arts. But it is curious that the artist here chose also to include an astrolabe, the ancient tool for determining latitude, as one of Prospectiva's attributes. The astrolabe, a familiar device to astronomers and geographers, normally had no significance for opticians. Prospectiva also displays the oak branch symbol of the deceased pope's family (della Rovere) and a copy of a book open to a page inscribed with scattered phrases. The phrases, interestingly enough, are from John Pecham's *Perspectiva communis*.[2]

Why should Pollaiuolo's Prospectiva be holding an astrolabe? Perhaps his contemporary Leonardo da Vinci gives us part of the

Illustration VII–1: Antonio Pollaiuolo, *Prospectiva*, from the tomb of Pope Sixtus IV, San Pietro in Vincoli, Rome, c. 1493. Courtesy, Alinari-Art Reference Bureau.

answer in his notebooks. "The eye," he wrote, "is the master of astronomy. It makes cosmography. It advises and corrects all human arts. . . . The eye carries men to different parts of the world. It is the prince of mathematics. . . . It has created architecture, and perspective, and divine painting. . . . It has discovered navigation." [3]

Hans Baron, in his provocative *Crisis of the Early Italian Renaissance*, presents a thesis that it was the traumatic effects of the Florentine wars with Milan and Naples during the first quarter of the fifteenth century which were chiefly responsible for the whole new Renaissance psychology of perspectival perception.[4] These wars encouraged a new sense of civic pride and self-reliance, and Frederick Hartt sees this as having encouraged artists to a new perception of man as individual.[5] Accordingly, linear perspective brought God—in the form of religious subject mat-

ter—into the focus of man, reversing the ethos of the Middle Ages.

The observations of certain civic humanists of the period such as Leonardo Bruni and Goro Dati, Baron points out, reflect this new "perspective" in a way that departs significantly from related writings of the Trecento. Hartt, going still further, has applied Baron's arguments to explain the sudden flourishing of painting and sculpture in Florence—specifically, the poignant new drama of Ghiberti's Baptistery reliefs, the heroic sculpture of Donatello and Nanni di Banco for Orsanmichele, and the monumental paintings by Masaccio and Masolino in the Brancacci Chapel.

I should now like to argue that another event in the city, which occurred at the same time as the first Milanese Wars, may have been just as stimulating to this new awareness of perspective, and may indeed have led even more directly to the actual linear perspective experiments of Brunelleschi. This was the appearance of Ptolemy's *Geographia* (or *Cosmographia*), previously unknown in the Latin West. In spite of its ancient origin, this work offered the most sophisticated and mathematically sound means even then known for visually comprehending the globe.

The story of the stroke of luck that brought the *Geographia* to Florence is fascinating in itself. It involves some of the most influential and enlightened people of this remarkable city—the very men who were most keen about the new ideas to which Baron has called attention, men who served on the progressive public commissions that chose the new works by the enterprising Florentine artists. The relationship between the increasingly volumetric art in the early fifteenth century and the contemporaneous developments in cartography was first pointed out by Dagobert Frey,[6] and more recently by Joan Gadol.[7] Yet neither of these historians analyzed the respect in which Ptolemy's ideas paralleled and served trends unique to the "mental set" of Florence. Even in the Arab world and the Byzantine East, where the *Geographia* had been well known for centuries, Ptolemy's work made no parallel impression on the perceptions of artists.

It seems that in about 1395 in Florence a number of leading intellectuals and businessmen had organized themselves into a kind of seminar or "study group" for the purpose of learning Greek. This group included prominent citizens such as Palla Strozzi, Leonardo Bruni, Antonio Corbinelli, Coluccio Salutati, Roberto

de'Rossi, and Jacopo d'Angiolo da Scarperia. In their common lingual effort they hired a teacher, Byzantine scholar Manuel Chrysoloras, who turned out to be an extraordinarily gifted and inspiring teacher. He so charged up his new students, in fact, that they quickly outran their meager supply of Greek literature, and Chrysoloras, along with Jacopo d'Angiolo, decided to return to Constantinople for more books. When these two, about 1400, came home again to Florence—after a nearly disastrous shipwreck off Naples—they brought with them in their salvaged selection what was to prove a historic dividend: Ptolemy's world atlas.[8]

To BE SURE, the Florentines had not been unknowledge-able about maps, and since the thirteenth century their char-acteristic spirit of practical artisanship had carried over into cartography. Italian sailors, in fact, were the first in Europe to

Illustration VII–2: Petrus Vesconte, Pages from his portolan chart atlas, Cod. Pal. Lat. 1362A, folios 4v-5r, Vatican Library, Rome, c. 1311. Courtesy Biblioteca Apostolica Vaticana, Rome. This atlas was intended to be used by sailors standing all around a chart table; hence, many of the inscriptions are upside down.

work out a systematic mapping method for negotiating the Mediterranean sea routes as trade began to expand in the late Middle Ages. This resulted in the harbor-finding or "portolan" sea charts, the earliest known example of which (1275) may have been produced in Tuscany.[9] By the early Trecento these charts were in general use among Italian seamen, and as late as 1700 were still the best means for sailing not only the Mediterranean but the Atlantic and Pacific oceans. While Florentine merchant captains knew portolan charts from the very beginning, the most renowned centers for their production were Genoa and Catalonia. Illustration VII-2 shows a Genoese portolan chart of about 1311, by one Petrus Vesconte, who for the arguments of this chapter we may consider the Giotto of cartography.

When a portolan chartmaker like Petrus sat down to draw such a map, he first laid in a stretch of shoreline that he had either sketched on site himself or learned about from other sailors. He then added place names, carefully inscribing them to the side so as not to mar the important configuration of the coast. Different colored inks were employed in order to distinguish the best harbors, and sometimes the chartmaker even painted in little flags to denote the arms of the ruling princes. Finally and most importantly, he superimposed over his coastal contour a so-called compass rose. This was a starlike polygon having sixteen points interconnected by fans of lines, or "rhumbs." The directional points of the compass rose he labeled with the traditional names of the four winds: *tramontana* (north), *levante* (east), *ostro* (south), and *ponente* (west); the other twelve points of the polygon represented the half and quarter winds.

When the ship's navigator put the portolan chart to use, he opened it upon the map table, took a ruler and laid it down between his own port and that to which he was bound, and ascertained the nearest rhumb which ran parallel to his proposed course. When the proper rhumb was found, he traced it back to its direction-point vertex on the compass rose, and set his own course accordingly.[10] Some of these portolan charts also showed a scale of miles—the 1275 *Carta pisana* is the earliest known map with such a scale—or a superimposed *grid* for reckoning distance. Such grids, as we shall see, represent a skeletal geometric key to the link between Quattrocento cartography and the paintings which gave birth to linear perspective.

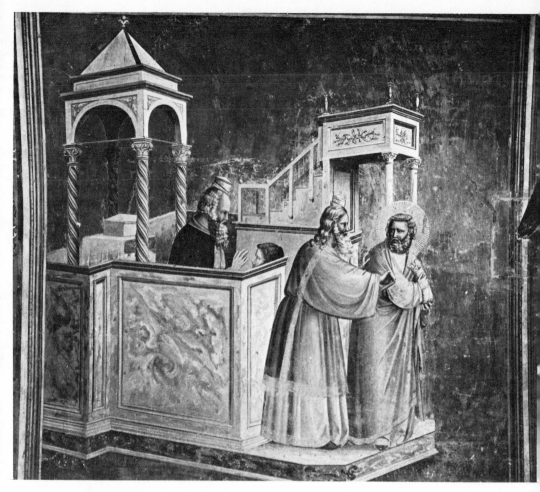

Illustration VII-3: Giotto, *Expulsion of Joachim from the Temple*, Arena Chapel, Padua, c. 1306. Courtesy, Alinari-Art Reference Bureau.

More often than not, the charts were not particularly successful in giving accurate distances, being more useful for showing precise directions. But they enabled a navigator to determine instantly the direction of his destination and the sequence of landmarks he would pass along the way. (The rhumb line system per se did not provide him ready information on how far apart these landmarks were.)

At this point we could well compare our portolan chart by Petrus Vesconte to a nearly contemporary painting (1306) by Giotto, a scene from the Arena Chapel (Illustration VII-3). Here we see that the limitations and advantages characteristic of the portolan chart are also characteristic of Giotto's *Expulsion of Joachim from the Temple*. In Giotto's art one always has a clear

idea of just which objects were intended to be viewed as being in front of others and in which direction the eye is to follow the painted buildings into the putative depths of the picture. But the viewer does not receive cues as to *how far apart* the pictorial objects are, or how "deep" the foreshortened planes and objects go; the relative heights of the architectural elements remain ambiguous. In other words, Giotto's painting, like a Petrus Vesconte map, gives a good approximation of angle and direction but not of distance. So far as the psychology of seeing is concerned, the portolan chart reflects the tactile perceptions—looking, touching, and moving about—which characterized art not yet attuned to geometric abstraction.

As this comparison demonstrates, the coming of Ptolemy's cartographic system to Florence in 1400 did to the psychology of map making exactly what linear perspective—arriving there about twenty-five years later—did to the psychology of looking at pictures. Had nautical instruments for determining longitude and latitude at sea (i.e., chronometers) also been available at this time, Ptolemaic maps would have displaced portolan charts in seafarers' use.

THE GREEK EDITION of Ptolemy's *Geographia* which Chrysoloras and Jacopo d'Angiolo brought back to Florence in 1400 is unfortunately not extant, but very likely it was similar to the several handsome copies of the work, written and illuminated in the fourteenth century, which are now to be found in the Vatican Library in Rome and the Biblioteca Laurenziana in Florence.[11] These works, which vary in format from medium folio size to huge octavo, contain the eight books of Ptolemy's text plus twenty-seven maps, including a two-page *mappamundi*.

Manuel Chrysoloras began to translate Ptolemy's geographical work into Latin almost immediately after his return, for the members of the Greek seminar were quick to recognize the universal implications of the *Geographia*. After an interruption, the translation task was resumed about 1405 by Jacopo and finished perhaps in the next year. Annotated Latin copies of the colored maps

were not added, however, until the following decade, when two distinguished young Florentine gentlemen named Francesco di Lapacino and Domenico di Lionardo Boninsegni undertook the task.[12] These men were not artists but scions of important Florentine families; Domenico was subsequently to occupy several high posts in the government. I stress this because it shows the impact which Ptolemy's atlas made upon the wealthy, intellectual, and highly influential laymen of Florence, who now set the tone for the arts and all other cultural enterprises. Vespasiano de'Bisticci, writing many years later about his genteel and bibliophile friends, mentioned the Ptolemaic *Geographia* in four separate biographies (and, incidentally, referred each time to the maps as *pitture*).[13] Furthermore, a scriptorium for the reproduction of these Ptolemaic atlases seems to have been set up in Florence to supply a steadily rising demand.

It was not so much Ptolemy's knowledge of geography proper that was now so captivating but rather his system for mapping the surface of the world. Equally important, this system allowed for corrections and additions; already, by 1424, improved maps of Northern Europe began to be drawn up.[14] Florence was becoming a center of cartographic and geographic study as well as a mere scriptorium, and the Portuguese under Henry the Navigator began to beat a path to the Italian city. Henry's brother Dom Pedro was there in 1428, perhaps also to purchase maps,[15] and Dom Pedro's own son became Cardinal James of Portugal, now buried in Florentine splendor at San Miniato.[16] Florentine gold also was stimulating the Portuguese to make their spectacular expeditions down the African coast.

Interest in Ptolemy's atlas also permeated the august ecclesiastical councils on schism and heresy going on in Pisa, Rome, and Constance during the second decade of the Quattrocento.[17] The French cardinal Guillaume Filastre, the stolid antagonist of John Hus, was sufficiently interested to purchase a copy from Florence in 1417 and another, with updated maps, ten years later.[18] His friend Cardinal Pierre d'Ailly was himself a learned geographer and had already composed a long compendium on the subject, *Ymago mundi*, when he heard about the new Ptolemaic atlas while attending the council. Around 1412, he wrote two commentaries on the Geographia.[19] D'Ailly's commentaries on Ptolemy eventually found their way to the library of Christopher

Columbus where, Samuel Eliot Morison has indicated, they made up his principal bedtime reading.[20]

Should anyone have further doubts about the prestige of these Ptolemaic atlases in Florentine intellectual life, let him but inspect the magnificent Latin copies in the Biblioteca Laurenziana, and particularly the great edition prepared for the *condottiere* Camillo Maria Vitelli now in the Biblioteca Nazionale. This latter work of the late fifteenth century was not only updated with the latest geographical information, but was lavishly decorated with gold leaf and brightly colored miniatures in the style of Ghirlandaio.[21] The huge Vitelli atlas represents the culmination of a whole industry fostered in Florence during the Quattrocento—an industry that brought together scientists, artists, and rich patrons. The city, as if it had not contributed enough to the Renaissance already, also became the most important center in all Europe for the study and production of the revolutionary Ptolemaic system of geography and map making.

When Jacopo d'Angiolo and Chrysoloras first discovered Ptolemy's atlas among the wares of the Byzantine book merchants, they were not exactly unprepared to sense its worth, beyond its desirability as a Greek language text or as a collection of pretty colored maps. They may or may not have known about Ptolemy's optics, but they were certainly aware of the Alexandrian's fame as author of the *Almagest*, the standard work on astronomy during the Middle Ages. A mere thumbing through the pages of the *Geographia* would have revealed to the two travelers from Florence that Ptolemy had studied the earth with the same assiduousness as he had the heavens, and that he had given a similar sense of proportion and order to the global world.

WHAT, INDEED, MADE the *Geographia* such a major event in the West? To begin with, it provided not one but three alternative cartographic methods. In Book One of his text, Ptolemy described two ways to map the world in the form of conic sections. Later, in Book Seven, he described a third method which is of the greatest interest to our study. All three methods had in

common the aim of mapping on a plane surface the longitudes and latitudes of the globe. Ever since ancient times, certain scientists had conceived of the spherical world as abstractly divided into evenly spaced meridians (longitudes) converging at the poles and intersected by parallels (latitudes) crossing at right angles. We need not concern ourselves with the history and mathematical reckoning of this latitude-longitude system, except to say that in medieval Europe no one had as yet presented a satisfactory way to map such a reticulated spherical surface onto a flat chart. Ptolemy's three methods now showed how to project the coordinates of any geographic location in the world, and how to compensate for the distortion of the spherical surface when stretched out on a two-dimensional plane.

The world that Ptolemy charted, however, was only the *oikumene* or that part known in ancient times. It began with the mythical Fortunate Islands (west of Gibraltar off the African coast, probably the Canaries)—the "Greenwich" in Ptolemy's longitudinal reckoning—and stretched eastward to China. While it showed the northern regions of Scandinavia and Russia, it extended southward only slightly below the equator. The rest of the world was *terra incognita* as far as Ptolemy was concerned, although his longitude-latitude system was applicable to the whole of the globe—which he fully realized was considerably larger than the *oikumene* itself.

Ptolemy offered three separate mapping solutions because he knew there must be some distortion no matter how his spherical surface was unfolded on a plane. The first two were attempts at preserving a spherical character by having the meridians converge; thus, the *oikumene* appears in the shape of a curved trapezoid (Illustration VII-4).[22] Neither of these two methods was in any sense a projection from a fixed eyepoint. However, the second, which Ptolemy himself preferred, did take the eyepoint into some consideration by what amounts to a remarkable application of optics to cartography. Just before introducing this second method, Ptolemy asked his readers to hold a globe motionless before the eyes and to locate the parallel (latitude) which passed through Syene (modern Aswan in Egypt)—twenty-four degrees north of the equator. This line was to mark the center between the northern and southern extremities of the *oikumene*.[23] The viewer was then to direct his visual axis—Ptolemy here ap-

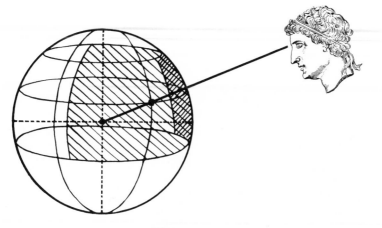

Diagram VII–1

plies his knowledge of optics—toward the internal *center* of the sphere in such a way that this *axis visualis* would pass through the external surface of the globe at just that point where the parallel through Syene crosses the meridian directly in the middle of the viewer's visual field (see Diagram VII–1).

In other words, Ptolemy was saying, before the viewer did any mapping at all, he should have a firm optical impression of the *oikumene* as the imagined base of his visual cone, with his visual axis marking its precise geographical center.[24] The viewer was to observe the centermost meridian (longitude) as a perfect vertical, while the other meridians would appear to bend concavely, to left and right, as they converged on either side. The actual mapping according to Ptolemy's second method did not use this visual orientation as a basis. Rather, this zeroing in served only to give the mapmaker a clearer picture of the *oikumene*, especially of the true widths of the northern latitudes, before submitting it all to the charting scheme.

After detailing the first two methods of map making in the second book of his *Geographia*, Ptolemy goes on to discuss more ordinary geographical questions, but he was by no means finished with the problem of projection. Suddenly he raised the issue again in Book Seven, almost apologetically, as if he felt there was still another way to represent the globe.

This time he presented a method much more akin to an artist's frontal approximation. Again he asked his reader to position his eyes at a specific location vis-à-vis the globe—this time, how-

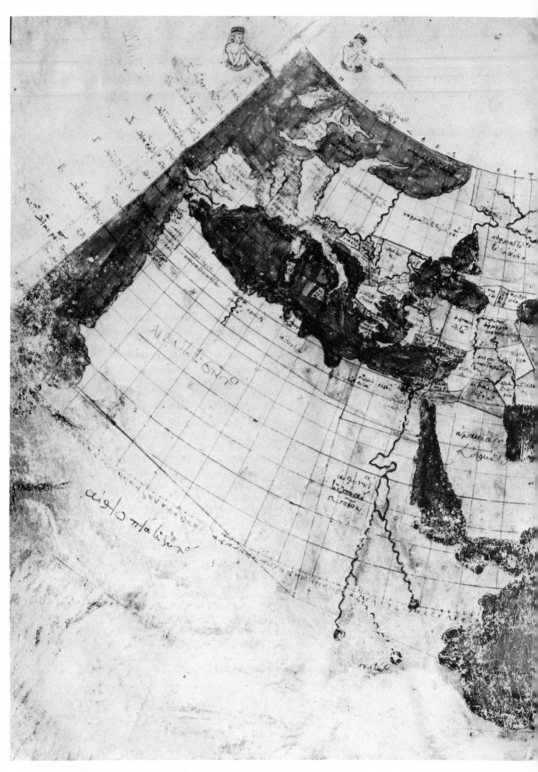

Illustration VII–4: *Mappamundi;* Ptolemy's *oikumene* as illustrated in a late fourteenth century Greek edition of the *Geographia*, Plut. 28.49, c.11, folios 98v-99r, Laurentian Library, Florence. Courtesy, G. B. Pineider, Biblioteca Laurenziana, Florence.

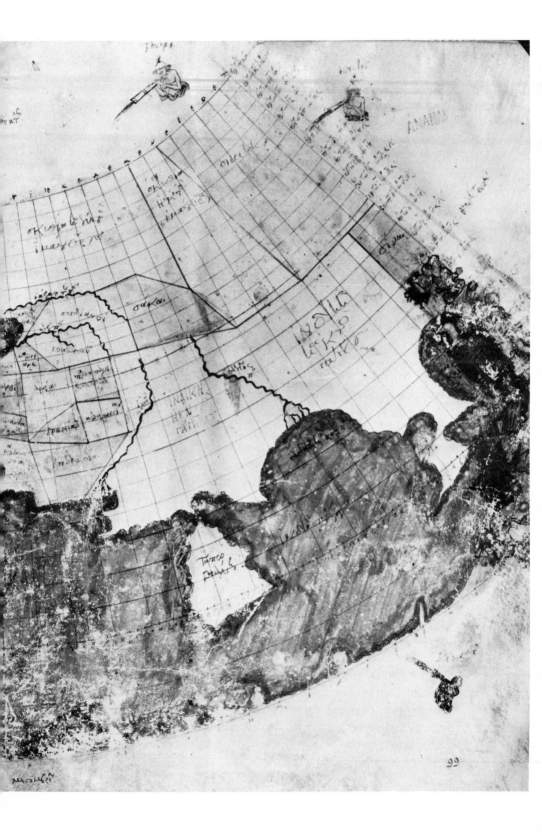

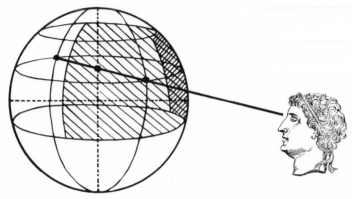

Diagram VII–2

ever, with the visual axis *lying in the plane* of the latitude through Syene; that is, so the latitudinal rings around the earth would be parallel rather than at angles with the visual axis. Thus, as Diagram VII–2 shows, he intended the whole three-dimensional "earth" to be positioned frontally before the eyes in the conventional manner of looking at a picture.

What Ptolemy now proceeded to explain is almost a clear-cut linear perspective projection based on geometric principles. This, indeed, is the first recorded instance of anybody—scientist or artist—giving instructions on how to make a picture based on a projection from a single point representing the eye of an individual human beholder. It was this third system, in fact, which fostered a special "distance point method" for arriving at linear perspective which became popular among Italian theoreticians of the sixteenth and seventeenth centuries.[25] (Ptolemy also implies that his method was rather well known among mathematicians of his own time.)

The details of Ptolemy's solution, to be sure, derive from the optics, the geometry of conic sections, and the cartography of his day. The *Geographia* was not in any way meant to serve artists. It was written for scholars who could understand the intricacies of higher mathematics, and the perspective explanation is most difficult for a nonmathematician to decipher. Furthermore, the original diagram for his method in Book Seven, if there ever was one, is lost. In most later Greek and Renaissance Latin copies there is either no explanatory diagram at all, or, if there is one, it misconstrues the text.[26] It was apparently even so difficult that cartographers could not understand it—for never, to my knowl-

edge, was this third method employed in the making of Ptolemaic maps.

Professor O. Neugebauer has recently published a definitive reconstruction of Ptolemy's map projection method, but without acknowledging its important role in the history of linear perspective.[27]

But while we have no evidence that Ptolemy's construction was understood by or even available to painters in antiquity, this Alexandrian stood out among the Greek mathematicians for his manifest interest in art. There are several passages in his *Optica*, for example, in which he makes reference to painting and sculpture, and in the *Almagest* itself there is a charming account, in which the author writes with craftsmanlike sensitivity, on how to construct and paint a model of the celestial globe.[28] Ptolemy was, indeed, very much an Alexandrian counterpart of Alberti, and it is thus not surprising that it was he who brought the world a cartographic method of linear perspective.

VIII

Ptolemy's Third Cartographic Method

HAVING CONSIDERED the situation in Florence at the time of the auspicious arrival there of the *Geographia*, we may now take a closer look at the part of it (Book Seven) that makes this second-century A.D. atlas of significant relevance to the discovery of linear perspective. How, specifically, did Ptolemy's third mapping method work?

As we have already noted, he intended this final method as a means of representing the *oikumene* as seen from an individual human eyepoint. He began his construction by drawing a circle representing the earth and another around it which was to represent the circumference of the heavens. Through both circles he then drew a vertical axis which fixed the north and south poles on the earth (Π and P in Diagram VIII–1). Horizontals were then drawn through this axis representing the equator (BΔ) and the northern and southern solstitial circles (ZH, ΘK). He also fixed, on the vertical axis, the latitude through Syene (Σ; the center of his *oikumene*), and the northern (Υ) and southern (T) limits of the then known habitable world (just above the northern solstitial circle on the one hand and just below the equator on the other).

Ptolemy's Third Cartographic Method

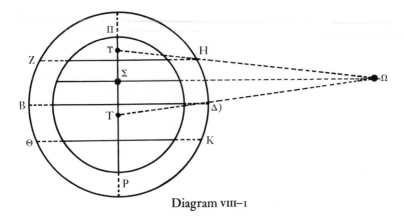

Diagram VIII–1

Ptolemy then bid the viewer to fix his visual axis on the parallel through Syene at the point where it crossed the center vertical (which becomes the central meridian). Thus he established a point of sight (Σ), that is, a point where the visual axis from the viewer's eye strikes the surface of the about-to-be depicted globe. This point marks simultaneously the center of the viewer's visual field and the center of the *oikumene*. The point functions in the ensuing construction very nearly like Alberti's own *punctus centricus* from the perspective explanation in the *De pictura*. As we shall now observe, the lateral locus acts also like Alberti's distance point. As Ptolemy explains it:

Under these assumptions it is clear that the said meridians [the central meridian on the visible side of the globe and its counterpart on the hidden side] appear in one straight line, coinciding with the axis, since the eye falls into their plane; also, by the same reason, that the parallel of Syene appears perpendicular to it whereas the remaining of the given circles appear turned concavely toward these straight lines [that is, as if they were bending away from the center] . . . the more [so] the further they are distant from them.[1]

In other words, Ptolemy knew that his point of sight determined that the latitudinal rings above and below would appear as ellipses—later in the text he refers to them as "egg-shaped" forms—and that the circles through Syene on which the point of sight itself was fixed must appear as a straight line. What he is talking about here is nothing less than the *horizon line* principle—a principle which was not to be scientifically applied to a pictorial situation until Brunelleschi's mirror experiment. The text remains somewhat un-

clear, however, as to whether Ptolemy understood that his point of sight was also coincident with the locus of orthogonals in his construction—that is to say, with his vanishing point.

If the Alexandrian geographer was not so clear about projecting from a centric vanishing point, he certainly showed thorough understanding of the other ingredient of Albertian perspective, the distance point. Furthermore, since the distance point represents the same frontal eye position as that symbolized by the centric vanishing point, a satisfactory perspective picture can be projected by means of the distance point alone.[2] Ptolemy obviously understood this because he extended a line horizontally from his point of sight Σ and established on it his distance point, called by him the "eye" and given the symbol Ω. The distance that this "eye" should be from the object seen—the globe—Ptolemy determined by drawing lines representing visual rays from the point Υ and T, the northern and southern limits of the *oikumene*, through H and Δ, the points where the northern solstitial circle and the equator touch the great circle of the heavens, to where they intersect—at Ω. Without concerning ourselves with the mathematical reasoning for all of this, we observe that Ptolemy constructed a visual triangle in which, as he said, "the distance of the eye" is figured "such that the whole known part of the earth is visible in the space between the equatorial ring and the solstitial ring" (Diagram VIII–1).[3]

In the next step Ptolemy explained how to project the circles made by the parallels on the sphere just as they would appear when seen from Σ at distance $\Sigma\Omega$. The author's text here is quite technical, and at this point he also introduced a modification in order that the upper latitudes which curve around the top of the globe not appear closer together than they should in reality. This, of course, was to make for a clearer map, since Ptolemy was only trying to adapt the most useful aspects of perspective to map making.[4]

We may recapitulate Ptolemy's directions with the aid of Diagram VIII–2. First, he would have lines drawn from Ω to H and Δ, the points marking where the northern solstice and the equator, respectively, touch the outer sphere. These lines are then extended to the vertical axis ΠP, meeting the points where these rings intersect the centermost meridian on the *near* side of the globe. Similarly, lines are drawn from Ω to Z and B, intersecting the vertical axis where the rings touch the centermost meridian on the *far* side of the globe.

Ptolemy's Third Cartographic Method

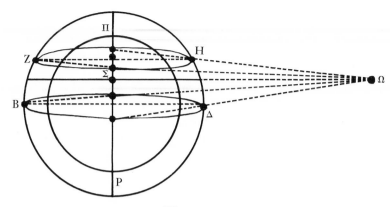

Diagram VIII-2

We now have four points related to each ring—points which define each elliptical form in perspective. The major axes of the two ellipses (dotted line ZH and BΔ) are seen to be slightly off center, that is, not dividing the figures evenly in half horizontally. (It is apparent that the shorter the viewing distance from Ω, the wider the minor axis in each ellipse, and therefore the thicker each foreshortened circle.) One must also remember that the circle through Syene, on which the point of sight Σ lies, is seen as a straight line. Therefore, the northern solstitial circle is seen as if *from below*, while the equatorial ring is observed *from above*.

Ptolemy goes on to say that the ends of the elliptical rings should be shown rounded, as we are so used to seeing today. This was a singular observation in the late classical period of Ptolemy, when foreshortened circles in pictures were often shown with pointed ends—looking more like American-style footballs than true perspective ellipses. The Alexandrian geographer also noted that the rings in perspective should overlap the borders of the encompassing circle. This is another precocious observation, for, in true linear perspective, that half of the circle appearing nearer the viewer seems larger than the more distant half. In other words, the diameter of a circle in perspective (as opposed to one in a true geometric ellipse) appears not to pass through the center but to divide the figure into unequal parts. The parallel rings of Ptolemy's globe would appear to fatten slightly as they curved outward toward the viewer's eye from the encompassing vertical circle.

It must be remembered that Ptolemy's perspectival rings were really only imaginary circles in the sky which surrounded the

earth like latitudes. The form of the *oikumene* itself would have to be derived from these, and Ptolemy made purely cartographic modifications to mitigate distortion. Indeed, what he was actually describing in Book Seven was how to draw a so-called armillary sphere, the three-dimensional model of the geocentric universe found on scholars' desks down through the Renaissance. Nor did he overlook the matter of color, thereby demonstrating his artistic interest. He urged that brighter hues be used to define those parts of the depicted sphere nearest the viewer, while fainter colors be used for those parts further away:

At the design of the rings, one has to watch that each goes through the said four points, in an egg-shaped form and not ending sharply where they meet the outermost circle, in order not to give the impression of a break, but it should be given a consistent direction even if the convexities which end the ellipse fall outside the circle which encompasses the figure; this also appears to happen with the real [rings of a globe].

One must also take care that the circles are not merely [represented by simple] lines but with an appropriate width and in different colors and also that the arcs across the earth [be given] in a fainter color than those near the eye; and that of [apparently] intersecting parts those which are more distant from the eye be interrupted by the nearer ones, corresponding to the true position on the rings and on the earth; and that the zodiac with its southern semicircle which passes through the winter solstice, lies above the earth, while the northern [semicircle] which passes through the summer solstice be interrupted by it [the earth].[5]

The globe that Ptolemy describes here is apparently transparent, and seems to have been laid out in the manner of an armillary sphere; that is, with ribs representing the longitudes and latitudes and with the *oikumene* painted on something stretched over its proper place in the open, perspectival construction.

WHAT OF THE REST of the *Geographia*? In reading through any number of paragraphs, especially in Book One, we find idea after idea providing us with insights, not only into Ptolemy's own period, but—prophetically—into Florentine artistic thought in the early fifteenth century. In the very first paragraph

of the *Geographia,* for example, Ptolemy makes a cogent analogy between geography and painting as he attempts to separate his subject from chorography—the word he gives to the decoration of maps with topographical details:

The end of chorography is to deal separately with a part of the whole, as if one were to paint only the eye or ear by itself. The task of geography is to survey the whole in its just proportion, as one would the entire head. For in an entire painting we must first put in the larger features and afterwards those detailed features which portraits and pictures may require, giving them proportion in relation to one another so that their correct distance apart can be seen by examining them, to note whether they form the whole or part of the picture.[6]

We have already seen how Ptolemy conceived of the earth as having its surface organized by a grid system of longitudes and latitudes, so that all parts could be thought of in proportion to one another:

We are able therefore to know the exact position of any particular place; and the position of the various countries, how they are integrated in regard to one another, how situated in regards to the whole inhabited world.[7]

In Ptolemy's classical geography, as in classical art, the whole should express the sum of all its parts. I think it important to observe again that Ptolemy's atlas arrived in Florence in 1400—just before the great flowering of artistic creativity in this city, the city which was to establish this dictum as an ubiquitous Renaissance ideal.

Illustration VIII–1 shows a map page from a fourteenth-century Greek Ptolemaic atlas, which may well have been a copy purchased by the influential Antonio Corbinelli, a member of the elite Greek "study group" in Florence. Of the twenty-seven charts in this and similar editions, only the first, the *mappamundi* showing the whole *oikumene*, was ever projected according to Ptolemy's first or second method (as in Illustration VII–4). All the other maps were strictly rectilinear grids on which were shown the separate regions of the then known world. Ptolemy's world, of course, still centered on the European-North African-West Asian land mass; not until much later in the fifteenth century did maps include broader reaches of the western ocean-sea. But the text does explain—and his perspectival third projection method made

Illustration VIII-1: Map pages from Ptolemy's *Geographia*, Plut. 28.49, c.11, folio 51v, Laurentian Library, Florence, late fourteenth century. Courtesy, G. B. Pineider, Biblioteca Laurenziana, Florence.

even more explicit—that the *oikumene* occupied only a part of the whole sphere of the earth. Thus, if one can determine longitudes eastward from the Fortunate Islands, one can also, theoretically, determine them westward as far as the shore of China and the East.[8] This is certainly implicit in another of Ptolemy's statements:

From the ratio of any given arc to the total circumference of the great circle, the number of *stadia* [between places on that arc on the surface of the earth] can be calculated from the known number of *stadia* in the circuit of the whole earth.[9]

Of course, this was much easier said than done. Although Ptolemy had made a reasonably good estimate of the circumference of the globe, the actual geography of his book left much to be desired, as is obvious from our illustration above. *The advantage was the grid system,* which reduced the traditional heterogeneity of the world's surface to complete geometrical uniformity. From the moment the atlas appeared in Florence, the gauntlet was down, awaiting the vision of a restless navigator, a Columbus, to pick it up.

P TOLEMAIC MAPS, we must remember, were not intended for seafaring use and by no means supplanted the portolan chart for that purpose (until the eighteenth century, when nautical instruments were adequate to measure longitude and latitude while a ship was at sea). The new maps instead were studied by "landlubbing" intellectuals, and thereby gave powerful impetus to the Renaissance rationalization of the world. Furthermore, an interesting parallel can be observed between Ptolemaic cartography and the ideals of art in the fifteenth century. The portolan sailing charts of the fourteenth century, while useful for direction-finding at sea, did not furnish a geometrical framework for comprehending the whole world. The Ptolemaic grid, on the other hand, posed an immediate mathematical unity. The most far-flung places could be precisely fixed in relation to one another

by unchanging coordinates so that their proportionate distances, as well as their directional relationships, would be apparent.

At just the time when much new information was becoming available concerning the outside world, the Ptolemaic system gave the Florentines a perfect, expandable cartographic tool for collecting, collating, and correcting geographic knowledge. Above all, it supplied to geography the same aesthetic principle of geometric harmony which Florentines demanded in all their art.

The power to render an abstract image of space in our minds, regulated by an inflexible coordinate framework of horizontals and verticals, is what makes any grid system of measurement so instantly meaningful. No matter how the grid-squared surface is shrunk, enlarged, twisted, warped, curved, or peeled from a sphere and flattened out, the human observer never loses his sense of how the parts of the surface articulate. The continuity of the whole picture remains clear so long as he can relate it to at least one undistorted, modular grid square.

Although the grid system itself was not new to Western Europe—it had long been used by land surveyors, architects, and even portolan cartographers—Ptolemy's book reached Florence at a particularly opportune moment, when the intellectual climate of the city was ripe to take advantage of it in resourceful ways.[10] While a grid mentality had already shown forth in town layout constructions, patterned farmland, and even bank accounting, it was given a decided psychological boost by the *Geographia*. The fact that the system arrived through the vehicle—and imprimatur —of an ancient Greek manuscript, just when Greek studies were obsessively fascinating to certain intellectuals in Florence; that it arrived in the midst of the Milanese wars; and that it arrived at a time when mathematical studies generally were taking on new moral significance, spawned an unprecedented excitement about the *Geographia*.

One of the outspoken testaments to the extent to which these mental threads wove their way into the Florentine consciousness is the fact that they were used, quite nonabstractly, for actual territorial fences. In his *Istoria Fiorentina* of about 1440, Giovanni Cavalcanti described a territorial dispute between his home city and Milan during the wars of the 1420s, and mentions that a longitudinal line was to be established as a boundary between the two states. This may have been the first instance in history in

which an imaginary mathematic line—rather than a physical land-mark—was recognized as a political-territorial limit:

And thus the eye is the ruler and compass of distant regions and of longitudes and abstract lines. Everything is comprehended under the geometric doctrine, and with the aid of the arithmetic art, we see that there is a rule for measuring . . . with the eye. . . .[11]

MORE TO OUR INTEREST here, it may be no coincidence that, at just the moment when the *Geographia* was being copied and disseminated from the busy scriptoria of Florence, Masaccio seems to have abandoned the old *sinopia* for laying out his Trinity fresco in Santa Maria Novella. Instead, to transfer the face of the Virgin Mary (Illustration VIII-2), he chose a grid framework tooled right into the *intonaco* surface. As Ugo Procacci has pointed out, it was at this very time that Florentine artists generally began using the grid technique to transfer details from preliminary drawings to the full scale of the wall to be frescoed.[12] But perhaps the most striking example of the new-found fascination with the grid among artists—and, indeed, with the grid as applied to the surface of a sphere—is seen in Paolo Uccello's geometrically reticulated drawing of a chalice (Illustration VIII-3). In the elegant anatomization of this drinking vessel, we can discern the new spirit of Renaissance cartography.

Alberti himself became interested in cartography and even worked out his own mapping technique, which he applied to a new city plan of Rome. His scheme, derived from Ptolemy's, is carefully explained in one of his treatises entitled *Descriptio Urbis Romae*, written about 1450. The original accompanying map is lost, but a recent and thorough reconstruction has been published by Luigi Vagnetti (Illustration VIII-4).[13]

What Alberti did was to start with a circle, which he called a "horizon," and divide it into a number of equal parts or degrees, each numbered and connected to the center by radii. These radii acted as meridians, and equally spaced, concentric circles or parallels were also drawn and numbered from the center. From

Illustration VIII-2: Masaccio, Detail of head of Mary, from his *Trinity*, Santa Maria Novella, Florence, c. 1425. Courtesy, Fototeca Berenson, Villa I Tatti, Florence.

this he constructed a measuring device in the same disk shape and set it up on the Capitoline Hill, which was to be in the exact center of the map. With the instrument lined up so that zero degrees on the circle (his "horizon") pointed north, he devised a small ruler (called by him a "radius") fixed with one end in the center of the disk and rotatable so that he could site different landmarks along its edge. He could then fix the various buildings in the city in relation to each other on the meridians; by actually pacing off the distance each building was from the center, he was able to locate them on the proper parallels.

Thus he had devised a very simple system for assigning to each landmark in Rome a set of coordinates. He then provided a table listing all the sites and their coordinates so that they could be found on the map. To this day, chartlike street plans constructed on the same principle are mounted in the public squares of many

Ptolemy's Third Cartographic Method

cities in France, and tourists can find their proper location merely by twisting a dial (according to the given coordinates supplied on an accompanying alphabetical chart). Alberti described a similar surveying device in his *Ludi matematici*, and also applied the same principle to an instrument for sculptors—to model from nature—in his *De statua*,[14] the sculptural companion piece to his treatise on painting.

Illustration VIII–3: Paolo Uccello, Drawing of a chalice, Gabinetto dei Disegni, Uffizi Gallery, Florence, c. 1450. Courtesy, Galleria degli Uffizi, Florence.

Illustration VIII–4: Vagnetti's reconstruction of Alberti's *Descriptio urbis Romae*, c. 1450. The thin grayish line represents the actual walls of the old city as recorded in a 1950 survey by the Istituto Geografico Militare. The thicker black line follows Alberti's survey after his original calculations. Similarly, the small numbered circles represent the various locations on Alberti's map, while the small numbered squares indicate the same positions in the I.G.M. survey. Courtesy, Dr. Luigi Vagnetti, Università degli Studi di Genova.

But certainly the most interesting adaptation of Ptolemaic "space structuration" to the practice of painting in the early fifteenth century is Alberti's *velo*, which he described in Book Two of *De pictura:*

It is like this: a veil loosely woven of fine thread, dyed whatever color you please, divided up by thicker threads into as many parallel square sections as you like, and stretched on a frame. I set this up between the eye and the object to be represented, so that the visual pyramid passes through the loose weave of the veil.[15]

Ptolemy's Third Cartographic Method

For the author of the treatise on painting, the grid-formed *velo* was not merely a device for transferring a scale drawing. It was a means for organizing the visible world itself into a geometric composition, structured on evenly spaced grid coordinates. Alberti exhorted his artist-readers to learn to *see* in terms of such grid coordinates in order that they develop *an intuitive sense* of proportion (Illustration VIII–5):

A further advantage is that the position of the outlines and the boundaries of the surfaces can easily be established accurately on the painting panel; for just as you see the forehead in one parallel, the nose in the next, the cheeks in another, the chin in one below, and everything else in its particular place, so you can situate precisely all the features on the panel or wall which you have similarly divided into appropriate parallels. Lastly, this veil affords the greatest assistance in executing your picture, since you can see any object that is round and in relief, represented on the flat surface of the veil.[16]

Illustration VIII–5: Johann II of Bavaria and Hieronymus Rodler, Woodcut illustration from their *Ein schön nützlich büchlein und unterweisung der Kunst des Messens*, Simmern, Germany, 1531.

Ptolemy's Third Cartographic Method

How similar Alberti's attitude is to Ptolemy's, especially to the latter's explanation of the purpose of chorography in the opening pages of the *Geographia!*

Antonio Manetti, Brunelleschi's contemporary biographer, tells us how the Duomo architect and Donatello used the grid in their surveys of ancient Roman buildings. They did this, the author writes, by drawing their elevations "on strips of parchment graphs with numbers and symbols which Filippo alone understood." [17] In other words, he drew charts, squared like those in the Ptolemaic atlas, and including a similar system for numbering and lettering the parallels and meridians at the sides. Brunelleschi not only employed the grid for copying other buildings to scale, he incorporated the concept as a module system for planning his architecture. The grid is a conspicuous feature in the architectural plans of the churches of San Lorenzo and Santo Spirito. Brunelleschi's perspective construction, devised after his return from Rome (and during the time when interest in Ptolemy's *Geographia* was at its height in Florence), was probably based also on the geometry of a foreshortened reticulated *pavimento*.

All in all, Ptolemy's *Geographia* may be a kind of missing link between Brunelleschi's architecture and his linear perspective investigations. It appears not that the latter came out of the former, or vice versa, but that both together related to the visual attitude in Florence inspired by the impact of the great world atlas. Like the patron saint of the city itself, Ptolemy's *Geographia* "made straight the way" for two of Florence's greatest triumphs: the architecture of Brunelleschi and Alberti and their rediscovery and codification of linear perspective.

AND THAT MAY not be all. Ptolemy's atlas seems also to link this rediscovery of linear perspective to the most spectacular Renaissance achievement of the fifteenth century—the discovery of America by Christopher Columbus.

In this case the relationship may revolve around a distinct personality whom we mentioned earlier, a man who was both a close friend of Brunelleschi and a correspondent of the great discoverer at the time when both made their momentous contributions. According to all the fifteenth- and sixteenth-century accounts of Brunelleschi's life, the famous Florentine architect

knew the scholarly Toscanelli, the medical doctor-cum-astrologer-astronomer-mathematician-geographer. There is good reason to believe that Toscanelli supplied Brunelleschi with the necessary scientific information to make his first linear perspective experiments successful; Alessandro Parronchi has already made a good case for Toscanelli and Brunelleschi being collaborators.

Brunelleschi himself was not a university scholar and, unless he studied the subject on his own, had not the occasion to know much about the science of optics. Who among Brunelleschi's friends, other than Toscanelli, would have been better able to provide the necessary optical background for the first perspective experiments? Toscanelli, we know, was very much interested in Ptolemaic geography; indeed, his importance in history rests most of all upon his contributions to geography and cartography. Many years after his early association with Brunelleschi, Toscanelli received some inquiries from the Portuguese court about sailing routes to the Orient. His answer, dated June 25, 1474, to his friend the canon of Lisbon may be one of the decisive letters of history:

Paul the physician to Fernam Martins, canon of Lisbon, greetings. . . . On another occasion I spoke with you about a shorter sea route to the lands of spices than that which you take for Guinea. And now [your] Most Serene King requests of me some statement, or preferably a graphic sketch, whereby that route might become understandable and comprehensible, even to men of slight education. Although I know this can be shown in a spherical form like that of the earth, I have nevertheless decided, in order to gain clarity and save trouble, to represent [that route] in the manner that charts of navigation do. Accordingly I am sending His Majesty a chart done with my own hands in which are designated your shores and islands from which you should begin to sail ever westward, and the lands you should touch at and how much you should deviate from the pole or from the equator and after what distance, that is, after how many miles, you should reach the most fertile lands of all spices and gems, and you must not be surprised that I call the regions in which spices are found "western," although they are usually called "eastern," for those who sail in the other hemisphere always find these regions in the west. But if we should go overland and by the higher routes we should come upon these places in the east. The straight lines, therefore, drawn vertically in the chart, indicate distance from east to west, but those drawn horizontally indicate the spaces from south to north. . . . From the city of Lisbon westward in a straight line to the very noble and splendid city of Quinsay [China] 26 spaces are indicated on the chart, each of which covers 250 miles.

. . . So there is not a great space to be traversed over unknown waters. More details should, perhaps, be set forth with greater clarity, but the diligent reader will be able from this to infer the rest for himself. Farewell, dearest friend.[18]

What better testimony could we ever find to the critical influence of the Ptolemaic grid on the course of human history? Would it be too presumptuous to suggest that linear perspective also played a role in Toscanelli's concept? The original map is missing, but a copy of it, along with this letter, came into the hands of Christopher Columbus a few years later.[19] Toscanelli wrote again to Columbus personally, encouraging him to carry out his epochal mission. This relatively unheralded Florentine doctor, whose biography is not even included in the *Encyclopaedia Britannica*, played a significant role in two of the most important events of the Renaissance: the birth of geometric perspective and the discovery of America. The same forces which changed the artist's view of the visible world sent man to confront the unknown terrestrial world and, closing the latitudinal circle, to discover his own planet.

The new geometrical grid system for conceptualizing space, such as Toscanelli describes, eventually became the *modus videndi* of the fifteenth and sixteenth centuries. This humble checkering method became such an ubiquitous device for so many things during these centuries that it, rather than the dome or classical nude, could justly lay claim to being the aegis or trademark of the Italian Renaissance. It is no coincidence that Pope Pius II (Enio Silvio Piccolomini), who planned one of the first Italian city squares in the form of a grid and also a palace with an eye to its literal "perspective" of the landscape (in his home town of Pienza during the early 1460s), was more than casually interested in Ptolemy's geography. It was he who gave the Ptolemaic atlas the official *Nihil Obstat* of the Roman Church, and he who himself wrote a lengthy *Cosmographia* (as part of his *Historia rerum ubique gestarum*) full of references to the Alexandrian geographer and including a chapter on longitudes and latitudes.[20] Among those who owned and annotated a copy of Pius II's work was Christopher Columbus.

There are several important differences between the Ptolemaic method and the means by which Brunelleschi made his first perspective pictures in Florence. It is doubtful that Brunelleschi

alone could have understood the highly technical language of the *Geographia*, but his friend Toscanelli could at least have sensed the implication of Ptolemy's directions. While the third projection method offered little in the way of advantages for cartographers (and was never used in the subsequent editions of the *Geographia*), it did have importance for artists, who, ever since the late thirteenth century, had been searching for a clear-cut geometric system for representing the phenomenon of pictorial depth. We may imagine therefore that Toscanelli, sometime just after his return to Florence in 1424 or 1425, befriended Brunelleschi precisely because the latter was well known for his practical understanding of mathematics. Toscanelli, along with certain other bright young intellectuals in Florence, could at least partially have fathomed Ptolemy's third perspective mapping method.[21] Having realized its importance, they may well have had an immediate thought: Brunelleschi should know about this.

Might they not then have paid a visit to their architect friend with words like this? "Filippo! As you well know, the painters in our city—for years—have been trying to make pictures of rooms, buildings, or whatever, scenes diminishing in distance just as nature shows. But have they ever studied enough geometry? Now, we are not painters, but, well, we have been studying the ancient authorities and—Filippo, we have come upon something! Our studies indicate—to us, at least—that one of the philosophers may have been quite close to unlocking the geometric secret. . . ."

It may have been quite an animated conference as Toscanelli explained Ptolemy's third method of projection to his architect friend. Brunelleschi had probably already applied what he himself knew of Ptolemy's map making to his architectural drawing in Rome. He was probably also aware of Vitruvius' strange statement, mentioned earlier, about perspective in ancient scenography. And however whimsical our attempt to hypothesize the conversation at a meeting of Toscanelli's scholarly circle with this giant-of-all-trades, one conclusion seems more than a vagary behind our gridwork of evidence. It is that Ptolemy's cartographic perspective lit the spark that fired Brunelleschi's competitive zeal —not only to undertake a form of perceptual application forgotten since antiquity, but to *outdo* the ancients, just as he had intended with his great dome over the Cathedral of Florence.[22]

IX

The Discovery of the Vanishing Point

IF H. G. WELLS'S famous time machine were ever to be on loan to our historical fancy, one of the more fascinating destinations for which we could set the dial would be: Florence, Italy, Piazza del Duomo, 1425, on that day (assuming it to be a helpful and suggestive machine) when a short, middle-aged man arrived at the piazza between the Cathedral and facing Baptistery toting a curiously small square wooden panel, and a similarly square mirror. These accouterments, as well as the probable early morning hour, would make it easy enough for us to pick out Filippo Brunelleschi, solver of the unsolvable, as he made his way to the portal of the unfinished Cathedral, with its embarrassingly open crossing; the very building over which, eleven years later, a huge dome from his designs would be raised, a dome the likes of which hadn't been seen in the West since the Roman Empire.

And there we might watch him as he stands within the portal, looking out toward the Baptistery opposite, with one hand holding the small painted panel, oddly enough, obversely right up against his face, and the other balancing the flat mirror. From

The Discovery of the Vanishing Point

our discreet distance away, it's difficult to make out the painting itself, other than some sort of silver background which the early morning light picks up. He moves the mirror away from time to time. Is that a mirror reflection in his eyes, or a glint of satisfaction?

If our time machine is generous enough, we might wait until he suddenly beckons to a passer-by—one of us?—to come over and see how good his painting is. Before handing over the painting and the mirror, he gently insists, we find, on explaining something about certain optical principles, the mechanics of mirror reflection, and the geometry of some kind of central "point." Whether out of modesty or inner excitement, or possibly the present arrival of one or two of his scholarly friends, Messer Brunelleschi neglects to mention that this singular moment marks the realization of one of the most profound ideas in all of world history: the perceptual "truth" of linear perspective.

THE EARLIEST KNOWN attestation of Brunelleschi's achievement is by Antonio Averlino, called Filarete, in his own treatise on architecture written during the early 1460s:

And so I believe that Pippo di Ser Brunellescho the Florentine found the way to make this plan [linear perspective] which truly was a subtle and beautiful thing, which he discovered through considering what a mirror shows to you.[1]

It is curious that Alberti himself never directly acknowledged his debt to Brunelleschi on this score, although we may assume it to have been implicit in his dedication to the architect in the *De pictura*. Along with Filarete's notice, however, there exists a more precise and detailed account of the Baptistery experiment by Antonio di Tuccio Manetti, scholar, mathematician, and biographer of Brunelleschi. This was written in the 1480s and is the longest and most authoritative text we have concerning the first application of linear perspective in the Renaissance.[2]

According to Manetti, Brunelleschi conducted two perspective experiments, one a picture of the Florentine Baptistery, or the Church of Santo Giovanni as it was then called, and the other

The Discovery of the Vanishing Point

of the Palazzo Vecchio, "the palace of the Signori." The date of the first experiment could not be later than 1425, since the new rules were employed by Donatello and Masaccio in their Siena *Feast of Herod* relief and *Trinity* fresco, respectively, works usually dated from just about that year.[3] Brunelleschi's second demonstration may or may not have been carried out at the same time; Manetti's account is unclear about the date of either. But it seems from the evidence of perspective constructions in pictures from this period that no such application of rules derived from Brunelleschi's demonstrations occurs in any known example before 1425; after that date, painters increasingly depended on perspective constructions.[4]

While Manetti's technical description of the two demonstrations is adequate, the biographer says almost nothing about how Brunelleschi arrived at his notion in the first place. It should be noted that Manetti was only two years old in 1425, which means he could hardly have been present when the famous demonstrations took place. Although he must have learned of them only many years later, when memories of exact details may have grown dim, he tells us, "I have had the painting in my hand and have seen it many times in those days, so I can give testimony."

In Manetti's account we have a conscientious, warmly personal report of Brunelleschi's first and second experiments, one in frontal perspective, the other in oblique or angular perspective Diagrams IX–1 and IX–2, respectively). In order to dramatize

Diagram IX–1

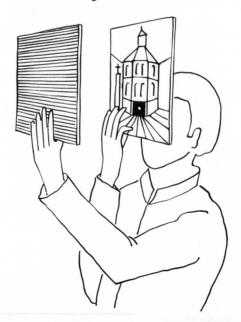

The Discovery of the Vanishing Point

his new idea to the utmost, Brunelleschi urged that his pictures be seen out-of-doors so that his representations would have to meet the test of comparison with the actual buildings. In the first experiment he painted on a small half-*braccio* square panel the Baptistery, showing certain familiar architectural landmarks on either side and some of the piazza in front. The artist then drilled a little hole through the back of the completed painting and asked his first "volunteer" to hold the panel close to one eye, with the painted surface facing away from the viewer. While the observer peered through the little hole, he was instructed to look at the *reflection* of the picture in a mirror, held with his other hand. (For his second experiment, Brunelleschi painted a much larger picture, which Manetti says had to be seen at a greater distance than in the case of the Baptistery panel; see Diagrams IX–1 and IX–2.)

In Florentine metrology, a half *braccio* is less than one foot in length. The "little braccio" mentioned in the passage refers to a measurement unit in smaller scale, much as we might indicate a "1/4 in. = 1 in." equivalency on a modern scale drawing. The *braccio*, one might add, was the Quattrocento Italian counterpart of the cubit, and hence rings with a certain aptness in this literally arm's-length demonstration. In the following English translation of Manetti's account, the lines have been numbered to facilitate later reference:

1 And this matter of perspective, in the first thing which he showed it, was in a small panel about half a *braccio* square, on which he made an exact picture (from outside) of the church of Santo Giovanni di Firenze, and of that church he portrayed as much as
5 can be seen at a glance from the outside: and it seems that in order

Diagram IX–2

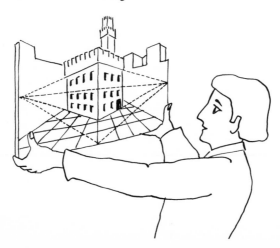

The Discovery of the Vanishing Point

to portray it he placed himself some three *braccia*, inside the middle door of Santa Maria del Fiore, done with such care and delicacy, and with such accuracy of colors of the white and black marbles, that there is not a miniaturist who could have done it
10 better; picturing before one's face that part of the piazza which the eye takes in, and so towards the side over against the Misericordia as far as the arch and corner of the Pecori, and so of the side of the column of the miracle of Santo Zenobio as far as the Canto alla Paglia; and as much of that place as is seen in the dis-
15 tance, and for as much of the sky as he had to show (that is, where the walls in the picture vanish into the air), he put burnished silver, so that the air and natural skies might be reflected in it; and thus also the clouds, which are seen in that silver, are moved by the wind when it blows.
20 In which painting (because the painter needs to presuppose a single place, whence his picture is to be seen, fixed at the top and bottom and in relation to the sides, as well as in distance, so that it is impossible to get distortions such as appear in the eye at any place which differs from that particular one) he had made a
25 hole in the panel on which there was this painting, which came to be situated in the part of the church of Santo Giovanni where the eye struck, directly opposite anyone who looked out from that place inside the central door of Santa Maria del Fiore, where he would have been positioned, if he had portrayed it; which
30 hole was as small as a lentil on the painting side of the panel, and on the back it opened out pyramidally, like a woman's straw hat, to the size of a ducat or a little more. And he wished the eye to be placed at the back, where it was large, by whoever had it to see, with the one hand bringing it close to the eye, and with the
35 other holding a mirror opposite, so that there the painting came to be reflected back; and the distance of the mirror in the other hand, came to be the distance of about a little *braccio* [in scale with] a true *braccio* from the place where he showed that he had been to paint it, to the church of Santo Giovanni, which on being
40 seen, with the other circumstances already mentioned of the burnished silver and of the piazza, etc. and of the point, it seemed as if the real thing was seen: I have had the painting in my hand and have seen it many times in these days, so I can give testimony.
He made in perspective the piazza of the palace of the Signori of
45 Florence, with everything on it and round about it, as much as can be seen, standing outside the piazza or really on a level with it, along the facade of the church of Santo Romolo, past the corner of Calimala Francesca, which rises on the aforesaid piazza, a few *braccia* towards Orto Santo Michele, whence is seen the palace
50 of the Signori, in such a way that two faces are seen completely, that which is turned towards the West and that which is turned toward the North: so that it is a wonderful thing to see what ap-

55 pears, together with all the things that the view includes in that place. Afterwards Paolo Uccello and other painters did it, who wished to counterfeit and imitate it; of which I have seen more than one, and it was not as well done as that. Here it might be said: why did he not make this picture, being of perspective, with that hole for the eye, like the little panel from the Duomo towards Santo Giovanni? This arose, because the panel of so great a piazza
60 needed to be so big to put in it so many different things, that it could not, like the Santo Giovanni, be held up to the face with one hand, nor the mirror with the other; for the arm of a man is not of sufficient length that with the mirror in his hand he could hold it at its distance opposite the point, nor so strong, that he
65 could support it. He left it to the direction of the onlooker as happens in all other paintings of all other painters, although the onlooker may not always be discerning. And in the place where he put the burnished silver in that of Santo Giovanni, here he left a void, which he made from the buildings up: and betook
70 himself with it to look at it in a place where the natural air showed itself from the buildings upwards.[5]

Would that either of these panels had survived! [6] Yet their loss can be emphatically mourned well apart from normal aesthetic considerations. Brunelleschi wanted his two demonstrations to be admired, not as works of art per se, but because they showed *a new geometric construction which could give a sense of unity and consistency to any illusionary picture.* He wanted to prove that, by applying his method, the familiar conventions of naturalism could be surpassed.

It has usually been maintained, beginning with Panofsky, that Brunelleschi became fascinated by linear perspective from making scale drawings of architecture, perhaps when, after the Baptistery door competition, he and Donatello were in Rome together studying the ancient ruins. This probability has been expanded upon by Richard Krautheimer, who worked out an architectural projection method which Brunelleschi might well have used.[7] Krautheimer's scheme assumes that Brunelleschi had been drawing (1) scale plans and (2) elevations of buildings on some sort of graph paper, and that he then discovered how to relate these two types of views to each other in such a way that a composite perspectival picture would result (Illustration IX–1).

Illustration IX–I: Krautheimer's Reconstruction of Brunelleschi's first perspective experiment. Reprinted by permission of Princeton University Press.

In such a method, Brunelleschi would first have to draw a plan of the eight-sided Baptistery and connect it, as the illustration shows, by visual rays from each salient point to his own eyepoint in the Cathedral portal. The octagonal form of the Baptistery and its distance from the observer's eye would have to be drawn in exact scale. Next, he would draw the side elevation, with its salient points similarly connected by visual rays to the same viewer's position in the doorway.[8] Through the "visual triangles" of each of these drawings, Brunelleschi would then insert an intersection, just as Alberti later advised. The two intersections, appropriately marked where each was crossed by a visual ray, would then be laid perpendicular to one another in a third drawing; the

marks on each would be coordinated, and the result would be a perfect perspective rendering, as Krautheimer's inset on the left shows.

It is worth noting here that this scheme is similar to the one used by Ptolemy in his third cartographic projection—the distance point method, a means for determining linear perspective without projecting directly from a vanishing point. It is frequently referred to in sixteenth- and seventeenth-century perspective treatises as an alternative to *costruzione legittima*, the normal vanishing point perspective discussed earlier in connection with Alberti.[9] This alternative method, however, like Ptolemy's construction, still depends on an implicit vanishing point. We have already seen how Ptolemy's axis determined a centric point on the surface of the *oikumene* which established the relative shape, in perspective, of his longitudinal and latitudinal rings. We noted further how he positioned his distance point for drawing these ellipses exactly on the same level with this centric mark. It is hard to believe that Ptolemy could have worked up his elaborate and complex procedure without at first understanding generally how a vanishing point functions in the illusion of perspective.

According to Professor Krautheimer's recapitulation, the vanishing point was only realized by Brunelleschi *after* he had first drawn a picture of the Baptistery as a coordinated architectural view. Yet, as with Ptolemy, it is hard to believe that Brunelleschi did not know how this phenomenon worked beforehand: indeed, the vanishing point is also implicit in the construction hypothesized by Panofsky and Krautheimer. One might well ask how Brunelleschi could have known that such a synthesis could depict the Baptistery better than naturalistic Trecento renditions if he did not understand a priori the principle of the vanishing point. In an age when visual perception was still conditioned by the imagery of the Middle Ages, how could anyone have known beforehand —without ever having seen a picture in geometric linear perspective—that such a representation of the Baptistery would turn out more "real"?

It seems clear that Brunelleschi undertook the demonstration primarily in order to discover the peculiar rules which governed the illusion of converging parallel edges in nature. As any perusal of Trecento painting shows, artists had been concerned with the "vanishing point problem" for generations. As we have already

noted, painters of the fourteenth century were increasingly intrigued by the ambiguity of illusion in the visual world they were trying to depict; by the apparent convergence of the parallel sides of long roads and large rooms, even as the sides of smaller, more tangible objects seemed to diverge. Craftsmen were confused, and, as the demand for a more rational and consistent cosmography increased in the fifteenth century, many of them wanted a consistent solution to this particular anomaly. After 1425 the new linear perspective rules became increasingly indispensable to artists, and there are very few pictures in which possible recourse to the superseded Krautheimer architectural-view construction is evident.[10] Now the artist started his picture with a central dot, representing the vanishing point, and constructed the perspective of his picture with little or no recourse to complexities of ground plan or elevation.

IT THEREFORE SEEMS clear that when Manetti wrote that the great Florentine architect "originated the rule that is essential to whatever has been accomplished [in linear perspective] since his time," [11] he was referring specifically to the fact that, by whatever method his hero had used, Brunelleschi's first task had been to fathom the mystery of the vanishing point.

How, we must now ask, did Brunelleschi find the optical key that was to revolutionize Western art? More specifically, what working procedure might he have followed in his first perspective experiment?

We concentrate here on his initial, unprecedented demonstration, his little picture of the Baptistery. Actually, this undertaking was not exclusively a frontal perspective but contained in its own construction all the elements necessary for the second panel, that of the Palazzo Vecchio.[12] The second experiment, which presented a setting in oblique perspective, had almost no influence on artistic composition in Italy during the rest of the fifteenth century. Once artists realized that optical laws could be applied to painting, there was general acknowledgment of the primacy of the centric visual axis in composing pictures. With few exceptions, painters during the ensuing decades relied on compositions focusing the observer's eye on a centric vanishing point.[13]

The Discovery of the Vanishing Point

WHY DID BRUNELLESCHI choose the Florentine Baptistery as the object of his historic depiction? Certainly the eight-sided building afforded him an opportunity to show the workings of both frontal and oblique perspective. But, interestingly enough, his choice may have been political as well as practical. During the two-month period of May–June 1425 he served as prior in the Signoria of Florence, representing his native *quartiere* of San Giovanni, the neighborhood surrounding the Baptistery. Since the traditional banner of this political subdivision of the city showed, as it does to this day, a picture of the Baptistery set against a blue field, Brunelleschi may have wished his first perspective experiment to serve as a kind of optical coat of arms. The burnished silver-leaf background which Manetti described as setting off the Baptistery image in the panel may, as it reflected the sky, have been intended to suggest the blue background of his home constituents' popular flag.[14]

To comprehend what Brunelleschi had to do in order to solve his perspective problem, one should imagine a horizontal plane passing edgewise through the eyes so that it corresponds exactly with the visual axis (Diagram IX–3). The visual axis is thus a radius in this imaginary plane, which itself must be thought of as extending infinitely in all directions so that it forms a vast three-hundred-sixty-degree circle about the viewer. As he looks straight ahead, the furthest "edge" of this plane forms the hori-

Diagram IX–3

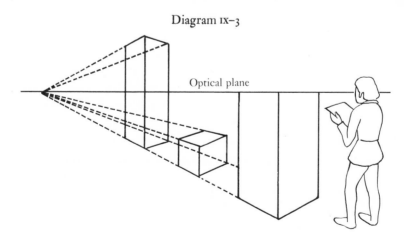

Optical plane

zon; if the observer raises or lowers his body while still looking straight ahead, the horizon will also be raised or lowered. Moreover, whenever the viewer observes a flat topside of any object which is at the same level as the optical plane, that surface will always appear as a straight line, such as occurs in the nearest block to the standing man in Diagram ix-3.

We have already noted that in antiquity and the Middle Ages, optical scientists were not concerned with explaining the vanishing point illusion either in nature or in pictures. The size of perceived objects, they felt, was a function of the visual angle; since this angle could never decrease to nothing (except when observation ceases altogether), the objects subtended to it could scarcely be conceived of as being reduced to dimensionless points. The thirteenth-century optician Witelo, for example, had emphasized that while parallel lines appear to approach one another as they recede from sight, they only seem to converge; they never really do.[15] Witelo was a schoolman in the best medieval tradition, and such thinkers were disposed to envisage the vanishing point problem much like the modern railroad engineer mentioned in our first chapter: If the tracks really do converge, he is in trouble.

How did Brunelleschi throw off the limitations of such medieval attitudes, enabling him to determine that the vanishing point has a geometric function in optics? He did this, I think, just as Filarete said—by looking in a mirror.

Our artisan-engineer was not, of course, the first artist to take an interest in mirrors. But the flat lead-backed looking glass (as distinct from the then more common convex glass or imperfect flat mirror made of shiny metal), introduced in the thirteenth century, was still a relatively new item in Europe. As its manufacture spread, it began to intrigue poets and painters almost as much as optical scientists. Dante made continual specular references and, as the chronicler Filippo Villani recounts, Giotto painted "with the aid of mirrors."[16] A passage in the already mentioned optics text *Della prospettiva*, attributed to Toscanelli, indicates a palpable public interest in mirrors. The author refers to placing a mirror above the unsuspecting heads of the citizenry during carnival in order to reflect, to the marvel of the crowd, "serpents, indeed dragons, and similar things" from pictures hidden out of sight below.[17] In his own treatise on painting, Alberti referred to the practice of holding a mirror before a work of art

The Discovery of the Vanishing Point

as an "excellent guide." [18] The art historian Heinrich Schwarz has recently described how the mirror became a standard piece of furniture in late medieval painters' studios.[19] Usually these were the easier-to-make convex girandoles, such as Jan Van Eyck painted behind his famous Arnolfini newlyweds (1434).

More importantly, Professor Schwarz goes on to show how certain artists, interested in the reflections of such curved mirrors, were inspired to represent appropriately distorted perspective effects on their depicted faces in pictures.[20] Thus the new flat mirrors played an important role in inspiring artists to investigate the less anomalous rationale behind the apparent convergence of parallel lines in vision. Filarete, who already had acknowledged Brunelleschi as the father of linear perspective, commented specifically on the illusion of such convergence:

If you want to see this more clearly, take a mirror and look into it. And you will clearly see that this is so. But if the same were opposite to your naked eye, [the orthogonal lines in the room] would seem but parallel to you.[21]

Filarete, unlike Manetti, may well have been a personal witness to the Baptistery demonstration. Born in Florence about 1400, he seems to have been practicing the goldsmith's trade, and possibly even working in Ghiberti's studio, at the very time Brunelleschi was "showing" his new principles.

In all the optical treatises having sections on catoptrics, there were theorems proving geometrically that any object held before a mirror appeared to be exactly as far behind the surface—that is, in the virtual space "through the looking glass"—as the object itself was before it. *The position of this object in the reflection could always be determined by extending a line from the object to where it struck the mirror surface perpendicularly.* The extension, or *cathetus*, of such a line into the putative space of the mirror then determined the position of the object in the reflection.[22] This same optical rationale, particularly its corollary that the angle of incidence equals the angle of reflection, was even applied by Dante in two verses of his *Purgatorio:*

The Discovery of the Vanishing Point

When a ray strikes a glass of water, its reflection
leaps upward from the surface once again
at the same angle but opposite direction
from which it strikes, and in equal space
spreads equally from a plumb-line to mid-point,
as trial and theory show to be the case.[23]

Besides being a zealous student of Dante, Brunelleschi would likely have been familiar with the optical theorems concerning the *cathetus*. He would also have been aware of the nature of the visual axis in ordinary optics, and he might have put the two ideas together in such a way as illustrated in Diagram ix–4. Assuming this, we can reconstruct a step-by-step procedure he could have followed in order to extrapolate the principles of the vanishing point for the first time since antiquity.

W E MUST IMAGINE him standing before a flat mirror, considering how, as his own visual axis struck the center of the mirror surface perpendicularly, the mirror itself served as base of his "visual pyramid." He must then have noticed how the edges of all things parallel to each other in the room where he was standing were reflected in the mirror as converging in perspective to points precisely level with his own optical plane (that is, with his own eyes as reflected in the mirror). Furthermore, if the mirror were centered on one wall of a perfectly quadrangular room, and he looked squarely into it, he would notice that *all the receding edges of floor and ceiling* (the lines perpendicular to the wall on which the mirror was hung) *appeared to be converging directly on a point identical to his reflected eyes themselves.* Accordingly, if he raised or lowered himself, the locus of the converging lines always rose or declined, remaining identical with his changing eye level in the reflection.

Noting this, Brunelleschi could have concluded that the visual pyramid was actually reversed in the mirror; the apex—his eyes— of the first pyramid on the viewer's side of the mirror was connected by the visual axis and *cathetus* to the apex of the second pyramid as reflected in reverse. *The apex on the mirror side also marked the centric vanishing point.*[24] Brunelleschi would thus

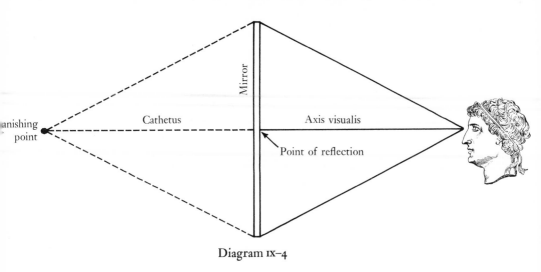

Mirror

Cathetus · Axis visualis

Point of reflection

Diagram IX–4

have come upon the fundamental logic of what came to be known as "one-point" or frontal perspective.

I think there can be no doubt that the little hole which Manetti described (lines 25 ff.) as having been drilled by Brunelleschi through the original panel was intended to demonstrate this very discovery. The viewer, as he observed his hand-held mirror through this hole from the back of the picture (as Manetti describes further), would have noticed that *all the lines of the piazza and architectural setting*, which the artist had painted extending into distance around the Baptistery, *converged on a point identical with his own eyepoint.* This hole thus provided scientific proof of the basic vanishing point principle in a most ingenious way. It dramatized to the viewer the optical fact that the visual axis, when directed straight ahead, determines the horizon—and therefore the single, unifying vanishing point.

As a "laboratory condition," Brunelleschi insisted the viewer look through the hole with only one fixed eye, ostensibly to avoid any visual confusion deriving from the phenomenon of binocular parallax. Actually, two holes, or one hole wide enough for two eyes, would not have caused any appreciable distortion in his experiment. It was then believed, however, that only one hole for one eye could yield the effect he wanted, since in binocular vision the visual axes of the two eyes overlap, thus making it *theoretically* impossible to concentrate on a centric point. Binocular vision might also, the Quattrocento Florentines thought, give the sensation of curved lines (as Leonardo Da Vinci later observed). But the crucial consideration for Brunelleschi was that two holes would have made the viewer too aware of the mirror surface, thereby mitigating the illusion of visual-field depth.

The Discovery of the Vanishing Point

Brunelleschi also made another happy discovery, namely, that the same logic of the centric vanishing point (and its relation to the viewer's optical plane and the horizon) extended easily to "two-point" or oblique perspective. This type of construction was the thrust of his second experiment at an angle from the Palazzo Vecchio. But the basic principles for such an angular representation, as we have said, are solidly implicit in the Baptistery demonstration.

So MUCH FOR the general theoretical insights which conceivably lay behind Brunelleschi's actual perspective experiment. What about its actual artistic-scientific execution in the Duomo piazza?

In following, in Chapter X, this author's photographic "reenactment" of a demonstration which occurred more than five centuries ago, it is important to stress a mathematical fine point. Manetti remembered Brunelleschi's panel as being "about half a *braccio* square" (line 2). According to our best knowledge of fifteenth-century Florentine metrology, a half *braccio* equals .2918 meters or about eleven and a half inches in our system.[25] (For the sake of familiarity and more immediate understandability, approximate inch equivalents—twelve instead of eleven and a half—for the *braccio* figures are occasionally used in this and the following chapter.) The small size of Brunelleschi's panel is of critical importance because it establishes conclusively (1) the original viewing distance and (2) the visual angle.

In depicting the Baptistery, Brunelleschi thought in terms of geometric proportion rather than arithmetical measurements. The Baptistery was an ideal subject in this regard because the building's width (approximately fifty-six *braccia*) nearly equals its height (exclusive of the lantern)—which, furthermore, nearly equals the distance of the building from the portal of the Cathedral where Brunelleschi stood to paint it.[26] This afforded him a remarkably neat ratio of 1:1:1 among height, width, and viewing distance. The father of Florence's great dome must well have appreciated this ratio because its handiness allowed him to demon-

strate most easily another essential element of logic in his perspective: that the picture acts as a window between viewer and object, so that the visual rays are interrupted and the image of the object beyond is momentarily stopped, as a miniature representation, upon its surface.

About two years earlier, in 1422 or 1423, his friend Donatello had carved a relief sculpture showing the Madonna standing in a window embrasure, with an empirically derived but convincingly perspectivelike window frame slanting in from all four sides.[27] The brilliance of Brunelleschi's solution was precisely that he had been able to show how this vaguely understood window effect could also be explained in terms of the mirror. First, however, he had to apply his findings, using Euclidian geometry, to the notion of the picture as a window.

Euclid's Proposition Twenty-one (see Diagram IX–5) states that

Diagram IX–5

whenever a triangle like ΔΓB has a line ZK parallel to side ΓB, then the two resultant triangles ΔZK and ΔΓB are similar.[28]

If we can for a moment imagine Brunelleschi applying this theorem to his situation before the Baptistery, then vertical ΓB in Euclid's diagram could represent the height of the Baptistery, and the horizontal ΔB Brunelleschi's nearly equal viewing distance away. ZK would represent the height of his intersecting picture and, according to the proposition, must be in the same proportion to its distance from Δ (i.e., ΔK) as ΓB is from its distance (i.e., ΔB). Thus the size of the picture and its distance

from the viewer must always be in the same proportion as the size of the actual object and its distance from the same viewer.

It is also important to note that the sides of the two triangles remain in the same ratio, no matter where ZK is placed. In other words, when applied to Brunelleschi's problem, the same 1:1 ratio of picture size to viewing distance would always remain, no matter how large or small his picture, or how long or short his viewing distance.

Now, if the picture was, as Manetti indicates, just about twelve inches square, then the viewing distance could only have been the same twelve inches. While Manetti does not tell us exactly what Brunelleschi's viewing distance for the little picture was, he does stress that the viewer should look at it *circa di braccia piccoline quanto a braccia vere* (lines 37–38). This quaint phrase is actually an old Italian idiom to express what we mean today by "scale." [29] Brunelleschi constructed the perspective of his small panel, we may reasonably assume, from a distance of some twelve inches; presumably, he expected the viewer to recapitulate the picture from the same viewing distance. In spite of the fact that Donatello, Masaccio, and Masolino—the first painters to apply the new perspective principles—quickly discovered to their own satisfaction that a picture loses little of its "realism" if seen from a position different from the artist's working standpoint, Brunelleschi could hardly be so sure in his unprecedented venture.[30]

NOWHERE IN THE Manetti account does it say what the visual angle was at Brunelleschi's eyepoint inside the doorway of the Duomo. The biographer only mentions that the artist painted what could be seen *a uno sguardo*—"at a glance" (line 5) from where he stood. In some of the old optics treatises, it was stated that the human eye could take in as much as ninety degrees; but in the *Della prospettiva*, which may better reflect Florentine opinions about the science during Brunelleschi's own lifetime, the visual angle was specifically regarded as "always acute and never as an obtuse or right angle." [31] Since the proper viewing distance for Brunelleschi's twelve-inch panel was only twelve inches, the most

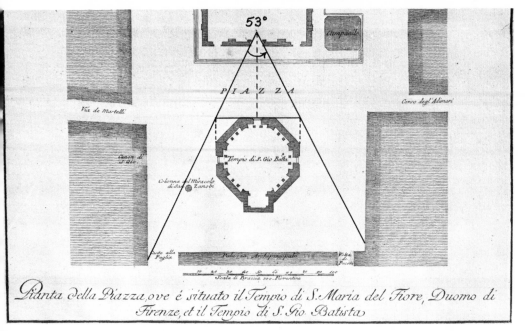

Illustration IX-2: Reconstruction of Brunelleschi's visual angle from the portal of the Duomo toward the Baptistery. Site-plan from Bernardo Sansone Sgrilli, *Descrizione e studi dell' insigne fabbrica di Santa Maria del Fiore* . . . , Florence, 1733.

plausible viewing angle would be just about fifty-three degrees—the apex angle of any isosceles triangle in which the base equals the altitude. In our case, the base of Brunelleschi's visual triangle when traced upon a plan of the piazza (Illustration IX-2) represents the width of the Baptistery frontage.

In other words, for Brunelleschi to have included in his twelve-inch picture what might be seen within any angle wider than fifty-three degrees, he would have had to construct the painting (and also ask the viewer to look at it) from a distance of *less* than twelve inches away. As experiment and common sense will show, one cannot comfortably regard a twelve-inch square picture by holding it less than a foot away.

But what of the visual angle vertically? Obviously, the discrepancy between Brunelleschi's own height and the considerable elevation of the Baptistery makes this very difficult to estimate on an ordinary drawing. Furthermore, it remains uncertain how much piazza in front of the Baptistery Brunelleschi wanted to show in relation to the sky above. Thus it is hard to say where the visual angle, measured on the elevation, should even start.

For reason of this very uncertainty, I believe the artist did not concern himself with such discrepancies at this stage of his

141

planning. Rather, he depended on the square format of his mirror and picture and the convenient 1:1:1 ratio of Baptistery height, width, and viewing distance to carry him through. As my own mirror-camera demonstration was to show, Brunelleschi did not have to solve the problem of how much piazza or sky should be shown by geometry beforehand. For a man who hoisted one of the greatest cathedral domes in Europe, it was no feat to move a piazza, octagonal Baptistery, and silver sky in one gesture— through the mere adjustment of a half-*braccio* mirror.

X

Brunelleschi's First
Perspective Picture

JOHN WHITE, in his otherwise authoritative *Birth and Rebirth of Pictorial Space*, postulates that the great master included in his first picture all that could be seen within a ninety-degree lateral angle at his eyepoint within the Duomo portal (Illustration x–1).[1] While this angle does indeed offer a handsome perspective of buildings receding on either side of the Baptistery, the only possible distance for constructing such a wide view would be at about six inches (one-quarter *braccio*), or half the already diminutive picture width. This is so because in the resultant right triangle the altitude perpendicular to the hypotenuse (the extended Baptistery frontage) is always just half the length of the hypotenuse. Thus a perspective picture embracing a ninety-degree visual angle would have to be constructed from an eyepoint only *half the picture width* away.

Using this assumption, Brunelleschi would have had to construct his picture from a distance of no more than six inches; the viewer, when looking at the result, could hardly be expected to see the twelve-inch picture clearly from the same distance. Moreover,

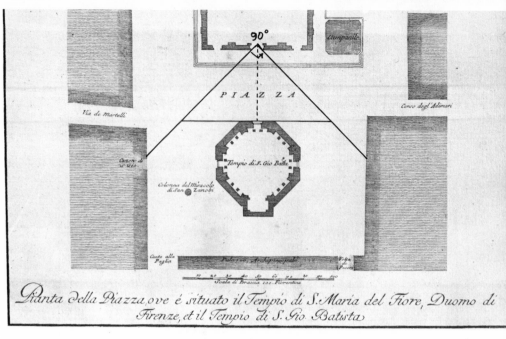

Illustration x–1: Reconstruction of a ninety-degree visual angle from the portal of the Duomo toward the Baptistery. Site-plan from Sgrilli's *Descrizione....*

since any object or picture seen in a mirror must appear just as far behind the mirror surface as the object itself actually is before it, the viewer would have had to hold the mirror no more than three inches away to compensate for the mirror's doubling of the viewing distance (the proper distance being half the picture's width). Obviously, it would be impossible to make out any sort of image from so close a range.

White's hypothesis is even more confusing with his argument that Brunelleschi had his viewer see the panel from a distance of a full *braccio*, or about two feet—four times the artist's original distance for constructing the perspective panel.[2] The mirror inexorably doubles this distance once again. Thus the reflected picture as hypothesized by White gives an impression that the Baptistery stands nearly a fifth of a mile away. Such an image would conflict with Manetti's memory of how the site was meant to be viewed "at a glance" by anyone emerging from the Cathedral portal. Since the original purpose of Brunelleschi's experiment was to prove that a perspective picture could duplicate a familiar landmark exactly as seen from an equally familiar viewpoint, he would hardly have selected a perspective distance so totally out of keeping with the actual hundred feet or so that separates the Baptistery from the central portal of the Duomo.

Brunelleschi's First Perspective Picture

IN ALL LIKELIHOOD, Brunelleschi had no particular visual angle in mind when he first embarked on his experiment. I believe he was guided instead by the largest mirror size available to him. Flat glass mirrors were still somewhat rare—and expensive—in those days, and certainly there were few around much larger than half a *braccio* in size. (Because such mirrors were at a premium, the same mirror used for the actual painting of the picture was probably also used—after being cleaned of marks and paint—for the viewing phase of the experiment.) Brunelleschi most likely set up his twelve-inch-square mirror in the central portal of the Cathedral and focused it upon the Baptistery opposite. The resultant reflection served then as the *modello* for his small painting, which rested on an easel beside the mirror (Diagram x–1). After first establishing the centric vanishing point by means of a dot, placed in the same location on his picture where it falls in the mirror reflection, he could then go ahead and transfer his preliminary construction (presumably from a sketch in a different scale),

Diagram x–1

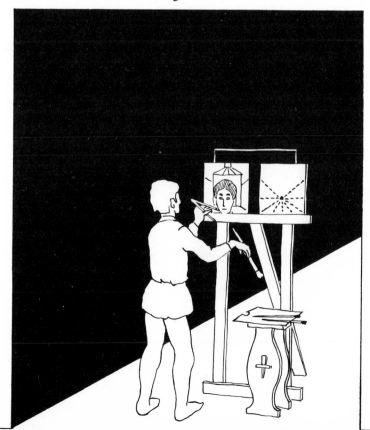

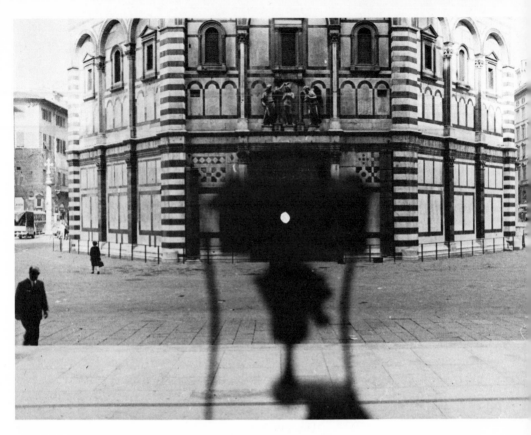

Illustration x–2: Edgerton, Photograph of the Baptistery taken in a one-half *braccio* square mirror, from a distance of one-half *braccio*. White dot denotes exact center of the camera lens.

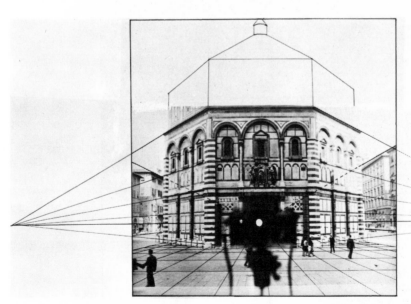

Illustration x–3: Edgerton, Brunelleschi's first perspective picture reconstructed.

worked out beforehand, perhaps in the manner already described by Panofsky and Krautheimer.[3] He would then find it quite easy to add details and other measurements by means of calipers, transferring from the mirror reflection to his picture.

The feasibility of all this can be proved by anyone who stands in the Duomo portal even today. As the following reconstruction by this author shows, at a twelve-inch viewing distance, a twelve-inch mirror reflects the Baptistery perfectly and includes as well the Canto alla Paglia and the Volta de'Pecori (lines 10 ff. in Manetti), just to the right and left of the Baptistery (although reversed, of course, in the mirror).

Illustrations x–2 and x–3 are photographs taken by me of the Florentine Baptistery as reflected in a half-*braccio* (about eleven and a half inches) square mirror placed on an easel (Illustration x–4); the supported mirror stood about five feet above the floor of the Duomo and some nine feet within the portal itself. A 35 mm. Nikon camera with a wide-angle lens (sixty degrees) was placed on a tripod so that the center of its aperture was five feet, six inches above ground level (Illustration x–5), and the film surface itself just eleven and a half inches from the surface of the mirror.[4] Because the Nikon frame is rectangular, the whole of the square mirror could not be photographed at once. Nonetheless, it should be clear from Illustration x–3 that had the frame been square, the whole upper part of the Baptistery would have been exposed, as actually appeared to me in the mirror reflection and as the superimposed drawing indicates.

Illustration x–3 also shows how the top and bottom edges of the two oblique sides of the octagonal Baptistery converge to lateral vanishing points right and left on the same "horizon." Here we see how Brunelleschi's first experiment also contained the essential rule of two-point or oblique perspective such as he demonstrated more specifically in his second picture of the Palazzo Vecchio. When edges of objects are parallel to the ground but askant from the picture plane, they seem then to converge to points at the sides— but always on the same horizon as the centric vanishing point. In Brunelleschi's picture, the level of this horizon line, linking the two lateral vanishing points for the oblique sides of the octagonal Baptistery and the centric vanishing point for the piazza, was established by the eye of the artist—in our photographic recapitulation, the camera. It is to be noted that the camera—no more than

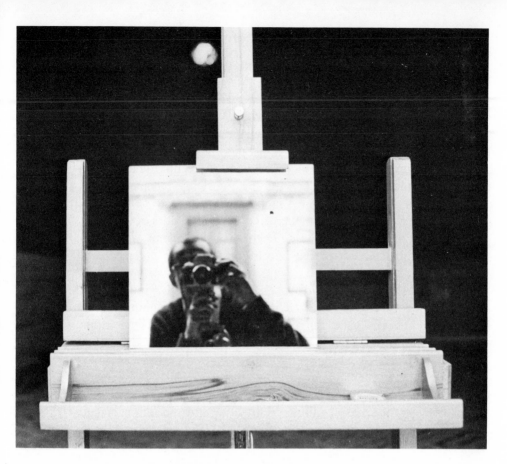

Illustration x–4: Edgerton, Mirror, one-half *braccio* square on an easel in the portal of the Duomo facing toward the Baptistery.

Brunelleschi's own head as he bobbed back and forth to relate his painting to the mirror image (Diagram x–1)—does not obtrude excessively into the reflection. The center of the camera aperture, indicated as a white dot in Illustration x–2, marks the approximate eyepoint of Brunelleschi himself, described by his biographer as being a short man, as he stood in the portal. Our photographic dot may thus be said to represent at once (1) Brunelleschi's eyepoint, (2) the hole in his panel, and (3) the vanishing point.

Illustration x–2 also represents the mirror reflection of the Baptistery more nearly as Brunelleschi actually saw it, that is, before he made certain compositional adjustments. The "eye level" in this photo is exactly in the center. Had my camera frame been square, we would see not only the top of the Baptistery but more foreground piazza as well. This is because in one's normal field of view (i.e., the visual pyramid), the visual axis passes directly to the center. But Brunelleschi clearly had to do some jug-

Brunelleschi's First Perspective Picture

gling in order to make his mirror reflection relate more closely to the simple aesthetic demands of a painting. Above all, he had to locate his vanishing point slightly lower, in order to eliminate much of the obtrusive and unnecessary piazza foreground. This would have been done simply by tilting the mirror very slightly.

Illustration x–3 shows the advantageous effect of such an adjustment. The "eyepoint" is just above the center of the camera

Illustration x–5: Edgerton, Portal of the Duomo with apparatus for recapitulating Brunelleschi's first perspective experiment.

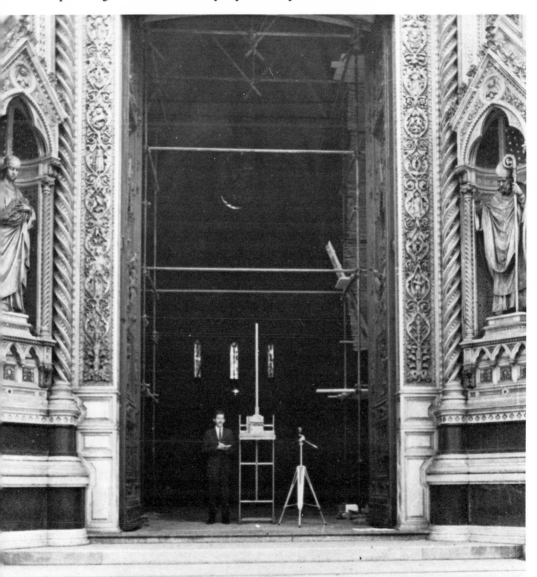

aperture because the camera itself was also tilted slightly to help form the composition of this picture. The camera also unmitigatingly records certain accompanying distortions, such as the unfelicitous sloping sides of the building, but these are not so discernible to the naked eye as to the camera. In an age which did not know photography, Brunelleschi could easily ignore any such distorting "side effects" in his finished picture.[5]

Both photographs of the Baptistery, however, show that the width of the mirror reflection includes all the surrounding landmarks mentioned by Manetti, except for the Misericordia, which remains out of sight (the original building of Brunelleschi's day was rebuilt after a fire in 1439). The Column of St. Zenobius, seen just to the left of the Baptistery (in actuality it is on the right), stood in the early fifteenth century a few yards away from its present position; the old Misericordia, while in a somewhat different situation than today, probably never extended far enough along the square to the left to be included in a picture with less than a ninety-degree visual angle. Manetti did not say specifically that either of these two monuments was depicted by Brunelleschi —only that they roughly represented the boundaries of the painting.[6] It is also not very clear from Manetti's account just where Brunelleschi stood within the portal of the Duomo. The original Duomo facade, before restoration in the nineteenth century, had a greater projection to the west of the portal enclosure.[7] Nevertheless, it was discovered in the present photographic experiment that the amount of open space on either side of the Baptistery reflected in the mirror varied little, no matter where the easel was set up within the portal (that is, up to six feet within the innermost wall surface surrounding the doorway).

So FAR SO GOOD. With his preliminary calculations, sketch transferral, on-site painting, and studio finishing touches done with, Brunelleschi was now ready to exhibit his deceptively modest perspective panel. The revolutionary new realism of this picture was certainly not dependent on any special talent of the

artist's for painting; indeed, he wore too many other hats to have time to excel behind the easel. Rather, Brunelleschi wished his viewers to appreciate the special construction, hidden beneath the paint, as it were, which gave his illusion a geometric uniformity never before seen, either in Florence or the world.

We cannot be certain to what extent the first witnesses to his demonstration were cognizant of the full import of his achievement. Indeed, Brunelleschi's use of the picture hole and the viewing mirror suggest that he needed a special approach to impress his contemporaries—a scientific aura, if you will. And this despite the fact that the first subjects for the demonstration were undoubtedly some of his artistic and intellectual friends. We are therefore not remiss in imagining further that Brunelleschi accompanied his demonstration with a running lecture on optics, on the nature of the visual axis and how the hole in the picture would demonstrate this, and particularly on his new theory of the vanishing point. He might even have talked about cartography, about how the viewer should think of the piazza before him as being divided into abstract parallels and meridians (which, as in Illustration x–3, he may even have drawn into his painting), and about how Ptolemy, the ancient geographer, had investigated the same principles of perspective centuries before, only to have his findings forgotten by history.

Brunelleschi would then lead his witness to the doorway of the Duomo, and have him stand, with his back to the Baptistery, in the same place where he had stood while painting the picture. He would have his viewer hold the little panel against one eye so that he could look through the hole from the back. In the viewer's other hand, Brunelleschi adjusted the mirror which was to reflect the picture and reverse the left and right elements to their proper positions. The distance between the panel and mirror was set at just a half *braccio*.[8] He would go on to explain how the ratio of this viewing distance to the size of the picture equaled exactly that between the distance separating their standpoint and the real Baptistery and the actual height of the building itself.

Following this dramatic build-up, the viewer would then be turned so that he faced out-of-doors. The painting with its burnished silver background could thus reflect "the air and natural skies," as Manetti says (lines 17 ff.). This illumination effect, in turn, would be reflected back to the viewer by the mirror, in-

cluding, Brunelleschi hoped, "clouds . . . moved by the wind when it blows." With his viewer under such a spell, the painter, with a theatrical flourish, would suddenly remove the mirror from the hand of his astonished friend so that the real Baptistery suddenly loomed into his view through the hole. "Oh maestro," one can almost hear the comment, "truly, I see no difference between your painting and our own Santo Giovanni!" [9]

Another speculation is irresistible. It is that Brunelleschi had his viewer use a mirror chiefly to disguise the painted flatness of his picture. The shrewd master may have realized something which has received attention from perceptual psychologists in recent times: that perspective illusion is strong only when the observer's awareness of the painted picture surface is dispelled. When the viewer loses his "subsidiary awareness," as the phenomenon is now called, he tends to believe the picture surface does not exist and that the illusionary space depicted is actually three-dimensional.[10] The image in a mirror seems so real precisely because we tend to disregard that the mirror is actually only a two-dimensional face.

But the compelling reason for using the mirror for the viewing phase of the experiment, in my view, has more to do with the desire of this resourceful artisan-engineer to sustain the science of his own time. In what better way could he prove that his perspective picture reproduced the very process of vision as it was understood in his day? The peep-hole in the back of the panel, Brunelleschi may well have explained, acts like the pupil in the eye itself, while the mirror represented the sensitive anterior membrane of the crystalline lens. Thus the observer could imagine himself, as he was led through this demonstration, to be looking into an actual eye through its pupil, to be observing the image being formed in the way that the optical scientists adduced.

Medieval opticians, we know, frequently referred metaphorically to the mirror in discussing the *crystallinus*. And we have already noted a literary fascination among Brunelleschi's contemporaries with the new, flat instrument of reflection. It is not impossible that the architect of the first work of linear perspective was inspired in this aspect of his demonstration by none other than Dante, who in the *Convivio* noted that the image-forming *crystallinus* in the eye was "almost like a mirror which is a piece of glass backed with lead." [11]

XI

The "Symbolic Form" of the Italian Renaissance

J<small>UST</small> FIFTY YEARS ago, the late great art historian Erwin Panofsky wrote an essay called "Die Perspektive als 'symbolische Form.' " [1] This article created extraordinary interest in subsequent decades because the author argued that linear perspective by no means conclusively defined visual reality, rather that it was only a particular constructional approach for representing pictorial space, one which happened to be peculiar to the culture of the Italian Renaissance.

Art historians, trying at that time to justify the rise and spread of modern abstract art, were pleased because Panofsky seemed to be saying that linear perspective was not the last word in pictorial truth, that it, too, could pass away as had all earlier artistic conventions. Modern artists had therefore been correct in rejecting perspective in favor of the new "symbolic forms" such as Impressionism or Cubism, which corresponded more to the iconoclastic visual attitudes of the twentieth century. Such a notion has since been expressly defended by various writers on art and

psychology, among them Rudolf Arnheim, Gyorgy Kepes, and Nelson Goodman.[2]

However, Panofsky's essay did contain one egregious error. With ingenious reasoning, the author tried to show that the ancient Greeks and Romans—Euclid and Vitruvius in particular—conceived of the visual world as curved, and that since the human retina is in fact a concave surface, we do indeed tend to see straight lines as curved.[3] Hence, Panofsky proposed, classical optics are perhaps nearer than Renaissance linear perspective to true reality. Since Renaissance perspective assumes a flat visual field, it is not actually "real" at all. But Panofsky's reasoning was based on theories in German perceptual psychology which are no longer held. Nor indeed have historians of science discovered any notable evidence that the ancient optical writers ever thought the visual world was "curved."

Panofsky's essay, particularly in recent years, has come under criticism from scientists, as well as from E. H. Gombrich and other scientific-minded art historians.[4] Writers on optics and perceptual psychology such as James J. Gibson, G. Ten Doesschate, and M. H. Pirenne have challenged Panofsky for his subjective curvature hypothesis and denial that linear perspective has a catholic or "ultimate" veracity.[5] They are especially put off by Panofsky's reference to perspective as a "symbolic form," which is to say, a mere convention. As Pirenne has written:

Professor Panofsky recently stated that "perspective construction as practiced in the Renaissance is, in fact, not 'correct' from a purely naturalistic, that is, a physiological or psychological point of view." Panofsky went further, claiming that Renaissance perspective is a "symbolic form," which apparently means little more than a system of conventions similar to the forms of versification in poetry . . . [but] . . . the suggestion that perspective has changed with the evolution of the mind of man is untenable. It is the understanding of the science of perspective by man, and its methods of application, which have developed during the course of prehistory and history. "The strange fascination which perspective had for the Renaissance mind" was the fascination of truth.[6]

Unfortunately, Panofsky never explained definitively just what he meant by the phrase "symbolic form." However, he certainly had in mind a more subtle meaning than a "system of conven-

tions [like] versification in poetry." Indeed, Professor Pirenne and other scientist critics misunderstand the ingenuity of Panofsky's approach as much as they find Panofsky himself misunderstood classical optics and modern perceptual psychology.

ACTUALLY, THE TERM "symbolic form" is not original with Panofsky at all but goes back to the philosopher-historian Ernst Cassirer, Panofsky's colleague at the Warburg Library during the years 1920 to 1925. Indeed, Cassirer was there to write the second part (*Das mythische Denken*, Leipzig, 1925) of his monumental three-volume *Die Philosophie der symbolischen Formen*. Cassirer's unabashed neo-Kantian idealism made a strong impression on Panofsky, who borrowed of his philosophical principles as a basis for the article on perspective. Unfortunately, Cassirer's somewhat vague philosophy did not survive the onslaught of the fact-worshiping logical positivists or more fashionable existentialist pessimism during the 1930s and 1940s. The philosophy of symbolic forms received only limited acceptance, and Panofsky himself abandoned it for more positivistic historical writing when he came to the United States in the 1930s. It is significant that Cassirer's *Die Philosophie* was not translated into English until 1955, and Panofsky's "Die Perspektive als 'symbolische Form'" has never been translated into English at all.[7]

The major premise of Cassirer's philosophy of symbolic forms is rooted in Kant's idea that man can never know the real world absolutely, only how the real world is apprehended through his own mental apparatus. This led Kant to his system of "transcendental logic," whereby the mental faculty itself is considered as having a special structuring power or "schema," which not only imposes subjective order on the natural world but integrates the two traditional aspects of the thinking process, perceiving and conceiving. According to Kant, it is not the conceiving faculty alone which imposes its forms a priori on raw information coming in through the senses; forms are also and simultaneously imposed by the perceiving faculty as well. There thus exists a synthesis or unity between intellect (conceiving) and intuition

(perceiving) effected by the schema, which simultaneously selects sensory information and translates it into knowledge.

Cassirer, further influenced by Hegel and Herder, wished to broaden Kant's transcendentalism to apply to the whole range of man's cultural enterprises, to history, language, myth making, and art; it was his wish to found a new cultural philosophy that would be compatible with the latest scientific theories in psychology, anthropology, and linguistics. Like Kant, he was interested less in the old philosophical quest for "naked truth" than in the "index of refraction" between objectivity and subjectivity; that is, how the human mind manages to modulate the "real" world for its own purposes. In fact, he saw this peculiar "distorting" quality of the mind as the very essence of creative power, a quality which creates the "symbolic forms" of language, art, myth, and science. Words, for example, are the symbolic forms for objects in verbal communication. Pictures are the symbolic forms for ideas in visual communication; myths, for unexplainable natural phenomena; and numbers for scientific concepts. Cassirer emphatically did not mean symbolic forms to be thought of as mere conventions or simple shorthand devices for abstract ideas. As he explains in *Language and Myth*:

[Symbols are not] mere figures which refer to some given reality by means of suggestion or allegorical renderings, but in the sense of forces, each of which produces and posits a world of its own. The question as to what reality is apart from these forms, and what are its independent attributes, becomes irrelevant here. For the mind, only that can be visible which has some definite form; but every form of existence has its source in some peculiar way of seeing, some intellectual formulation and intuition of meaning.[8]

This passage, published originally in the *Studien der Bibliothek Warburg* in the same year that "Die Perspektive als 'symbolische Form'" appeared, provides the keynote, it seems to me, for understanding Panofsky's own application of the term "symbolic form." What Cassirer means here is that the symbols man uses to communicate ideas about the objective world have an autonomy all their own. Indeed, the human mind systematizes these symbols into structures that develop quite independently of whatever order might exist in the natural world to begin with.

Words, for example, become subject to their own syntactical

structures. Cassirer points out that children at first tend to fuse word and object together indistinguishably ("this is a dog" instead of "this is called a dog"), whereas the adult learns to consider words as having their own special distinction (hence poetry). Pictorial images, however mimetic, are similarly worked by the experienced artist into autonomous structures that we refer to as "style." Myths also remove themselves more and more from the natural phenomena which inspired them, ultimately taking on their own ineluctable reality. In antiquity, civilization viewed star groupings as biomorphic forms, as real people and animals that were part of a distinct, complex suprahuman realm of gods and heroes. Numbers and geometric figures likewise generate their own laws and proportions; whatever man thinks he knows of scientific truth, it is only that residue of objective evidence which is translatable into the symbolic forms of mathematics. As Charles Hendel wrote: "Whatever human consciousness appropriates for any purpose whatsoever, whether to gain knowledge or to handle imaginatively in art, is already possessed of form at the very taking." [9]

As relatively forgotten as Cassirer's philosophy has become in recent years, it should be noted that "symbolic forms" may still be alive and well—under a currently more fashionable name, "structuralism." Jean Piaget has recently published a little book in which he outlines the theory, now largely subscribed to by Gestalt psychologists, anthropologists, linguists, mathematicians, biologists, and philosophers, that the human mind possesses an innate capacity to structure. This assumption has become a common denominator for the study of the above disciplines.[10] Piaget's definition of structuralism, especially as he tries to reconcile interpretations as divergent as those of Claude Lévi-Strauss and Noam Chomsky, is remarkably similar to Cassirer's old notion of symbolic form. Sadly, Cassirer's name is never mentioned.

BUT LET US RETURN to Panofsky. First of all, the real thrust of his essay is not to prove that the ancients believed the visual world was curved or that Renaissance perspective was a mere artistic convention, but that *each historical period in Western*

civilization had its own special "perspective," a particular symbolic form reflecting a particular *Weltanschauung*. Thus linear perspective was the peculiar answer of the Renaissance period to the problem of representing space.

In antiquity, Panofsky notes, space was understood by artists as a discontinuous residue between objects rather than as something which transcends and unites them. Such a conception allows a proper sensation of above, below, ahead, behind, but never of a unified continuum such as today informs us about the relative distance between objects in perspective pictures. By late antiquity, Panofsky continues, artists became more interested in continuous space, especially in landscape; but even there this new interest seemed to entail a diminution of volumetric solidity. In such works as the first-century B.C. *Odyssey Landscape*, for example, the pictorial space is all mist and dream, with solid bodies depicted as if dissolved in atmosphere. Here space seems to symbolize the world of the spirit rather than of matter.

With the advent of the Christian era, the classical notion that a picture should be like a window gave way to the concept of a decorated surface. Space, now designated by monochromatic gold or purple, became stylized as a "unifying fluid," no longer giving a sense of depth or direction. While Byzantine artists did manage to retain some ties to the classical conception, their vestigial perspective was really only "space-signifying," not "space-enclosing."

The Romanesque era saw the definitive demise of classical space representation in pictures. Space and body became compressed into patterns, so that one could not be distinguished from the other. Surface reigned absolute. But strangely enough, it was this very compression of body and space which paved the way for the eventual "systematic space" of the Renaissance. Since space and body were now completely equal in their uniform flatness, any change in one implied a corresponding change in the other.

During the Gothic period, the single and distinct object or body asserted itself once again. On rising cathedrals, sculpted figures began to emerge from the piers and splays where earlier they were compressed. Gothic statues now stood forth in the round, each encapsulated under a little baldacchino; the enclosing space around each figure was not shared with its neighbor. Gradually, as the thirteenth century yielded to the fourteenth, artists began to make these individual spaces flow together, to combine several figures and their spaces into a single stagelike, homogeneous setting.

The "Symbolic Form" of the Italian Renaissance

Thus it was that painters such as Duccio and Giotto began to represent things as if the picture were a window.

According to Panofsky, much of the hesitation in the Middle Ages to represent a more homogeneous, uniform space was due to the acceptance of Aristotle's belief that space was discontinuous and finite. "We see here," Panofsky wrote, ". . . that aesthetic space and theoretical space in a given period indicate that the space one actually perceives (*Wahrnehmungsraum*) is formed by one and the same sensation . . . in the one case symbolized intuitively, in the other made logical in the intellect."[11] In other words, the space one perceives is conditioned by both the way one enjoys seeing it—perhaps as traditionally shown in pictures—and the way it is explained in contemporaneous thought, that is, according to its accepted explanation by the science of the day. Pictorial representations of space in any given age are thus symbolic forms of this combined perceiving process.

According to Aristotle, all the universe, space included, was contained in one huge, finite sphere. All the planets and stars fit snugly together, with intervening atmosphere, as aggregate bodies. The earth was in the center, and the stars and planets were fixed to concentric rotating spheres within the total sphere. Outside this there existed only void. Nothing. In Aristotle's conception, space was only what one imagined as existing between the aggregate bodies, such as between water and the inner surface of its container, or between the outer surface of any body and the atmosphere which encloses it. The philosopher was concerned that everything should have its proper place, not in relation to other objects, but to the center of the universe. An all-pervasive and uniform space as we now conceive it was then unimaginable. Because of this medieval attitude, artists were constrained from thinking about objects in the "same space."[12]

Christian theologians, however, were troubled by Aristotle's notion. If the universe was finite, where then was God? In Illustration XI-1, a mosaic detail from the twelfth-century Byzantine-Sicilian church at Monreale, we see a good early medieval example of this paradox. God the Creator is shown seated outside the finite Aristotelian universe which He is in the act of creating. Is He then seated in the void? The artist escaped the problem simply by placing God against a gold background, symbolizing His own "space" as mystical, while that within the circles of the universe is colored blue. As ingenuous as such a matter of pictorial protocol

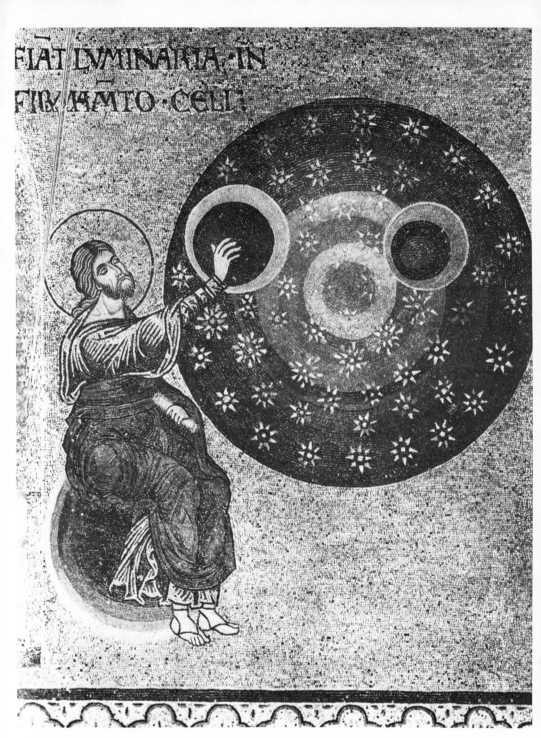

Illustration XI–1: Unknown Sicilian-Byzantine artist, *God Creating the Universe*, mosaic detail from the Cathedral of Monreale, Sicily, c. 1175. Courtesy, Alinari-Art Reference Bureau.

may seem to us today, it was of no minor theological concern to medieval Western Christendom. Ultimately, the Church tried to settle the issue in 1277 by banning the teaching of Aristotle altogether.

As the metaphysic of Aristotelian space fell into disfavor in the late thirteenth century, artists both north and south of the Alps began to accept what Panofsky (borrowing from his contemporary German psychological terminology) calls "psychophysiological space." This is the kind of space we see empirically, without theological preconceptions or mathematical structure; it is neither homogeneous, infinite, or isotropic (extending uniformly in all directions). In this kind of space the moon, for example, is perceived not as a huge body hundreds of thousands of miles away or as a divine being, but rather as an ordinary physical object about the size of a basketball which, if it were to fall, would drop within a few yards of the observer.[13] While such a notion of space is "naive," it does allow for a factual observation of physical interrelationship between objects never conceivable in the "mystical" or Aristotelian space of the earlier Middle Ages. Duccio and Giotto in Italy and Jean Pucelle and the Boucicault Master in France, for example, managed very well with this psychophysiological space. Their pictures achieved a charming aesthetic harmony, if without geometric perspective unity.

Finally, in the fifteenth century, there emerged mathematically ordered "systematic space," infinite, homogeneous, and isotropic, making possible the advent of linear perspective. What produced the transition from the easy and hedonistic psychophysiological space to the coldly geometrical "systematic space" of the Renaissance? In his famous essay, Panofsky did not go into cultural reasons for this development, other than to acknowledge that the change was self-conscious. Linear perspective, whether "truth" or not, thus became the symbolic form of the Italian Renaissance because it reflected the general world view of the Italian people at this particular moment in history.

IS PANOFSKY'S USE of the term "symbolic form" in this connection necessarily misguided merely because of his dubious visual curvature theory? Are Pirenne and the scientists critical of

The "Symbolic Form" of the Italian Renaissance

Panofsky justified in dismissing so summarily the notion that linear perspective can be a specific cultural "convention" for depicting "truth"?

I think not, in both cases. What is crucial here is the fact that linear perspective came about in the early Renaissance, not in order to reveal visual "truth" in the purely heuristic sense as meant by Pirenne, but rather as a means of—literally—squaring what was seen empirically with the traditional medieval belief that God spreads His grace through the universe according to the laws of geometric optics. As applied to linear perspective in the Renaissance, the words "convention" and "symbolic form" mean only that artists of that time sought out and practiced this construction in response to specific cultural demands within the Renaissance paradigm.

I use "paradigm" here in the sense that Thomas S. Kuhn has propounded, namely, as denoting a cultural constellation of related ideas; a realm in which science, art, philosophy, and religion all interact and prejudice one another to the extent that no scientific invention, work of art, or philosophical or religious concept can escape the influence of the paradigm as a whole.[14] A cultural paradigm prevails, it follows, only so long as all these scientific ideas, artistic creations, and philosophic concepts generally sustain the encompassing ethos. When they do not, when some new demand or new idea comes along that cannot be answered in a culture's traditional terms, then the whole paradigm must change.

The cultural paradigm is not a very tidy entity, of course. The beginnings and endings of its various constituent strains do not all happen at once. Thus, it could be said that the paradigm of the Middle Ages did not really end until the acceptance of the heliocentric universe discovered by Copernicus and Galileo. The paradigm of the Renaissance, in turn, ended finally with Einstein's special theory of relativity. Within the Renaissance paradigm, given further mechanical structure as it was by Newton, linear perspective served as the most *appropriate* convention for the pictorial representation of "truth." And today? It is widely agreed that Cubism and its derivative forms in modern art are in the same way the proper pictorial means for representing the "truth" of the post-Einsteinian paradigm.

It is ironic, as Kuhn has pointed out, that such cataclysmic

changes of cultural paradigms were never intended by those whom we today view as being the truly "revolutionary" innovators. The earnest men who paved the way for Galileo and Einstein, for example, were motivated basically by the desire to make more secure the traditions of their own paradigm, and not at all to violate it. Linear perspective, the invention of printing, Columbus' voyage, Copernicus' observations—these advances were all undertaken, if anything, to celebrate the medieval Christian world view. They failed. Instead of bringing all men closer to the Word of God as intended, they succeeded only in provoking disquieting issues fundamentally at odds with established medieval "truth."

WHAT THEN, is the accomplishment of linear perspective? Pirenne, the optical physiologist, describes the "truth" of linear perspective thus:

The picture in perspective of a scene or a set of objects is not a replica of the retinal image produced by the objects in the artist's eye. It is rather a substitute of the actual objects themselves, so constructed that it sends to the eye a distribution of light similar to that which would be sent by the actual objects, with the result that, for any given eye, the picture produces retinal images similar in shape and dimension to those which would be produced in the same eye by the actual objects.[15]

So long as both artist and viewer are aware that such a picture represents what is seen from one specific viewpoint, the linear perspective depiction is certainly true in the objective sense.[16] What Brunelleschi and Alberti discovered was that only that which is seen from one fixed point can be represented on a flat surface according to precise geometrical rules derived from the science of optics. What is seen in the visual world, that is, as the viewer moves naturally about the objects to be depicted, can indeed be rendered geometrically—but at the expense of the illusion of depth.

Thus the artists of the Italian Renaissance did contribute to the "progress" of science by finding a relatively nonsubjective way to make pictorial images which everyone, regardless of cultural

background, could learn to become oriented to or respond to. I stress *learn to* because it is not natural to the human race to assume this attitude about a picture either as viewer or artist. Little children, for instance, do not, nor did the ancient Chinese or the medieval Christians. The Arabs had the classical science of optics under their very noses for centuries, yet failed to make connection between the theory of the centric visual ray and pictorial representation. Once again, this optical-aesthetic connection might never have been realized in the West had it not been for the Christian opticians who believed a special relationship existed between the centric visual ray and the moral power of God.

It should not be overlooked that almost coincidental with the appearance and acceptance of linear perspective came Gutenberg's invention of movable type. Together these two ideas, the one visual, the other literary, provided perhaps the most outstanding scientific achievement of the fifteenth century: the revolution in mass communication.[17] Linear perspective pictures, by virtue of the power of the printing press, came to cover a wider range of subjects and to reach a larger audience than any other representational medium or convention in the entire history of art. It is fair to say that without this conjunction of perspective and printing in the Renaissance, the whole subsequent development of modern science and technology would have been unthinkable.

Hence the real contribution of linear perspective seems to have been more to the advancement of science than to the history of art. If perspective often seems inimical to the impatient and introverted aesthetic sensibility of artists today, it certainly appealed to the more extroverted, acquisitive attitudes of the Renaissance. In the early Quattrocento, it was the professed goal of artists to know as much about their physical surroundings as possible in order to lend conviction to their moral message. As linear perspective fixed their eyes more intensely on the natural world, these humanist craftsmen became quasi scientists. And as their perspective pictures proliferated, especially through the medium of printed books, more and more people from all walks of life began to be aware of the underlying mathematical harmonies of nature which perspective articulates.

So far as science is concerned, can there be any question that the special geniuses of Leonardo da Vinci, Columbus, and Copernicus were given a very special catalysis at this time by the new

communications revolution of linear perspective? Indeed, without linear perspective, would Western man have been able to visualize and then construct the complex machinery which has so effectively moved him out of the Newtonian paradigm into the new era of Einsteinian outer space—and outer time? Space capsules built for zero gravity, astronomical equipment for demarcating so-called black holes, atom smashers which prove the existence of anti-matter—these are the end products of the discovered vanishing point.

Or are they? Surely in some future century, when artists are among those journeying throughout the universe, they will be encountering and endeavoring to depict experiences impossible to understand, let alone render, by the application of a suddenly obsolete linear perspective. It, too, will become "naive," as they discover new dimensions of visual perception in the eternal, never ultimate, quest to show truth through the art of making pictures.

Notes

I

1. James J. Gibson, *The Perception of the Visual World* (Boston, 1950); idem, *The Senses Considered as Perceptual Systems* (Boston, 1966).

2. See Jan B. Deregowski, "Pictorial Perception and Culture," *Scientific American* 227, no. 5 (1972): 82–90; also Marshall H. Segall, Donald T. Campbell, and Melville J. Herskovits, *The Influence of Culture on Visual Perception* (New York, 1966), and Gordon W. Allport and Thomas F. Pettigrew, "Cultural Influences on the Perception of Movement; the Trapezoid Illusion among Zulus," *Journal of Abnormal Social Psychology* 55 (1957): 104–113. See also Rudolf Arnheim, "Inverted Perspective in Art: Display and Expression," *Leonardo* 5 (1972): 125–135.

3. For more on this, see Sven Sandström, *Levels of Unreality* (Uppsala, 1963), pp. 21 ff., and passim, and John White, *Birth and Rebirth of Pictorial Space* (London, 1967), p. 40.

I I

1. This English translation is taken from Robert Belle Burke, *The Opus Majus of Roger Bacon* (Philadelphia, 1928 and 1962), vol. 1, pp. 232–234.

Notes

The original Latin text is given in John Henry Bridges, ed., *The Opus Majus of Roger Bacon* (London, 1897), vol. 1, pp. 210–211.

2. Alexandre Koyré, "Le vide et l'espace infini au XIVe siècle," *Archives d'histoire et littéraire au Moyen Age* 17 (1949): 45–91.

3. The passage as quoted below is from Bradwardine's *De causa Dei* as cited in Koyré, "Le vide," p. 87, note 2. Bradwardine excerpted it almost word for word from St. Augustine's second homily on the Gospel of John. See J.-P. Migne, *Patrologia Latina* (Paris, 1865), vol. 35, pt. 3, col. 1393, para. 10:

> In Mundo erat et Mundum per eum factus est; Quomodo, inquit, erat in Mundo? et respondet, quomodo Artifex regens quod fecit; Non enim sic fecit, quomodo facit faber foris qui secus est arca quam facit et illa in alio loco posita est, cum fabricatur; et quamvis iuxta ait, ipse alio loco sedet qui fabricat, et extrinsecus est ad illud quod fabricat; Deus autem infusus Mundo fabricat, ubique positus fabricat, et non recedit aliquo, non extrinsecus quasi versat molem quem fabricat, praesentia maiestatis facit quod facit praesentia sua gubernat quod fecit. Sic ergo erat in Mundo, quomodo per quem mundus factus est.

4. James J. Gibson, *The Perception of the Visual World* (Boston, 1950), p. 38.

5. See Herbert Ginsburg and Sylvia Opper, *Piaget's Theory of Child Development: An Introduction* (Englewood Cliffs, N.J., 1969), pp. 207–218; Jean Piaget, *Structuralism*, trans. Chaninah Maschler (New York, 1970); idem, *Psychology and Epistemology*, trans. Arnold Rosin (New York, 1971).

6. David Herlihy, *Medieval and Renaissance Pistoia: The Social History of an Italian Town* (New Haven, Conn., 1967), pp. 240–268.

7. Richard C. Trexler, "Florentine Religious Experience: the Sacred Image," *Studies in the Renaissance* 19 (1972): 7–42.

8. Such an example is shown in a fourteenth-century Archimedes treatise by Johannes de Tinemue (*De curvis superficiebus*). See Marshall Claggett, *Archimedes in the Middle Ages* (Madison, Wisc., 1964), vol. 1, p. 505.

9. As published, for instance, in *Archimedes opera . . . illustrata per Davidem Rivaltum . . .* (Paris, 1615), p. 28.

10. Lynn White, Jr., "The Flavor of Early Renaissance Technology," in *Developments in the Early Renaissance*, ed. Bernard S. Levy (Albany, N.Y., 1972), pp. 36–58.

11. Cecil Grayson, "The Composition of L. B. Alberti's 'Decem libri de re aedificatoria,'" *Münchener Jahrbuch der bildenden Kunst* 2 (1960): 158.

12. For studies concerning the origin of the word *istoria*, see Thomas Wharton, *History of English Poetry* (London, 1824), vol. 2, p. 189, and pp. 305–306 in the revised edition published in 1871 by W. C. Hazlitt, ed. Also, Payne Toynbee, "A Note on *storia storiato*," *Mélanges offerts à M. Emile Picot* (Paris, 1913), vol. 1, pp. 195–208. The best and most recent study of Alberti's concept of *istoria* and what he meant by "copying nature" is Ivan Galantic, "The Sources of Leon Battista Alberti's Theory of Painting" (Ph.D. diss., Harvard University, 1969).

Notes

13. The purpose, if not the specifics, of *istoria* had long been called for by outspoken members of the Church during the late fourteenth and early fifteenth century in Florence. There are several such passages in a book (c. 1408/9) called *Regola del governo di cura familiare* by the stern Dominican and Cardinal Giovanni Dominici, mentor of St. Antonine. Families, he urged, should not bedeck their burial chapels with gaudy frills, but "paint churches in honor of God." In a curious reference to paintings of the Virgin Mary, he stated that patrons should not "clothe 'Donna Eva' in gold and fine azure on the wall," while leaving "her daughter of the true flesh to die of cold or hunger." Mothers should have holy pictures in the home for the edification of sons; such pictures should even be exposed to infants as "nutriment for the present life." However, parents must beware lest these pictures become too ornamented with "gold and silver . . . and precious stones," thus making them more like idols than "mirrors" which "reflect your [infant] sons when they open their eyes"; such ornamentation only leads to "reverence for the gold and stones and not to the figures or true message represented by those figures." It is interesting that this book was originally written for Donna Bartolommea Alberti, wife of Antonio Alberti, uncle to Leon Battista, shortly after the family's exile from Florence. Dominici's ideas certainly seem close to those Alberti himself expressed later in his treatise on the family (*Della famiglia*) and also prefigure the famous diatribe by St. Antonine against the excesses of painters practicing, apparently, in the International Style. Dominici's quotations in the Italian original are found in Donato Salvi, ed., *Regola del governo di cura familiare compilata dal Beato Giovanni Dominici Fiorentino* (Florence, 1860), pp. 125, 131–133.

III

1. For a more thorough analysis of the relationship between everyday life and art in Florence during the fifteenth century, see Michael Baxandall, *Painting and Experience in Fifteenth Century Italy* (Oxford, 1972).

2. As translated by Hans Baron in *The Crisis of the Early Italian Renaissance* (Princeton, N.J., 1966), p. 207.

3. This translation is published in W. R. Dennes, ed., *The Idiota of Nicolaus Cusanus* (San Francisco, 1940) (South Branch California State Library; Occasional Papers, Reprint Series, no. 19). The original Latin is found in L. Baur, ed., *Nicolai de Cusa opera omnia* (Leipzig, 1937), vol. 5, pp. 4–5 ff.

4. I. Moutier and F. G. Dragomanni, eds., *Cronaca di Giovanni Villani* (Florence, 1863), vol. 5, bk. 11, chap. 94. See also Achille Pellizzari, *Il quadrivio nel Rinascimento* (Naples, 1924), pp. 36–37; also Piero Sanpaolesi, "Ipotesi sulla conoscenze matematiche, storiche, e mechaniche del Brunelleschi," *Belle arti*, 1951, pp. 25–54.

5. Gino Arrighi, ed., *Paolo dell'Abbaco. Trattato d'aritmetica secondo la lezione del Codice Magliabechiano XI, 86, della Biblioteca Nazionale di Firenze* (Pisa, 1964) (*Testimonianza di Storia della Scienze*, 2).

Notes

6. Pellizzari, *Il quadrivio*, pp. 9–10.

7. See Lynn White, Jr., "The Flavor of Early Renaissance Technology," in *Developments in the Early Renaissance*, ed. Bernard S. Levy (Albany, N.Y., 1972), pp. 36–58.

8. See Federigo Melis, *Storia della ragioneria* (Bologna: 1950); also Raymond de Roover, "The Development of Accounting prior to Luca Pacioli according to the Account Books of Medieval Merchants," in *Studies in the History of Accounting*, A. C. Littleton and B. S. Yamey, eds. (Homewood, Ill., 1956).

9. As De Roover, "Development of Accounting," observed, double-entry bookkeeping originated in Italy, although possibly in Genoa before Florence, but in any case remained the exclusive province of Italian merchants even through the sixteenth century.

10. Concerning Pacioli's treatise on bookkeeping, see Edward Peragallo, *Origin and Evolution of Double Entry Bookkeeping: A Study of Italian Practice from the Fourteenth Century* (New York, 1938), pp. 55–56. For the passages concerning perspective from the *Divina proportione*, see Constantin Winterberg, ed., *Luca Pacioli; Divina Proportione* (Vienna, 1889) (*Quellenschrift für Kunstgeschichte, Neue Folge*, vol. 2), p. 40.

11. The most recent argument in favor of *Della pittura* being first is made by Maria Picchio Simonelli, "On Alberti's Treatises of Art and their Chronological Relationship," *Yearbook of Italian Studies, 1971* (Florence, 1972), pp. 82–92. See also Cecil Grayson, "The Text of Alberti's *De pictura*," *Italian Studies* 23 (1968): 71–92.

12. See Georg Wolff, "Leon Battista Alberti als Mathematiker," *Scientia* 60 (1936): 355–359.

13. In this and following chapters, I shall quote passages from Alberti's treatise as translated by Cecil Grayson from his *Leon Battista Alberti: On Painting and On Sculpture: The Latin Texts of De Pictura and De Statua edited with English Translations, Introduction, and Notes* (London, 1972) (hereafter cited as *De pictura*). Occasionally I shall also refer to the Italian version, published by Luigi Mallè as *Leon Battista Alberti; Della pittura, edizione critica* (Florence, 1950) (hereafter cited as *Della pittura*), and to the English translation by John R. Spencer, *Leon Battista Alberti On Painting* (New Haven, 1966). Spencer's text attempts to conflate both Italian and the Latin passages.

14. See Girolamo Mancini, ed., *Leonis Baptistae Alberti opera omnia* (Florence, 1890), pp. 47–65; also Alessandro Parronchi, "Sul significato degli *Elementi di pittura* di L. B. Alberti," *Cronache di archeologia e di storia dell'arte* 6 (1967): 107–115.

15. *De pictura*, pp. 56–57.

16. Ibid., pp. 54–55.

17. Ibid., pp. 56–57.

18. My translation. For Grayson's, which is the same in substance, see ibid., p. 57; the Latin original is on p. 56.

19. The prevailing interpretations of Alberti's *areola* or *picciolo spatio* are summarized as follows: It is an extra piece of paper on which the artist

makes a full-size or scale drawing (Panofsky); it is only an extra space outside the lateral margins of the picture area (Parronchi); it is an extra piece of paper, smaller than the intended picture space on which the artist sketches out his construction to scale beforehand (Grayson).

20. Grayson's textual find was originally reported in Cecil Grayson, "L. B. Alberti's 'costruzione legittima,'" *Italian Studies* 19 (1954): 14–28. My own reconstruction, which followed Grayson, was then published as Samuel Y. Edgerton, Jr., "Alberti's Perspective: A New Discovery and a New Evaluation," *The Art Bulletin* 48 (1966): 367–378.

21. Alberti decried just such an arithmetical means which he claimed some artists were using, based on an old Boethian number series called *superbipartiens*. See *De pictura*, pp. 54–55.

22. Edgerton, "Alberti's Perspective," pp. 373–375.

23. See, for instance, the fresco in the Lower Church of St. Francis at Assisi of *Jesus Among the Doctors*, attributed to an early fourteenth-century Sienese follower of Giotto, and also Ottaviano Nelli's c. 1415 *Circumcision* panel now in the Vatican Museum. Both of these works are illustrated with "bifocal" overlays in Edgerton, "Alberti's Perspective."

I V

1. For a synopsis of other views concerning Alberti's perspective, see Robert Klein, "Études sur la perspective a la Renaissance, 1956–1963," *Bibliothèque d'Humanisme et Renaissance; Travaux et Documents* 25 (1963): 577–587; Marisa Dalai, "La questione della prospettiva, 1960–1968," *L'arte*, N.S. 1 (1968): 96–105; Joan Gadol, *Leon Battista Alberti; Universal Man of the Renaissance* (Chicago, 1969), pp. 21 ff.

2. See my earlier discussion of these two drawings, including other interpretations of their perspective and their possible relationship—along with Alberti's perspective theories—to the court of Leonello d'Este of Ferrara, in Samuel Y. Edgerton, Jr., "Alberti's Perspective: A New Discovery and a New Evaluation," *The Art Bulletin* 48 (1966): 375–377.

3. I am grateful to Professor Creighton Gilbert for pointing out to me this and many other useful passages which I have cited in these pages. Meister Eckhart's text in original medieval German is given in Franz Pfeiffer, ed., *Meister Eckhart* (Leipzig, 1857), p. 139 (sermon XLI). Its relation to art history has also been pointed out by Carl Schnaase, *Geschichte der bildenden Kunst* (Düsseldorf, 1874), vol. 6, p. 36.

4. See *Sancti Antonini Summa Theologica* (Verona, 1740), reprinted in facsimile edition by the Akademische Druck-und Verlagsanstalt (Graz, 1959) pt. (Tomus) 1, Titulus III, Caput III, col. 118.

5. See Julius von Schlosser, *Lorenzo Ghiberti's Denkwürdigkeiten (I Comentarii)* (Berlin, 1912); Ottavio Morisani, ed., *Lorenzo Ghiberti; I commentari* (Naples, 1947); G. Ten Doesschate, *De derde commentaar van Lorenzo Ghiberti in verband met de middeleeuwsche optick* (Utrecht, 1940).

Notes

6. For more of Toscanelli, see Gustavo Uzielli, *La vita e i tempi di Paolo dal Pozzo Toscanelli* (Rome, 1894); Eugenio Garin, "Ritratto di Paolo dal Pozzo Toscanelli," in his *Ritratti di umanisti* (Florence, 1967), pp. 41–67; Giorgio de Santillana, "Paolo Toscanelli and his Friends," in his *Reflections on Men and Ideas* (Cambridge, Mass., 1968), pp. 33–47; Paul Lawrence Rose, "Humanist Culture and Renaissance Mathematics," *Studies in the Renaissance* 20 (1973): 46–106.

7. On the role of mathematics in medieval universities, especially at Padua, see Antonio Favaro, "I lettori di matematiche nella università di Padova dal principio del secolo XIV alla fine del XVI," *Memorie e documenti per la storia della università di Padova* 1 (1922): 1–70; also Nancy Siraisi, *Arts and Sciences at Padua: The Studium of Padua before 1350* (Toronto, 1973).

8. Ugolino Verino, *De illustratione urbis Florentiae*, published in *Carmine illustrium poetarum italorum* (Florence, 1724), 10, p. 347; the verse on Toscanelli reads as follows:

Quid Paulum memorem? terram qui norat et astra, qui prospective libros descripsit, et artem, egregius medicus, multos a morte reduxit.

9. Giorgio Vasari, *Le vite de'più eccellenti pittori scultori ed architettori . . . con nuove annotazioni e commenti di Gaetano Milanesi* (Florence, 1906), vol. 2, p. 333 (hereafter cited as *Vasari-Milanesi*):

Tornando poi da studio maestro Paulo dal Pozzo Toscanelli, e una sera trovandosi in un orto a cena con certi suoi amici, invitò Filippo, il quale, uditolo ragionare dell'arti matematiche, presse tal familiarità con seco, che egli imparò la geometria da lui; e sebbene Filippo non aveva lettere, gli rendeva sì ragione di tutte le cose con il naturale della pratica esperienza, che molte volte lo confondeva.

Similar references to Toscanelli's friendship with Brunelleschi are recorded in the *Codex Magliabechiano* life of Brunelleschi (see Karl Frey, ed. [Berlin, 1892], p. 62), and in the *Vita di Brunelleschi* by Antonio di Tuccio Manetti (see Howard Saalman, ed., and Catherine Enggass, trans., *The Life of Brunelleschi by Antonio di Tuccio Manetti* [University Park, Pa., 1970], pp. 409–410). Gustavo Uzielli in his *Paolo dal Pozzo Toscanelli iniziatore della scoperta d'America* (Florence, 1892) makes some even more interesting connections between the lives of the two men.

10. In Michele Savonarola, *De laudibus Pativii*, published by Arnaldo Segarizzi, ed., *Libellus de Magnificis Ornamentis Regie Civitatis Paduae Michaelis Savonarole* (Città di Castello, 1902), p. 55.

V

1. *De pictura*, pp. 40–41.

2. The work was translated as the *Vitae philosophorum* about 1435 by Ambrogio Traversari, humanist and minister general of the Camaldolite Order, at the behest of Cosimo de'Medici.

Notes

3. See R. D. Hicks, ed. and trans., *Diogenes Laertius: Lives of Eminent Philosophers* (London, 1931).

4. *De pictura*, pp. 40–41. It is of interest that in one of the fifteenth-century Latin manuscripts of *De pictura*, Bibl. Vat. Cod. Ottob. Lat. 1424, folio 3 verso, the word *anima* or "soul" is referred to in relation to the function of the eyes. This word is not in the same passage cited by Grayson, but if it is original to Alberti's lost holograph draft, then it is another instance of the author's knowledge of classical, Arab, and medieval optics, as these earlier optical writers frequently described the soul as being profoundly related to the power of seeing.

5. For the history of Greek optics, see Arthur Erich Haas, "Antike Licht-theorien," *Archiv für Geschichte der Philosophie* 20 (1907): 345–386. Incidentally, Alberti himself was much taken by the atomistic philosophy of Democritus and cited him often; see Eugenio Garin, "Alberti's Thought," *Encyclopedia of World Art* (New York, 1960), vol. 1, p. 207.

6. See Epicurus' letter to Herodotus in Hicks, *Diogenes Laertius*, vol. X, p. 48.

7. Euclid's complete optics is included in J. L. Heiberg and H. Menge, eds., *Euclidis opera omnia* (Leipzig, 1896), vol. 6, with Theon's *Recension* as vol. 7.

8. On Ptolemy, see Albert Lejeune, ed., *L'Optique de Claude Ptolémée* (Louvain, 1956); idem, *Euclide et Ptolémée; deux stades de l'optique geometrique grecque* (Louvain, 1948). Ptolemy's five-book *Optica* unfortunately arrived in the West without its most important and still lost first section.

9. *De usu partium* is available in Latin as vols. 3 and 4 in Karl Gottlob Kühn's edition, *Claudii Galeni opera omnia* (Leipzig, 1829). See also Rudolph E. Siegel, *Galen on Sense Perception* (New York, 1970).

10. The inclusion of scenography as a subscience under optics is specifically mentioned by Proclus Diadochus, fifth-century A.D. commentator on Euclid. The passage below has been translated by Morris R. Cohen and I. E. Drabkin, *A Source Book in Greek Science* (New York, 1948), p. 4:

Again optics and canonics are derived from geometry and arithmetic respectively. The science of optics makes use of lines as visual rays and makes use also of the angles formed by these lines. The divisions of optics are: a) the study which is properly called optics and accounts for illusions in the perception of objects at a distance, for example, the apparent convergence of parallel lines or the appearance of square objects at a distance as circular; b) catoptrics, a subject which deals in its entirety with every kind of reflection of light and embraces the theory of images; c) scenography, as it is called, which shows how objects at various distances and of various heights may be so represented in drawings that they will not appear out of proportion and distorted in shape.

11. Vitruvius, *De architectura*, I, chap. 2, 2, and VII, praef. 11. See Frank Granger, ed. and trans., *Vitruvius on Architecture* (London, 1934), vol. 1, pp. 26–27, and vol. 2, pp. 70–71:

Item scaenographia est frontis et laterum abscedentium adumbratio ad

Notes

circinique centrum omnium linearum responsus. . . . Namque primum Agatharchus Athenis Aeschylo docente tragoediam ad scaenam fecit, et de ea commentarium reliquit. Ex eo moniti Democritus et Anaxagoras de eadem re scripserunt, quemadmodum oporteat, ad aciem oculorum radiorumque extentionem certo loco centro constituto, ad lineas ratione naturali respondere, uti de incerta re incertae imagines aedificiorum in scaenarum picturis redderent speciem et, quae in directis planisque frontibus sint figurata, alia abscedentia, alia prominentia esse videantur. The English translations of Vitruvius here and their Latin originals are at best only "neutral" renditions. For some interesting interpretations, see Erwin Panofsky, "Die Perspektive als 'symbolische Form,'" *Vorträge der Bibliothek Warburg; 1924–1925* (Leipzig, 1927), p. 265, notes 18 and 19, pp. 301 ff.; also John White, *Birth and Rebirth of Pictorial Space* (London, 1967), pp. 251–258. Panofsky's translation may be considered a bit forced, to the end of supporting his thesis that the ancients considered visual space as curved; hence that of White is more trustworthy. For more on the subject of antique perspective, see White, *Birth and Rebirth*, pp. 258–273.

12. See Chapter IV, note 5.

13. *De pictura*, pp. 56–57:
As we can judge easily from the works of former ages, this matter probably remained completely unknown to our ancestors because of its obscurity and difficulty. You will hardly find any *istoria* of theirs properly composed either in painting or modelling or sculpture.

14. On the translation of Arab manuscripts during the twelfth century, see Charles Homer Haskins, *The Renaissance of the Twelfth Century* (Cambridge, Mass., 1927).

15. See David C. Lindberg, "Alkindi's Critique of Euclid's Theory of Vision," *Isis* 62 (1971): 469–489.

16. See Graziella Federici Vescovini, *Studi sulla prospettiva medievale* (Turin, 1965), pp. 77–88.

17. See David C. Lindberg, "Alhazen's Theory of Vision and its Reception in the West," *Isis* 58 (1967): 321–341. Also useful but difficult to acquire is A. C. Crombie, "The Mechanistic Hypothesis and the Scientific Study of Vision: Some Optical Ideas as a Background to the Invention of the Microscope," *Proceedings of the Royal Microscopal Society* 2, pt. 1 (1967): 3–113.

18. See Carlo Malagola, ed., *Statuti delle università e dei collegi dello Studio Bolognese* (Bologna, 1888), p. 276.

19. The idea of the eye as a "living mirror" was also expressed by Democritus, Alberti's favorite Greek philosopher, in Aristotle's *De sensu et sensibili*, a text Alberti very likely studied in Bologna (see Malagola, *Statuti*, p. 252). See *De sensu*, II, 438a; also J. L. Beare, *Greek Theories of Elementary Cognition from Alcmeon to Aristotle* (Oxford, 1906), p. 25.

20. See Enrico Narducci, "Intorno da una traduzione italiana fatta nel secolo decimoquarto, del trattato d'ottica d'Alhazen, matematico del secolo undecimo," *Bullettino di bibliografia e di storia delle scienze matematiche e fisiche* 4 (1871): 1–48.

Notes

21. Alhazen's lengthy optical treatise was first printed in the West by Frederick Risner in *Optica thesaurus Alhazeni Arabis libri septem item Vitellonis Thuringopolonis opticae libri decem* (Basel, 1572). This work has been recently reissued by the Johnson Reprint Corporation (New York, 1972), David C. Lindberg, ed. Risner's large publication no doubt also inspired Johannes Kepler to title his own compendium on optics *Ad Vitellionem paralipomena* or "supplement to Witelo" in 1604. Although Kepler was ostensibly arguing against Witelo, the thirteenth-century Polish scholar whose optical treatise was bound in with Alhazen's in the Risner edition, it was really Alhazen himself he was attacking. Alhazen's ingenious explanation of how the light rays pass into the eye, make their "image" on the crystallinus, and then become refracted (all save the centric ray) in the vitreous humor in order to pass the image upright to the optic nerve and brain, was finally proven wrong by Kepler. Following the experiments by Felix Platter, Kepler proved that the crystalline lens was not the seat of visual power but merely a dioptric focusing agent of light rays upon the sensitive retina at the back of the eye. In spite of the fact that in Kepler's explanation the visual image in the eye remains inverted, he proved that this is in fact the way we "see."

22. Lindberg, "Alhazen's Theory," p. 322.

23. I am indebted at this point to Professor A. I. Sabra of Harvard University for helping me understand Alhazen's complex theory of vision.

24. For a discussion of this paragraph, see David C. Lindberg, *John Pecham and the Science of Optics: Perspectiva communis* (Madison, Wisc., 1970), p. 19.

25. See St. Antonine's chapter entitled *De duodecim proprietatibus divinae gratiae ad similitudinem lucis materialis* in his *Summa Theologica* (Verona, 1740), reprinted in facsimile by the Akademische Druck-u. Verlagsanstalt (Graz, Austria, 1959), pt. (tomus) 4, titulus IX, caput I, col. 462 f.

26. Grosseteste's works, including his papers pertinent to our discussion, *De lineis, angulis, et figuris seu de fractionibus et reflexionibus radiorum* and *De luce seu de inchoatione formarum*, have been edited and republished by Ludwig Baur, "Die philosophischen Werke des Robert Grosseteste, Bischof von Lincoln," *Beiträge zur Geschichte der Philosophie des Mittelalters* (Münster/W., 1912), vol. 9, pp. 59–65, 51–59. See also A. C. Crombie, *Robert Grosseteste and the Origins of Experimental Science: 1100–1700* (Oxford, 1961), pp. 99 ff; also E. J. Dijksterhuis, *The Mechanization of the World Picture* (Oxford, 1961), pp. 145–152.

27. On this see Vescovini, *Studi sulla prospettiva medievale*, p. 10.

28. The entire Latin text of Bacon's *Opus majus* as well as the *De multiplicatio specierum* has been published by John Henry Bridges, ed., *The Opus Majus of Roger Bacon*, 2 vols. (London, 1897). It has also been translated into English by Robert Belle Burke, *The Opus Majus of Roger Bacon*, 2 vols. (Philadelphia, 1928) (republished in facsimile, 1962).

29. *Opus majus*, V, I, dist. 7, chap. 4 (Burke, vol. 2, p. 470; Bridges, vol. 2, p. 52).

Notes

30. Lindberg, *John Pecham*, p. 29, note 69.

31. See Vescovini, "La questioni di 'Perspectiva' di Biagio Pelacani da Parma," *Rinascimento* 1, second ser. (1961): 163–245. The *Quaestiones* itself has never been published in its entirety. Manuscript copies, however, are found in the Biblioteca Laurenziana, Plut. 29, cod. 18, and Cod. Ash. 1042.

32. The Plut. 29, cod. 18 manuscript of Blasius' treatise is inscribed at the end with the name "Bernardus Andreae de Florentia." This Bernardus may then be the same "Magister Bernardus Andreae Bonaventure" recorded in 1425 as the newly elected vicerector of the Florentine university and occupant of the chair of astrology and surgery in 1439 (see Alessandro Gherardi, *Statuti della università e studio fiorentine* [Florence, 1881], pp. 406–444 [*Documenti di storia italiana*, vol. 7]).

33. The text of *Della prospettiva* is published in full in Alessandro Parronchi, *Studi su la dolce prospettiva* (Milan, 1964), pp. 599–645. Parronchi's convincing arguments about Toscanelli's authorship are also in his book, beginning on pp. 506–510, and 583 ff. It is interesting that *Della prospettiva* was also once attributed to Alberti himself (see Anicio Bonucci, *Opera volgari di Leon Battista Alberti* [Florence, 1843], vol. 4).

34. Parronchi has already made this same argument in *Studi su la dolce prospettiva*, pp. 226–296.

VI

1. *De pictura*, pp. 36–37.

2. Ibid.

3. It is always interesting to compare Alberti's picturesque language to the dull statements of the scientific texts from which he borrowed his ideas. Below are Euclid's definitions of point, line, and plane from the *Elementa* (see J. L. Heiberg and H. Menge, eds., *Euclidis opera omnia* [Leipzig, 1896], vol. 1, defs. 1–6):

> 1. Punctum est, cuius pars nulla est.
> 2. Linea autem sine latitudine longitudine.
> 3. Linea autem extrema puncta.
> 4. Recta linea est, quaecunque ex aequo punctis in ea sitis iacet.
> 5. Superficies autem est, quod longitudinem et latitudinem solum habet.
> 6. Superficiei autem extrema lineae sunt.

4. Leonardo Olschki, *Die Literatur der Technik und der angewandten Wissenschaft: Geschichte der neusprachlichen wissenschaftlichen Literatur vom Mittelalter bis zum Renaissance* (Heidelberg, 1919), vol. 1, p. 67. Fibonacci's geometry, by the way, was also available in Italian during the fifteenth century and has recently been republished; see Gino Arrighi, ed., *Leonardo Fibonacci: la pratica di geometria; volgarizzata da Cristofano di Gherardo di Dino, cittadino pisano, dal codice 2186 della Biblioteca Riccardiana di Firenze* (Pisa, 1966) (*Testimonianze di Storia della Scienze*, 3).

Notes

5. *De pictura*, p. 36.

6. Medieval arguments over this issue are discussed by Graziella Federici Vescovini, *Studi sulla prospettiva medievale* (Turin, 1965), pp. 213–237.

7. Published by Girolamo Mancini, ed., *Leonis Baptistae Alberti opera inedita* . . . (Florence, 1890), p. 66:

Puncta et lineae hic apud pictores sunt non quae apud mathematicos, ut in linea cadant puncta infinita. Ex nostra diffinitione punctum est signum quod ipsum pictor sentiat veluti medium quoddam inter punctum mathematicum et quantitatem quae cadat sub numero, quales forte sunt atomi. Tum et suscipit a natura pictor quae imitetur, cum lineas et angulos, tum et superficierum colores et lumina, quarum quodcumque cadit sub numero et partibus constat divisibus non facto sed natura. Aut quis dixerit tot esse radios luminis in linea pedali aeque atque in bipedale? Et sunt demum ob hoc possibilia fieri, ob hoc infinita non sunt ex rationibus possibilium operum, Hic paucis sat sit respondisse obstrectatoribus.

For some further consideration as to the significance of this passage, see G. Nicco Fasola, ed., *Piero della Francesca: De prospectiva pingendi* (Florence, 1942), p. 65, note 1.

8. *De pictura*, pp. 36–37.

9. In his *Elementa picturae*, Alberti expressed the same idea of "edge" with the word *discremen*, meaning "separation." In the Italian *Elementi di pittura*, he used the term *lembo*.

10. *De pictura*, pp. 38–39.

11. Pecham, *Perspectiva communis*, I, 71, in David C. Lindberg, *John Pecham and the Science of Optics: Perspectiva communis* (Madison, Wisc., 1970), p. 145.

12. *De pictura*, pp. 40–41.

13. *Ibid.*

14. Ibid., pp. 42–43.

15. Ibid.

16. Ibid.

17. Samuel Y. Edgerton, Jr., "Alberti's Color Theory: A Medieval Bottle Without Renaissance Wine," *Journal of the Warburg and Courtauld Institutes* 32 (1969): 109–135.

18. *De pictura*, pp. 42–45.

19. *Il Convivio*, II, 10 (E. Moore and P. Toynbee, eds., *Le opere di Dante Alighieri* [Oxford, 1924], pp. 261–262):

E qui si vuole sapere, che avvegnaché più cose nell' occhio a un'ora possano venire, veramente quella che viene per retta linea nella punta della pupilla, quella veramente si vede, e nella imaginativa si suggella solamente. E questo è, perocchè il nervo, per lo quale corre lo spirito visivo, è diritto a quella parte; e però veramente l'un occhio l'altro occhio non può guardare, sicchè esso non sia veduto da lui; che siccome quello che mira riceve la forma nella pupilla per retta linea, così per quella medesima linea la sua forma se ne va in quello cui mira. . . .

20. See Torgil Magnusson, *Studies in Roman Quattrocento Architecture* (Stockholm, 1958), pp. 65–97.

Notes

21. Alberti's treatise on architecture is available in English as Joseph Rykwert, ed., *Ten Books on Architecture by Leone Battista Alberti translated ... by James Leoni* (London, 1965) (facsimile of 1726 edition).

22. *De pictura*, pp. 48–49.

23. Ibid., pp. 50–51. Proposition 21 is given in Heiberg and Menge, *Euclidis opera omnia*, vol. 6, p. 179.

24. Roger Bacon, *Opus majus*, V, I, dist. 6, chap. 1. Available in Robert Belle Burke, trans., *The Opus Majus of Roger Bacon*, 2 vols. (Philadelphia, 1928), vol. 2, p. 455; John Henry Bridges, ed., *The Opus Majus of Roger Bacon*, 2 vols. (London, 1897), vol. 2, p. 36.

25. *De pictura*, pp. 52–53. Bacon's passage is not the only possible source in this case. As Parronchi has already shown, Blasius of Parma recited the same idea once more in his *Quaestiones perspectivae*. See Alessandro Parronchi, *Studi su la dolce prospettiva* (Milan, 1964), p. 259.

26. As translated by Kenneth Clark in "Leon Battista Alberti on Painting," *Proceedings of the British Academy* 30 (1944): 284. The original Italian text is given in Anicio Bonucci, *Opere volgari de Leon Battista Alberti* (Florence, 1843), vol. 1, pp. cii–civ.

27. W. M. Ivins, Jr., *On the Rationalization of Sight; with an Examination of Three Renaissance Texts on Perspective* (New York, 1938).

28. *De pictura*, pp. 46–47.

29. These observations on reflected rays of light go back to Aristotle's school; see *De coloribus*, 793b. Observations on the effects of reflected color, similar to Alberti's statement about "walking about in meadows," were also made by Ptolemy in his *Optica*, II, 13–21, and Galen in his *De Hippocrates et Platonis*, VII, 7. See also Mohammed Achena and Henry Massé, eds., *Avicenne; la livre de science II, physique et mathématiques* (Paris, 1958), p. 38.

30. Georg Wolff, "Zu Leon Battista Albertis Perspektivlehre," *Zeitschrift für Kunstgeschichte*, N.F. 5 (1936): 47–55.

31. *De pictura*, pp. 68–69.

VII

1. L. D. Ettlinger, "Pollaiuolo's Tomb of Pope Sixtus IV," *Journal of the Warburg and Courtauld Institutes* 16 (1953): 258–261.

2. Ibid., p. 258. See also David C. Lindberg, *John Pecham and the Science of Optics* (Madison, Wisc., 1970), p. 32. The Latin inscription from Pecham reads as follows:

Sine luce nihil videtur/ Visio fit per lineas radiosas recte super occulum mittentes/ Radius lucis in rectum semper porrigitur nisi curvetur diversitate medii/ Incidentiae et reflectionis anguli sunt aequales.

3. Contextual discussion of this passage is given in Vassily Zubov, *Leonardo da Vinci* (Cambridge, Mass., 1968), pp. 131 ff.

4. Hans Baron, *The Crisis of the Early Italian Renaissance*, rev. ed. (Princeton, N.J., 1966). For another insight into this new visual awareness

of the early humanists, see Creighton Gilbert, "The Earliest Guide to Florentine Architecture, 1423," *Mitteilungen des Kunsthistorischen Instituts in Florenz* 14 (1969): 33-46.

5. Frederick Hartt, "Art and Freedom in Quattrocento Florence," in *Essays in Honor of Karl Lehmann*, ed. Lucy Freeman Sandler (New York, 1964), pp. 114-131.

6. Dagobert Frey, *Gotik und Renaissance als Grundlagen der modernen Weltanschauung* (Augsburg, 1929), pp. 20 ff.

7. Joan Gadol, *Leon Battista Alberti: Universal Man of the Early Renaissance* (Chicago, 1969), pp. 70-74.

8. For a general discussion of Ptolemy's atlas, see Lloyd Brown, *The Story of Maps* (Boston, 1950), pp. 152 ff. Ptolemy's atlas was well known in the Byzantine world and in Islam after its writing in the second century A.D., but until the fifteenth century had completely escaped the notice of the West. For the best account of how the members of the Greek Academy brought it to Europe, see Joseph Fischer, S. J., *Claudii Ptolemaei Codex Urbinas Graecus 82* (Leipzig, 1932), vol. 1, pp. 186 ff.

9. This is the *Carta pisana* of c. 1275, now in the Bibliotheque Nationale, Paris. See E. G. R. Taylor, *The Haven Finding Art* (New York, 1957), pp. 109-111.

10. Ibid., pp. 109 ff; also Roberto Almagià, *Planisferi carte nautiche e affini dal secolo XIV al XVII esistenti nella Biblioteca Apostolica Vaticana* (Vatican City, 1944), vol. 1, pp. 13-16.

11. Such as the *Codex Urbinas;* see Fischer, *Claudii Ptolemaei.*

12. See Gustavo Uzielli, *La vita e i tempi di Paolo dal Pozzo Toscanelli* (Rome, 1894), pp. 392 ff. These original maps, like the holograph of the Jacopo d'Angiolo translation, are no longer extant.

13. See the biographies of Francesco di Lapacino, Domenico di Lionardo Boninsegni, Palla Strozzi, and Alessandro de'Bardi in Vespasiano de'Bisticci, *Le vite di uomini illustri del secolo XV*, ed. Paolo d'Ancona and Erhard Oeschlimann (Milan, 1961).

14. This first Renaissance "correction" of Ptolemy was made by a Danish geographer named Claudius Clavus. See Brown, *The Story of Maps*, pp. 77-78.

15. See Francis M. Rogers, *The Travels of the Infante Dom Pedro of Portugal* (Cambridge, Mass., 1961).

16. See Frederick Hartt, Gino Corti, and Clarence Kennedy, *The Chapel of the Cardinal of Portugal, 1434-1459* (Philadelphia, 1964), p. 29 and passim for a background of the relationship between Portugal and Florence during the fifteenth century. Also Uzielli, *La vita e i tempi di Toscanelli*, pp. 133 ff.

17. For something of the relation between this religious council and the later council of Florence, see Thomas Goldstein, "Fifteenth Century Geography Against the Background of Medieval Science" (Address before the Society for the History of Discoveries, Salem, Mass., November 13-14, 1964). Also his "Geography in 15th Century Florence," in *Merchants and Scholars*, ed. John Parker (Minneapolis, 1965), pp. 11-32.

Notes

18. Fischer, *Claudii Ptolemaei*, p. 191.

19. Edmond Buron, ed. and trans., *Ymago mundi de Pierre d'Ailly*, 3 vols. (Paris, 1930).

20. See Samuel Eliot Morison, *Journals and Other Documents on the Life and Voyages of Christopher Columbus* (New York, 1963); idem, *Admiral of the Ocean Sea* (Boston, 1942), vol. 1, pp. 121–125.

21. Bibl. Naz., Cl. XIII, 16, Lat. The title page states that the maps were drawn by Henricus Martellus Germanus. The decorations around the charts were done by Gherardo and Monte di Giovanni da Firenze, probably the same Gherardo del Fora (1444/5–1497) and his brother Monte (1448–?) who are listed in Thieme-Becker (Ulrich Thieme and Felix Becker, *Allgemeines Lexikon der bildenden Künstler* [Leipzig, 1920], vol. 13, pp. 525–526) as painters and miniaturists in Florence working in the manner of Domenico Ghirlandaio. It is also interesting that Lorenzo Ghiberti, too, writing in his *Commentari*, showed an interest in Ptolemy's *Geographia*. In describing the marvels of Simone Martini's art, Ghiberti remarks on a painting by the latter in the Palazzo Pubblico in Siena of a map of the world. Since the work was done in the previous century, Ghiberti observed, even as he admired the painting, "Non c'era allora notizia della cosmografia di Tolomeo, non è da maravigliare se la sua non è perfetta. (See Ottavio Morisani, ed., *Lorenzo Ghiberti I Commentari* (Naples, 1947), p. 38.

22. A full explanation of these first two mapping methods is given in Hans V. Mžik and Friedrich Hopfner, "Das Klaudios Ptolemaios Einführung in die darstellende Erdkunde," *Klotho* 5 (1938). The original atlas which Jacopo d'Angiolo and Chrysoloras brought back to Florence is lost, but there do exist many parallel Greek examples. The most famous of these is Codex Urbinas 82 now in the Vatican Library in Rome (see Fischer, *Claudii Ptolemai*) which may have belonged to Palla Strozzi. In the illustrated Greek atlases of this type, the *mappamundi* is projected by Ptolemy's first method. His second, more complicated spherical projection was first applied generally in the Latin translation after Nicolas Donis Germanus, a Benedictine monk working in Florence during the third quarter of the fifteenth century. See Brown, *The Story of Maps*, p. 154; Leo Bagrow, *History of Cartography* (Cambridge, Mass., 1964), pp. 78–79.

23. For a mathematician like Ptolemy it was important that his halfway latitude have astronomical significance. Syene was selected because at that place the sun can light up a well at high noon at the summer solstice. In other words, the sun stands near the zenith there every June 21.

24. Mžik and Hopfner, "Ptolemaios Einführung," p. 70. The Ptolemaic atlases are not illustrated at this point. My diagram is an adaptation from the text based on the reconstruction by Mžik and Hopfner. Ptolemy's own explanation is found in his Book Two, chap. 24.

25. Concerning this "distance point method" see Timothy K. Kitao, "Prejudice in Perspective: A Study of Vignola's Treatise," *The Art Bulletin* 44 (1962): 173–195.

26. The earliest Ptolemaic atlas that I have seen which shows a reconstruction of Ptolemy's third mapping method is the edition edited by Marco Beneventano, published in Rome, 1507 and subsequently.

Notes

27. O. Neugebauer, "Ptolemy's Geography, Book VII, Chapters 6 and 7," *Isis* 50 (1959): 22–29.

28. See K. Manitius and O. Neugebauer, eds., *Ptolemäus; Handbuch der Astronomie* (Leipzig, 1963), vol. 2, p. 72 (Book Eight, chap. 3).

VIII

1. O. Neugebauer, "Ptolemy's Geography, Book VII, Chapters 6 and 7," *Isis* 50 (1959): 23.

2. See discussion of such "distance point" methods in Timothy Kitao, "Prejudice in Perspective: A Study of Vignola's Treatise," *The Art Bulletin* 44 (1962): 173–195.

3. Neugebauer, "Ptolemy's Geography," p. 23.

4. Ibid., pp. 26–29. Ptolemy's purpose of course was, as in both his other methods of projection, to produce a clear and legible map. To achieve this even in his third method, he could not allow perspective distortions to interfere with comprehending the *oikumene*. His final drawing therefore did deviate from true perspective in that the *oikumene* itself did not actually conform to the perspective of the globe. It would even seem that he intended the *oikumene* to be drawn as a kind of isometric inset into the otherwise perspectively constructed world picture, with real distances betwen meridians and parallels being preserved as much as possible.

5. Ibid., p. 24. Ptolemy's color theory here derives from his expressions on atmospheric perspective in his *Optica*. See Samuel Y. Edgerton, Jr., "Alberti's Color Theory: a Medieval Bottle without Renaissance Wine," *Journal of the Warburg and Courtauld Institutes* 32 (1969): 109–135.

6. See Hans V. Mžik and Friedrich Hopfner, "Das Klaudios Ptolemaios Einführung in die darstellende Erdkunde," *Klotho* 5 (1938): 13, note 3. This passage from Book I, chap. 1 of the *Geographia* is a reasonably correct translation from the Latin version after the Greek original—in other words, as it became known in Florence. English translation of the whole of the Latin *Geographia* is found in Edward Luther Stevenson, *Ptolemy's Geography* (New York, 1932).

7. From Book I, chap. 19; see Mžik and Hopfner, "Ptolemaios Einführung," p. 61.

8. See John Kirtland Wright, "Notes on the Knowledge of Latitudes and Longitudes in the Middle Ages," *Isis* 15 (1922): 75–98; O. Neugebauer, "Mathematical methods in Ancient Astronomy," *Bulletin of the American Mathematical Society* 54 (1948): 1013–1014; Paul Lawrence Rose, "Humanist Culture and Renaissance Mathematics; The Italian Libraries of the Quattrocento," *Studies in the Renaissance* 20 (1973): 46–106.

9. Book I, chap. 3, pt. 1; see Mžik and Hopfner, "Ptolemaios Einführung," p. 20.

10. Concerning the application of "grid systems" in Europe prior to the Quattrocento, see D. J. Price, "Medieval Land Surveying and Topographical Maps," *The Geographical Journal* 121 (1955): 1–10; also Richard

Notes

Krautheimer and Trude Krautheimer-Hess, *Lorenzo Ghiberti* (Princeton, N.J., 1956), p. 237. The oldest surviving portolan chart, the so-called *Carta Pisana*, dating from about 1275 and now in the Bibliothèque Nationale in Paris, also shows a simple grid device over the compass rose. Indeed, the psychotic Opicinus de Canistris in the fourteenth century used a grid to frame his weirdly erotic map of Pavia (1336–1337); see Richard G. Salomen, "Aftermath to Opicinus de Canistris," *Journal of the Warburg and Courtauld Institutes* 25 (1962): 141–146.

11. Giovanni Cavalcanti, *Istoria Fiorentine* (Florence, 1838), vol. 1, ix, p. 20:

> E così l'occhio è regolo e sesta dei paesi lontani, e delle longitudini e linee incorporee. Ogni cosa si comprende sotto la dottrina geometrica, e con l'ajuto dell'aritmetica arte noi veggiamo che ci è una regola a misurare . . . col'occhio. . . .

12. See Procacci's comments in *The Great Age of Fresco*, Catalogue to an Exhibition of Mural Paintings and Monumental Drawings, Metropolitan Museum of Art (New York, 1968), p. 29. See also Millard Meiss, *The Great Age of Fresco: Discoveries, Recoveries, and Survivals* (New York, 1970), pp. 124–127.

13. Luigi Vagnetti, "La 'Descriptio Urbis Romae' di L. B. Alberti," *Quaderno n. 1*, Università degli studi di Genova; Facoltà di Architettura . . . (October 1968): 25–81; also Giovanni Orlandi, "Nota sul testo della 'Descriptio Urbis Romae' di L. B. Alberti," ibid: 81–91. Leonardo da Vinci also carried on an interest in cartography and made similar adaptations of the Ptolemaic method; see M. Baratta, ed., *I disegni geografici: Leonardo da Vinci* (Rome, 1941); L. Heydenreich, *Leonardo da Vinci* (New York, 1954), vol. 1, pp. 86–89. Most recently in English, although before publication of Vagnetti's researches, Joan Gadol has written a clear and revealing account of Alberti's mapping techniques in *Leon Battista Alberti; Universal Man of the Early Renaissance* (Chicago, 1969), pp. 70–76.

14. See Cecil Grayson, *Leon Battista Alberti On Painting and On Sculpture* (London, 1972), pp. 140–141.

15. *De pictura*, pp. 68–69.

16. Ibid.

17. Howard Saalman, ed., and Catherine Enggass, trans., *The Life of Brunelleschi by Antonio di Tuccio Manetti* (University Park, Pa., 1970), pp. 52–53, also p. 132, note 34. The Italian text reads as follows: ". . . in su striscie di pergamene che si lieuano per riquadrare le carte con numero d'abaco e caratte che Filippo intendeva per se medesimo."

18. This remarkable letter, which was the cause of so much controversy in the late nineteenth century, is now generally regarded as genuine; see Samuel Eliot Morison, *Journals and Other Documents on the Life and Voyages of Christopher Columbus* (New York, 1963), pp. 11–17.

19. While the map itself is missing, there does seem to exist in the Biblioteca Nazionale at Florence a simple *carta riquadrata* by Toscanelli—that is, a plain piece of parchment lettered and numbered at the sides for the placement of longitudes and latitudes without any further geographic

notations. For an unsubstantiated argument in favor of the existence of a real Toscanelli map, see Sebastiano Crino, *Come fu scoperta l'America* (Milan, 1943).

20. For Pius' writing see the printed edition *Aeneae Sylvii Piccolominei postea Pii II Papae opera Geographica et Historica* (Helmstadt, 1699–1700), chap. 4, pp. 10–11. On Pius' buildings in Pienza, see Enzo Carli, *Pienza, la città di Pio II* (Rome, 1967).

21. Toscanelli is recorded as being inscribed in the *Arte* (guild) of doctors and druggists in Florence, on June 21, 1425 (see the *Enciclopedia Italiana*, 1937 edition, vol. 34, p. 105). Most scholars agree that he probably returned to Florence about a year earlier and met Brunelleschi within that time. See, for instance, Gustavo Uzielli, *La vita e i tempi di Paolo dal Pozzo Toscanelli* (Rome, 1894), pp. 37 ff.

22. For more on the relationship between Brunelleschi and Toscanelli, see Cornelius Fabriczy, *Filippo Brunelleschi, sein Leben und seine Werke* (Stuttgart, 1892), pp. 6–7 and passim; Gustavo Uzielli, *Paolo dal Pozzo Toscanelli, iniziatore della scoperta d'America* . . . (Florence, 1892). J. G. Lemoine ("Brunelleschi et Ptolémée: les origines géographiques de la 'boite d'optique'," *Gazette de beaux arts* 51 [1958]: 281–296) has tried to prove a direct, point-by-point influence between Brunelleschi's perspective device and Ptolemy's second projection system. The author, in my opinion, has misunderstood Ptolemy's method in the first place and clearly overstates the case for Brunelleschi's application of it.

IX

1.

. . . e così credo che Pippo de Ser Brunellesco fiorentino trovasse il modo di fare questo piano che veramente fu una sottile e bella cosa; per ragione trovasse quello, che nello specchio ti si dimostra. . . .

Cf. John Spencer, ed., *Filarete's Treatise on Architecture* (New Haven, Conn., 1966), vol. 2, folio 178 recto.

2. See Howard Saalman, ed., *The Life of Brunelleschi by Antonio di Tuccio Manetti* (University Park, Pa., 1970), pp. 10–20. Brunelleschi's perspective experiments are also described by Vasari (see Vasari-Milanesi, vol. 2, pp. 332 ff.), but Vasari's account was taken largely from Manetti. Vasari, of course, was writing nearly one hundred and fifty years after the fact.

3. In spite of many scholarly writings which cite Donatello's *St. George* relief (1417) as the "earliest perspective," it is not an example of *linear* perspective. The few orthogonals that can be traced from the bit of floor on the right side only vaguely focus on a disputable horizon line. One can hardly imagine Donatello or anyone else who had just been shown the momentous innovation of linear perspective giving it such paltry exercise as revealed in the feeble architecture of this relief. For concurring opinion

Notes

to mine, see H. W. Janson, *The Sculpture of Donatello* (Princeton, N.J., 1957), pp. 29–32. See Janson also (p. 68 ff.) for a concurring opinion on the dating and perspective achievement of the *Feast of Herod*. Concerning the dating of Masaccio's *Trinity*, see Ursula Schlegel, "Observations on Masaccio's *Trinity* fresco in Santa Maria Novella," *The Art Bulletin* 45 (1963): 19–33. The most recent work discussing Masaccio's own perspective achievement is Joseph Polzer, "The Anatomy of Masaccio's *Trinity*," *Jahrbuch der Berliner Museen* 13 (1971): 18–59.

4. The best clue as to whether or not an Italian Renaissance painting has been done prior to or after Brunelleschian rules of linear perspective is what I have called in Chapter II "horizon line isocephaly," wherein all heads of the depicted figures are level with the perspective horizon line. While Brunelleschi's own two panels contained, as far as is known, no painted figures, this rule would have been implicit nonetheless, as is indeed apparent in the 1427 frescoes of Brancacci Chapel by Masaccio and Masolino—that is, several years before Alberti himself described the axiom in his treatise on painting. As far as I know, there exists *no* picture anywhere in the world before 1425 which shows a clear and distinct understanding of this concept. After 1425, however, the examples are numerous. Not only are there those by Masaccio, Masolino, and Donatello, but others by Fra Angelico and, unexpectedly, by the Gothic-minded Sassetta which show some application of this perspective rule between 1425 and 1435. For instance, Fra Angelico understood horizon line isocephaly when he painted the predella panels (particularly *St. Peter Preaching*) for his 1433 Linaiuoli Altarpiece, now in the Museo San Marco, Florence. Sassetta, or perhaps his follower, the so-called Osservanza Master, applied the same to his otherwise quite medieval looking panel *The Dying Virgin Taking Leave of the Apostles* in the Berenson Collection, Villa I Tatti, Florence, done about 1435. Masolino also, even after the death of Masaccio in 1428, continued to employ horizon line isocephaly in his pictures, such as in the commissions for Cardinal Branda in San Clemente, Rome, and at Castiglione d'Olona.

5. This translation has been adapted from John White, *Birth and Rebirth of Pictorial Space* (London, 1968), pp. 114, 116, 117. For a more readable if less literal translation, see Saalman, *The Life of Brunelleschi*, pp. 42–46. Saalman's translation is by Catherine Enggass. The original Italian text is published in the above mentioned book in facing page translation. The Italian text is also given in Elena Toesca, ed., *Vita di Brunelleschi* (Florence, 1927), pp. 10–12.

6. It has frequently been suggested that Brunelleschi's two perspective panels remained in the Medici collections at least through the fifteenth century. A long inventory, dated 1494, of the Medici Palace in Florence published by Eugène Müntz (*Les collections des Médicis au XVe siècle* [Paris, 1888], p. 62) mentions *uno quadro di legno dipintovi el duomo e san Giovanni* and *uno panno dipintovi drento il palagio de Signori* hanging in the room "above the stairs which you pass on going to the loggia." The first of these Medici pictures in the inventory seems to be describing a

Notes

view of the Duomo as well as the Baptistery, which does not, of course, conform to Manetti's account of what was in the original perspective picture. It would be equally hard to ascribe the other Medici picture of the Palazzo Vecchio to Brunelleschi on the basis of the 1494 entry. As Manetti noted, the same setting was painted by Paolo Uccello. Perhaps, then, the Medici inventory refers to Paolo's example rather than Brunelleschi's. Sadly, we must conclude that, except for Manetti's own recollection, no other trace of how these two pictures appeared has survived the fifteenth century.

7. Erwin Panofsky, *The Codex Huygens and Leonardo da Vinci's Art Theory* (London, 1940), p. 93, and Richard Krautheimer and Trude Krautheimer-Hess, *Lorenzo Ghiberti* (Princeton, N.J., 1956), pp. 235 ff. For an argument against the Krautheimer reconstruction, see Timothy Kitao, "Prejudice in Perspective: A Study of Vignola's Perspective Treatise," *The Art Bulletin* 44 (1962): 175–176, note 6.

8. According to Vasari (Vasari-Milanesi, vol. 2, p. 332), Brunelleschi did construct his perspective by means of a "plan" and "profile":

Attese molto alla prospettiva, allora molto in male uso per molte falsità che vi si facevano: nella quale perse molto tempo, per fino che egli trovò da sè un modo che ella potesse venir giusta e perfetta, che fu il levarla con la pianta e profilo e per via della intersegazione. . . .

9. On the complex problems of distance point construction versus *costruzione legittima* or vanishing point perspective, as argued by scholars over the past hundred years, see Edgerton, "Brunelleschi's First Perspective Picture," *Arte Lombarda* 18 (1973): 187–194.

10. In fact, only two fifteenth-century Italian paintings can be said with any authority to have been so constructed: Masaccio's *Trinity* and Piero della Francesca's *Flagellation*. See, respectively, H. W. Janson, "Ground Plan and Elevation in Masaccio's *Trinity* Fresco," in *Essays in the History of Art Presented to Rudolf Wittkower*, ed. Douglas Fraser, Howard Hibbard, and Milton J. Lewine (London, 1967), pp. 83–88, and Rudolf Wittkower and B. A. R. Carter, "The Perspective of Piero della Francesca's *Flagellation*," *Journal of the Warburg and Courtauld Institutes* 16 (1953): 292–302. See also Fernando Casalini, "Corrispondenze fra teoria e pratica nell'opera di Piero della Francesca," *L'arte* 1 (N.S.) (1968): 62–95.

11. Saalman, *Life of Brunelleschi*, pp. 42–43: "E da luj e nato la regola, che e la importanza di tutto quello che di cio se fatto da quel tempo in qua."

12. White, *Birth and Rebirth*, pp. 116–121, gives an interesting, if speculative, discussion on how Brunelleschi's second panel might have appeared and how the original buildings mentioned by Manetti related to it. See also Decio Gioseffi, "Complimenti di prospettiva: di un nuovo libro; di Apollidoro d'Atene; di Filippo, di Paolo e altre cose," I, *Critica d'arte* 4 (1957): 484 f.

13. On this see Kitao, "Prejudice in Perspective." It is particularly interesting that in the Trecento oblique views were commonplace, but they almost completely disappeared, except in background details or debatable "half-frontal" compositions such as in the Barberini panels, once linear

perspective rules had become established. See also Erwin Panofsky, "Once More the Friedsam Annunciation and the Problem of the Ghent Altarpiece," *The Art Bulletin* 20 (1938): 419–442.

14. See the manuscript *Priorista di palazzo* for 1425, folio 171 verso, in the Archivio di Stato, Florence. See also Cornel von Fabriczy, *Filippo Brunelleschi, sein Leben und seine Werke* (Stuttgart, 1892), p. 394. The original *stemma* of the *quartiere San Giovanni* can still be seen, although in damaged condition, on a fifteenth-century ceiling fresco in the old Palazzo dei Giudici e Notai in the Via del Proconsolo in Florence today. This interesting relationship of the *stemma* to Brunelleschi's first perspective picture has been independently noted by David Friedman and Miklòs Boskovits of the Villa I Tatti in Florence, and I am grateful to them for having recounted their own interpretations and shared in a discussion of the idea with me. Further thoughts about Brunelleschi's choice of the Baptistery are given in E. H. Gombrich, "From the Revival of Letters to the Reform of the Arts: Niccolò Niccoli and Filippo Brunelleschi," in *Essays in the History of Art Presented to Rudolf Wittkower*, pp. 71–83; and Rudolph Wittkower, "Brunelleschi and Proportion in Perspective," *Journal of the Warburg and Courtauld Institutes* 16 (1953): 275–291.

15. See Witelo's *Perspectiva*, IV, 21, as published in Frederick Risner, ed., *Optica thesaurus Alhazeni Arabis libri septem item Vitellonis Thuringopolonis opticae libri decem* (Basel, 1572), pp. 127–128.

16. Giammaria Mazzuchelli, ed., *Cronica di Matteo Villani; le vite d'uomini illustri fiorentini di Filippo Villani* (Florence, 1826), vol. 6, p. 49; also Umberto Forli, "Con Dante nel mondo della scienza e della tecnica," *La scuola in azione*, April 1965, pp. 19–20. Some further ideas concerning the availability, size, and prices of flat mirrors in the late Middle Ages is given in *Italienische Forschungen* 1 (1906): 315–316, under "Spiegelgeschäft . . . Inventare venezianischen Botteghen."

17. The full text containing this passage is given in Alessandro Parronchi, *Studi su la dolce prospettiva* (Milan, 1964), p. 640.

18. *De pictura*, p. 89.

19. Heinrich Schwarz, "The Mirror of the Artist and the Mirror of the Devout," *Studies in the History of Art Dedicated to William E. Suida on his Eightieth Birthday* (London, 1959), pp. 90–105. See also G. F. Hartlaub, *Zauber des Spiegels* (Munich, 1951), pp. 42 ff.

20. Such "curvilinear" perspective distortions occur particularly in the art of Jean Fouquet; see, on this, White, *Birth and Rebirth*, pp. 233–234, note 24. The Boucicault Master showed a similar propensity in some of his miniatures from the famous *Hours* now in the Musée Jacquemart-André. See, for instance, his *Coronation of the Virgin*, folio 95 verso, where the squares of the reticulated floor are shown noticeably wider at the sides of the picture than at the center.

21. See Spencer, *Filarete's Treatise*, vol. 2, folio 178 recto:
E se meglio le vuoi considerare torrai uno specchio e guarda dentro in esso. Vedrai chiaro, essere così. E se ti fussino al dirimpetto dell'occhio, non ti parrebbono se non tutte iguali.

22. Full explanation of this principle is given, for instance, in Pecham,

Notes

Part II, Propositions 20 ff., as published in David C. Lindberg, *John Pecham and the Science of Optics* (Madison, Wisc., 1970), pp. 171 ff. See also Colin M. Turbayne, "Grosseteste and an Ancient Optical Principle," *Isis* 50 (1959): 467–472.

23. *Purgatorio*, XV, 16–21, from the John Ciardi translation, *The Divine Comedy* (New York, 1961). See also Dante's comments on mirrors in the *Paradisio*, XXVIII, 4–9.

24. Leonardo da Vinci subsequently expressed almost the same idea (see Edward McCurdy, ed., *The Notebooks of Leonardo da Vinci* [New York, 1938], vol. 2, pp. 376–377):

Perspective employs in distances two opposite pyramids, one of which has its apex in the eye and its base as far away as the horizon. The other has its base towards the eye and the apex on the horizon. But the first is concerned with the universe, embracing all the mass of objects that pass before the eye, as though a vast landscape was seen through a small hole, the number of the objects seen through such a hole being so much the greater in proportion as the objects are more remote from the eye; and thus the base is formed on the horizon and the apex in the eye, as I have said above. The second pyramid has to do with a peculiarity of landscape, in showing itself so much smaller in proportion as it recedes farther from the eye; and this second instance of perspective springs from the first.

25. The Florentine *braccio* of the 1420s was probably the same as the *braccio di panno* of the early nineteenth century, which was rated at 5836 meters when the Tuscan region switched to the metric system. For a thorough discussion of the equivalence problem of the Florentine *braccio*, see Gustavo Uzielli, "Antonio di Tuccio Manetti, Paolo Toscanelli e la lunghezza della miglia nel Secolo delle Scoperte," *Rivista geografica italiana* 9 (1902): 473–497.

26. The Albertina Gallery in Vienna possesses a sixteenth-century ground plan of the Florentine Baptistery showing precise measurements in *braccia*. *Braccia* measurements of the Baptistery and piazza as well as the Duomo are also given in B. S. Sgrilli, *Descrizione e studj dell'insigne fabbrica di S. Maria del Fiore* . . . (Florence, 1733). For more modern measurement, in meters, see Eduard Isabelle, *Les édifices circulaires et les domes* (Paris, 1855). The distance from the Baptistery to three *braccia* within the portal was measured as slightly less than sixty *braccia* by Richard Krautheimer in 1951 (see his *Lorenzo Ghiberti*, p. 235, note 19), which does not quite correspond to the measurements given in Sgrilli. However, the intervening steps before the Duomo and the dip in the piazza itself make it virtually impossible to establish a consistent figure. Brunelleschi himself would have had to resort to pacing, or some other means of rough estimation. Actually, a considerable margin of error is tolerable before the essential ratio of 1:1:1 is upset. As my own photographic reconstruction showed, a change in the dimensions, of anywhere from six to ten feet in any of the elements described by Manetti in the original picture would have little effect on the outcome.

27. Concerning this relief, called the *Pazzi Madonna*, see the comments

and illustration in Janson, *The Sculpture of Donatello*, pp. 44–45, plate 19b.

28. For the Latin text of this basic proposition on the law of similar triangles, see J. L. Heiberg and H. Menge, eds., *Euclidis opera omnia* (Leipzig, 1896), vol. 6, p. 179.

29. In the Enggass translation of Manetti's *Vita* (Saalman, *Life of Brunelleschi*, p. 44.), the passage is rendered as follows: "The mirror was extended by the other hand a distance that more or less approximated in small *braccia* the distance in regular *braccia* from the place he appears to have been when he painted it up to the church of San Giovanni." White (*Birth and Rebirth*, p. 116.) merely translates the phrase literally: ". . . and the distance of the mirror in the other hand, came to about the length of a small *braccio*; up to that of a true *braccio*, from the place. . . ." Professor Richard Krautheimer, in a verbal discussion with me on this point, remembered numerous instances in other medieval and Renaissance Italian texts where these same words similarly referred to "scale."

30. For an interesting recent discussion of this old problem, see E. H. Gombrich, "The 'What' and 'How': Perspective Representation and the Phenomenal World," in *Essays in Honor of Nelson Goodman*, Richard Rodner and Israel Scheffler, eds. (Indianapolis and New York, 1972), pp. 129–149.

31. The full text is given in Parronchi, *Studi su la dolce prospettiva*, p. 602.

X

1. John White, *Birth and Rebirth of Pictorial Space* (London, 1968), p. 115.

2. Ibid., p. 116. In an added footnote (note 13, p. 131), White goes on to point out that the doubled viewing distance caused by the mirror would indeed make problems, particularly in reducing the visual angle to less than twenty degrees. While White excuses this discrepancy on the grounds that a viewer peeping through such an occluded hole could not have seen much more anyway, I can hardly believe that Brunelleschi, having gone to inordinate lengths to make his experiment conform to optical law, would have tolerated a condition that surely would have reduced his experiment to a casual empirical demonstration.

3. It is also quite possible that Brunelleschi had already devised some kind of short-cut distance point method similar to that described ten years later by Alberti. Indeed, evidence that such short-cut schemes existed before Alberti is discernible to this day on the surface of Masaccio's fresco of *St. Peter Healing with his Shadow* in the Brancacci Chapel in Florence (see Alessandro Parronchi, "Prospettiva in Donatello e Masaccio," *Rassegna della istruzione Artistica* 1 [1966]: n. 2.).

I think it likely that Brunelleschi did make a plan and/or an elevation of the Baptistery on squared paper first. To be sure, there is no certainty that

Notes

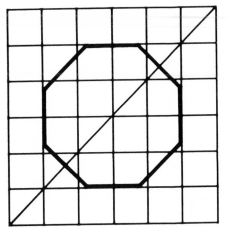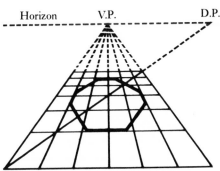

Diagram x–2

he would have been inspired to this by the topography of the piazza it-
self. In the early fifteenth century, the piazza was paved with rather ir-
regularly shaped stones giving no suggestion of parallels and meridians.
Yet, if we can imagine him so moved by Ptolemy's cartography as to be
able to conceive of the *piazza di San Giovanni* in squares, then such a
plan of the Baptistery projected toward a centric vanishing point as in
Diagram x–2 is not out of the question. Brunelleschi could have applied
the same conception to each of the ascending horizontal levels of the
building, joining them together with verticals and so constructing a perfect
perspective likeness conforming both to vanishing and distance points.

4. This photographic experiment was carried out early in the morning
of May 16, 1968, with the kind permission of the Sopratendenza alle Gal-
lerie and the generous assistance of Mr. Sherwood Fehm, research fellow
at the Villa I Tatti. In both photographs (Illustrations x–2 and x–3) the
mirror was positioned some nine feet eight inches into the Cathedral from
the bronze lip marking the present threshold. While this is not "three
braccia" from any clear-cut present point of measurement, it certainly
proved to be within any limitations Brunelleschi himself would have had
to contend with in his original perception of the scene. Photographs also
made at this time from points even further into the Cathedral, indeed all
the way up to sixteen feet from the outer threshold, continue to show
almost the same amount of space to the right and left, and above and
below, the Baptistery.

5. For an interesting discussion of photographic distortion vis-à-vis
what we actually see, see M. H. Pirenne, *Optics, Painting, and Photography*
(Cambridge, 1970), pp. 96 ff. Alessandro Parronchi, *Studi su la dolce
prospettiva* (Milan, 1964), tav. 90 opposite p. 232, has postulated Brunel-
leschi's vanishing point (and presumably the hole) as being exactly in the
middle of the panel and therefore above the East Doors. Krautheimer,

however, believed the eyepoint-vanishing point was lower, positioned as I have it on the East Doors (Richard Krautheimer and Trude Krautheimer-Hess, *Lorenzo Ghiberti* [Princeton, N.J., 1956], pp. 235 ff.).

6. The present Misericordia was built after 1439 when the original was partially destroyed by fire. The original *Misericordia vecchia* was also on the south side of the piazza, west of the corner where the present Via de'Calzaiuoli (the Corso degl'Adimari in the Sgrilli site plan) enters. It is impossible to know how much of the building Brunelleschi could have included in his picture, but clearly if he did include all the Misericordia, his visual angle would have been even larger than ninety degrees. If he had included the Misericordia, however, he would also have had to include a large group of buildings on the other side of the Baptistery, considerably to the north of the Column of Saint Zenobius. Manetti makes no mention of other buildings north of the piazza, saying only that the Column of Saint Zenobius is the prominent landmark on that side. By his reference to the Misericordia, Manetti probably meant the extension of the north wall of the building westward along the *piazza* to the Volta dei Pecori, a bit of which is indeed included in the hypothetical Brunelleschian visual triangle I have constructed in Illustration ix–2. See John White's helpful discussion of the fifteenth-century appearance of the piazza, and other buildings relative to Brunelleschi's perspective panel, in his *Birth and Rebirth*, pp. 114 ff.

7. A sixteenth-century drawing exhibited in the Museum of the Opera del Duomo in Florence shows this clearly. The problem of how the portal must have looked in Brunelleschi's time is discussed in White, *Birth and Rebirth*, pp. 114 ff.

8. At this point a serious problem arises that is the only one insoluble

Diagram x–3

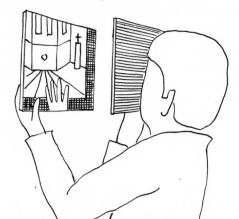

Notes

so far. Did Brunelleschi take into consideration that this second reflecting mirror must necessarily *double* the viewing distance?

Diagram x–3 may help clarify just what this means. The picture which the viewer holds before his eye would appear in the mirror just as far behind the surface as the picture itself was before it. Therefore, the Baptistery representation painted on it would be that much further again away. Hence, instead of appearing a half *braccio* before the viewer's eyes, the Baptistery image in the mirror appears a full *braccio* away. Furthermore, the size of the Baptistery image reduces by half at this doubled distance. If Brunelleschi understood this problem (as I'm sure he must have) and wished to compensate for it, he would then have had to move the mirror to within six inches (a quarter *braccio*) of his viewer's eyepoint so that the doubled viewing distance would return to normal. But this creates another problem—such a viewing distance is completely impractical.

One is led to conclude that in this instance Brunelleschi ignored scientific accuracy. He may have depended upon another phenomenon which modern psychologists call the "size constancy factor" to rescue him from this dilemma. He must have hoped that the average viewer when observing a mirror reflection at a reasonable distance usually overestimates the size of the image. (The reader may test this himself if he tries to estimate the size of the image of his own head in the mirror as he brushes his teeth in the morning!) This size constancy factor works only at a reasonably short distance. In the case of White's reconstruction of Brunelleschi's demonstration, the distance differentiation would have been much greater and therefore the size variation more noticeable.

9. For another interesting hypothesis on how Brunelleschi related his first perspective demonstration to the mirror, see Decio Gioseffi, *Perspectiva artificialis* . . . (Trieste, 1957), pp. 80–81. Gioseffi has postulated that Brunelleschi painted his picture of the Baptistery directly on top of its mirror reflection! See also his article, "Complimenti di prospettiva: di un nuovo libro; di Apollidoro d'Atene, di Filippo, di Paolo e altre cose," *Critica d'arte* 4 (1957): 484.

10. On this see Pirenne, *Optics, Painting, and Photography*, p. 114 and passim; also Michael Polanyi, *Personal Knowledge: Towards a Post-Critical Philosophy* (London, 1958), and idem, "What is Painting?," *The American Scholar* 39 (1970): 655–670.

11. For the full text see *Convivio*, III, Chapter 9, in E. Moore and P. Toynbee, eds., *Le opere di Dante Alighieri* (Oxford, 1924), p. 284.

XI

1. Erwin Panofsky, "Die Perspektive als 'symbolische Form'," *Vorträge der Bibliothek Warburg; 1924–1925* (Leipzig, 1927), pp. 258–331.

2. Rudolf Arnheim, *Art and Visual Perception: a Psychology of the Creative Eye* (Berkeley, Calif., 1971); Gyorgy Kepes, *Language of Vision*

Notes

(Chicago, 1944); and Nelson Goodman, *Languages of Art: An Approach to a Theory of Symbols* (New York, 1968).

3. Panofsky, "Die Perspektive," pp. 260–271, notes 16–24. The author here presents his argument that the Euclidian notion of the visual angle also presupposed a belief in antiquity that the visual field itself was curved. In other words, since the Greeks chose to measure magnitudes by angles perceived in the eye, these magnitudes must have been regarded as projected upon a spherical plane–i.e., the convex anterior surface of the eye. Hence, Panofsky asserted that artists in antiquity devised an artificial perspective scheme based on projecting a curved plane upon the flat surface of a picture. To imagine how they might have rationalized the vanishing point under such a concept, one must visualize how a convex or concave surface be cut and divided at the center in order to flatten it out. The single centric point on a curved plane of this sort must be made to spread out by a series of cuts away from the center. The centric point thus becomes a cluster of points when the curved surface is made flat. It is this essential reasoning, Panofsky believed, which led the ancients and then the artists of the Middle Ages to accept their peculiar "fishbone" or "vanishing area" perspective constructions. The same rationale he applied to the occasional appearance of straight lines as curves in antique and medieval paintings.

Panofsky's view was endorsed to some extent by Miriam Schild Bunim in *Space in Medieval Painting and the Forerunners of Perspective* (New York, 1940), pp. 195–198, but she misconstrued his curved visual space theory to mean that the ancients may have had a notion that images formed on the concave interior surface of the eye–i.e., the retina. While some of the optical thinkers in antiquity did indeed dispute about whether images formed on the convex exterior surface of the eye, it was not until the sixteenth century A.D. that any thought was given to the image-forming role of the concave retina.

4. E. H. Gombrich, *Art and Illusion: A Study in the Psychology of Pictorial Representation* (Princeton, N.J., 1960).

5. See M. H. Pirenne, "The Scientific Basis for Leonardo da Vinci's Theory of Perspective," *The British Journal for the Philosophy of Science* 3 (1952–1953): 169–185; G. Ten Doesschate, *Perspective: Fundamentals, Controversials, History* (Nieuwkoop, Holland, 1964); and James J. Gibson, "The Information Available in Pictures," *Leonardo* 4 (1971): 35, note 34. See also Decio Gioseffi, *Perspectiva artificialis: per la storia della prospettiva spigolature e appunti* (Trieste, 1957).

6. Pirenne, "Scientific Basis." Actually, Pirenne was commenting on Panofsky's *The Codex Huygens and Leonardo da Vinci's Art Theory* (London, 1940), in which the author repeated the same general arguments about perspective as in his earlier article.

7. The English translation of Cassirer's *The Philosophy of Symbolic Forms* is edited by Charles W. Hendel, 3 vols. (New Haven, Conn., 1955). See also Paul Arthur Schilp, ed., *The Philosophy of Ernst Cassirer* (New York, 1949); Carl H. Hamburg, *Symbol and Reality* (The Hague, 1956).

Notes

Panofsky's essay, while not in English, has been translated into Italian. See Guido D. Neri and Marisa Dalai, eds., *La prospettiva come 'forma simbolica' e altri scritti* (Milan, 1961).

8. Ernst Cassirer, *Language and Myth,* trans. Susanne K. Langer (New York, 1946), p. 8. Originally published as *Sprache und Mythos,* no. 6 in the *Studien der Bibliothek Warburg* (Leipzig, 1925).

9. Charles Hendel, Introduction to Cassirer, *The Philosophy of Symbolic Forms,* vol. I, p. 9.

10. See Jean Piaget, *Structuralism,* trans. Chaninah Maschler (New York, 1970).

11. Panofsky, "Die Perspektive," p. 271:

Und gerade hier zeigt sich besonders deutlich, dass der "ästhetische Raum" und der "theoretische Raum" den Wahrnehmungsraum jeweils sub specie einer und derselben Empfindung umgeformt zeigen, die in dem einen Falle anschaulich symbolisiert, in dem andern aber logifiziert erscheint.

12. For more on the history of "space," see Max Jammer, *Concepts of Space: The History of the Theories of Space in Physics* (Cambridge, Mass., 1969).

13. This analogy is not given in Panofsky but is paraphrased from Ten Doesschate, *Perspective,* pp. 63–64.

14. See Thomas S. Kuhn, *The Structure of Scientific Revolutions* (Chicago, 1970).

15. M. H. Pirenne, *Vision and the Eye* (London, 1948), p. 15.

16. Gombrich in his *Art and Illusion* has been particularly eloquent in pointing out the role of the viewer's own perceptual prejudices in the history of illusionism in painting.

17. For further provocative discussions on this, see William M. Ivins, *Prints and Visual Communication* (London, 1953), and Marshall McLuhan, *The Gutenberg Galaxy* (London, 1962). McLuhan particularly has some interesting observations on the possible correlation between the ability to read and the ability to "see" linear perspective pictures. Similarly, see H. J. Chaytor, *From Script to Print* (London, 1966), for another illuminating account of how printing changed people's perceptual habits from being predominantly auditory to predominantly visual, implying therefore their parallel acceptance of linear perspective.

Glossary

abacco: A public school in Italy during the fourteenth and fifteenth centuries. Intended particularly for the children of artisans and clerks, to teach arithmetic, practical geometry, and Italian grammar.

armillary sphere: A model in wood or metal showing the geocentric universe. The earth is a ball in the center, surrounded by longitudinal and latitudinal rings representing the location of the stars and planets and an oblique band representing the path of the sun, or ecliptic, inscribed with signs of the zodiac. An ubiquitous item on the medieval scholar's desk; frequently depicted in Renaissance paintings.

astrolabe: An astronomical instrument in use since ancient times, consisting of a flat metal disk fixed with a rotatable pointer. Used for determining the altitude of the sun in order to find the correct time at any given place on earth or at sea.

atmospheric perspective: Distinct from linear perspective. This is the phenomenon, observed by the ancient, Arab, and medieval Christian optical scientists, that objects in distance become less distinct through the increasing haziness of the intervening atmosphere, even appearing blue or purplish in color. Painters north of the Alps began to notice and paint atmospheric perspective effects during the late fourteenth century. Italian artists began doing the same in the early fifteenth. It is of interest that the discovery of atmospheric perspective by late medieval artists preceded and was independent of linear perspective.

Glossary

binocular parallax: The apparent displacement of objects in vision as seen by each eye separately and the two eyes together.

braccio (pl. *braccia*): The most common unit of measurement in medieval and Renaissance Florence. Literally, an "arm's length." While the *braccio* varied from location to location and from time to time, it apparently was fairly uniform in the fifteenth century, being equivalent to .5836 meters or 22.977 inches.

camera obscura: A box with a small hole (with or without a magnifying lens) at one end and open at the other in order to receive an illuminated image. This is projected through the box and the small hole and appears as inverted on a screen in front. The eye, in fact, is a kind of *camera obscura.*

camera ottica: A box into which a viewer looks, through a small hole at one end, at an image at the other end.

cathetus: In medieval optics (catoptrics), the imaginary line from the point of an object's reflection in the mirror, into the mirror's virtual space, to the apparent position of the object's reflection itself.

catoptrics: That branch of optics having to do with reflections in mirrors.

centric point: Literally, a point right in the middle of any picture surface. Alberti used this term to define what we now call the vanishing point in one-point perspective, that is, the locus in the middle of the picture toward which all the orthogonals perpendicular to the same picture plane recede.

centric ray: The single visual ray, according to the medieval science of optics, which travels from the center of the viewer's visual field, to the exact center of his eye, to the exact center of the sensitive seat of vision, the *crystallinus,* and to the exact center of the optic nerve. Since this ray arrives perpendicular to the cornea, the *crystallinus,* and the face of the optic nerve, it remains unrefracted. Being unrefracted and also the shortest ray between object seen and optic nerve, it was thought to carry its portion of the object most distinctly to the brain.

chorography: The study of topography, particularly of individual regions of the earth's surface.

compass rose: The display of lines connecting from the center each of the sixteen points of the compass.

costruzione legittima: Literally, "legitimate construction," or that form of linear perspective dependent, as Alberti's, on a vanishing point. To be distinguished from "distance point construction." This term became popular among art historians describing Renaissance linear perspective in the early twentieth century.

crystallinus or *crystalline lens:* The tractable and dioptric lens in the forepart of the eye. While now understood as the organ which focuses the incoming light upon the retina, it was believed all during the Middle Ages and Renaissance that this was actually the sensitive seat of vision. According to Galen, who gave the first complete "anatomy" of the eye, the image received in the eye first displayed itself in miniature and

to scale on the anterior surface of the *crystallinus* and then passed into the optic nerve.

dioptrics: That branch of optics having to do with refraction.

distance point: This point marks in a perspective construction the distance of the viewer's eye from the leading edge of the object to be depicted, that is, theoretically, from the surface of the imaginary intersection or picture plane through his visual pyramid. In Alberti's perspective method, a second drawing operation expressing this distance was necessary in order to determine the precise rate of diminution of his transversals in the projection of his squared floor. While a complete linear perspective picture of such a squared floor cannot be projected from the vanishing point alone, it is possible to project such a floor and even the position of the vanishing point from the distance point alone. Hence, another type of perspective construction called the "distance point method" was described by sixteenth- and seventeenth-century perspective theorists as an alternative to *costruzione legittima*.

eyepoint: The apex of the visual pyramid in the viewer's eye.

extromission: The ancient theory of vision which held that visual rays issue forth from the eyes.

great circle: The imaginary rings in the sky conceived by the ancients as having their centers coincident with the center of the earth, such as all the longitudes crossing over the poles, the ecliptic or sun's path around the earth, and the equatorial ring. Useful for plotting the paths of the stars and planets.

horizon line: An imaginary line determined by the eye level of an observer, staring straight ahead and standing on a horizontal plane. Such a line, as when one stands at the water's edge and looks out to sea, demarks the edge between ocean and sky. This horizon is always synonymous with the viewer's own eye level; when he stoops (but still stares straight ahead), this same horizon also seems to drop, and when he rises the same horizon also rises in exact concordance with the level of the eyes. It was Brunelleschi's most important discovery that the vanishing point, that is, the points of apparent convergence for parallel, horizontal orthogonal edges of objects in the visual field, always occur on this horizon line.

horizon line isocephaly: My pompous phrase for the illusionistic phenomenon, observed by Renaissance artists for the first time after 1425, that when the viewer stands on a horizontal plane, looking straight ahead at other persons of the same height and standing on the same plane, all the heads of these other persons, no matter how far distant, will appear to be on his own horizon line. Their perspective diminution will therefore occur "from the feet up." As far as I can determine, *no* pictures made by any artist in any civilization anywhere in the world before 1425 intentionally shows this phenomenon. After 1425, however, the examples, especially in Italian art, are numerous.

International Style: The style of painting and sculpture prevalent in

Glossary

Western Europe during the late fourteenth and early fifteenth centuries, predominantly inspired by the court tastes of the kings of France and the dukes of Burgundy. Lacking in linear perspective, yet showing an active interest in naturalistic detail; having a prevalence of accurately rendered flowers, trees, animals, people doing all sorts of casual things. Enjoyment of landscape, rich colors, and accent on individual and delightful details rather than on any sense of geometrically controlled whole. Figures shown in affected, often aristocratic attitudes, with emphasis on stylized poses, drapery, decorative materials, and fairyland-like mood.

intersection: An imaginary plane through the visual pyramid, perpendicular to the visual axis (centric ray). This imaginary "window" then becomes the picture itself. Brunelleschi and Alberti succeeded in proving that this intersection could be recapitulated by the artist according to the rules of Euclidian geometry; that the smaller intersection retained a point-for-point scale representation of the actual objects themselves at the base of the visual pyramid.

intromission: The ancient theory of vision which held that rays, which prompted sight, issued from all things in nature toward the eye, converging on it in the form of a cone. This theory exerted the greatest influence in medieval and Renaissance Europe following the optics of the Arab Alhazen.

istoria: The concept, prevalent in late medieval and Renaissance Europe, that the sole purpose of pictures is to show noble historical subjects as a means of elevating the moral character of the viewer. Such a didactic point of view about pictures was supported by the conservative Church at the time, and particularly by Alberti. *Istoria,* literally "history painting," deliberately eschewed the fineries of the International Style in favor of a more severe, geometrically ordered presentation which then seemed a metaphor of God's masterplan for the universe.

lateral vanishing points(s): In two-point or oblique perspective, objects so positioned that their sides are askant from the picture plane seem therefore to be diminishing not toward the center but to the sides. This necessitates at least two vanishing points. In the Renaissance it was frequently an artistic convention to place these on a common horizon line but on each lateral margin of the picture.

liberal arts (artes liberales in medieval Latin): The traditional body of learning under the umbrella of Philosophy during the Middle Ages, consisting of seven subjects divided into the *Trivium* (Grammar, Rhetoric, and Logic) and the *Quadrivium* (Arithmetic, Geometry, Astronomy, and Music).

linear perspective: In the Renaissance understood as the geometrical explanation for the illusion of convergence of parallel lines in distance. Distinct from atmospheric perspective and other forms of pictorial illusion through manipulation of light and shadow. Essentially the matter of the vanishing and distance points. For a thorough discussion of

Glossary

perspective in the wider, modern sense, see B. A. R. Carter, "Perspective," in Harold Osborne, ed., *The Oxford Companion to Art*, London, 1970, pp. 840–861.

mappamundi: Literally, "world map." The introductory map page in the Ptolemaic atlas, showing all the known lands of the earth. Then would follow detailed maps of each separate region.

meridian: On a map, a line which divides the depicted space vertically, such as a longitude which divides the surface of the earth from pole to pole into 360 sections east and west.

naturalism: The word is used in this book to denote that attitude in depicting which depends upon empirical, unmathematically structured vision; i.e., as in the late Gothic International Style (which see).

oblique view: Two-point perspective; the objects to be depicted are so situated that their sides stand at angles rather than perpendicular to the picture plane.

oikumene: Ptolemy's Greek term for the "known world" as shown in his *mappamundi* from the *Geographia.* Consisting of Europe, Asia, and Africa as far south as the equator.

one-point perspective: Derived from the frontal view, as distinct from oblique or two-point perspective in pictures. Here the objects depicted are seen with their near surfaces parallel to the picture plane. Presuming such objects to be rectilinear, the receding sides would then seem to converge upon a single vanishing point in the center.

orthogonal: A line in a perspective picture which represents an edge of an object receding into distance, that is, toward a vanishing point. To be distinguished from a transversal (which see).

parallel: A line which divides the depicted surface on a map into horizontal sections, i.e., perpendicular to the meridians, as the latitudes divide the earth's surface into 360 sections north and south.

perspectiva artificialis: Renaissance Latin term for artist's linear perspective, as distinct from "natural" *perspectiva* or optics.

picture plane: Literally, the surface of any picture. Conceptually, however, it must be imagined as a windowlike transparent "intersection" standing between the artist and the scene he is about to represent. This "surface," not the actual objects themselves, is what becomes transformed into the picture, as if one traces on a piece of glass the shapes of objects seen beyond.

point of sight: The point on a picture surface where the visual axis from the artist's eye first touches. In frontal perspective the point of sight thus also demarks the centric vanishing point.

quadrivium: In the medieval and Renaissance liberal arts (which see), the four disciplines of arithmetic, geometry, astronomy, and music. Hence, the forerunner of the modern curriculum of science, as differentiated from the Trivium, which stressed disciplines now grouped under the humanities.

realism: The word is used in this book to denote the pictorial attitude

Glossary

which depends upon a view of the world structured according to the laws of geometry, specifically linear perspective.

reverse perspective: The phenomenon whereby the sides of rectilinear, three-dimensional objects seem to diverge rather than converge toward a common vanishing point.While it is difficult today to believe that such a phenomenon actually is possible in human eyesight, so many examples of reverse perspective appear in pictures, not only from cultures outside Western influence, but even in Western classical and medieval art, that one must presume it a natural condition of seeing. Renaissance perspective seems to have obscured this fact, but it does seem clear that a rectilinear solid object shown frontally in a picture gives more information about itself when its sides diverge. If the sides are made to converge in true perspective, they would be out of sight behind the frontal plane.

rhumb line: A line in a compass rose (which see) which a portolan chart maker or sailor could use as reference for plotting his direction from one place to another. Similar to an azimuth in modern surveying.

sinopia: A preparation drawing for painting in fresco, so called because the artist used a reddish ink called *sinoper*. Common practice among Italian painters during the Trecento and early Quattrocento. In the fresco process, the *sinopia* would be gradually covered over by the artist with the *intonaco* or thin plaster layer into which the painting itself was applied. The artist had to remember what was under his patch of *intonaco* as he painted, or simply be guided by that portion of the drawing still visible below. With the advent of perspective, however, the traditional *sinopia* proved inadequate. The new dependence on straight-line measurement and overall geometric unity demanded that the artist find some new kind of preliminary drawing method which could be superimposed directly on the wet *intonaco* surface.

species: The word used by the thirteenth-century English scientists Robert Grosseteste and Roger Bacon to define a kind of energy or energized matter that seemed to flow from all things in the physical and metaphysical world. God, the sun, the eye, and all objects and things on the earth give off *species,* which leave in straight lines, fanning out from every point according to the geometric laws of the visual cone as defined by Euclid. These *species* then interact upon one another, those from the more active body influencing the *species* from the less active. By this *species* theory, Roger Bacon hoped not only to define the nature of vision but the entire cause and effect pattern of physics—and even of God and how His divine grace spreads throughout the universe.

split-view: Referring to a recent observation of perceptual psychologists that so-called primitive societies, as well as children generally, tend to draw pictures not in post-Renaissance linear perspective but as if the depicted object were pressed flat; split apart, as it were, so that all sides could be seen at once (or at least more sides than would be visible from a single fixed viewpoint of the immobile object). Very similar to reverse perspective (which see).

Glossary

transversal: A line in a perspective picture which represents the edges of objects receding into distance but which is *parallel* to the picture plane. Transversals do not of themselves converge on any vanishing point. They appear as horizontals and remain ever parallel, even in a perspective picture. However, they do appear to grow closer and closer together, even though in actuality equidistant apart, as they approach the vanishing point. The geometric rationale for their apparent condensing cannot be determined by simply determining the vanishing point for the orthogonals. As in Alberti's perspective, the progression of transverse space diminution must be worked out by a separate, distance point operation (which see).

two-point perspective: Derived from the oblique view, as distinct from frontal or one-point perspective in pictures. Here the objects depicted are seen with their presumably rectilinear sides standing askant with the picture plane. These oblique sides do not then converge on a single vanishing point in the center, but to at least two, one for each visible side, to the left and right respectively.

vanishing point: The term in English since the eighteenth century to express the phenomenon of convergence of parallel lines in distant vision. Referred to similarly as the *punto di fuga* (point of flight) in Italian, *Fluchtpunkt* in German, and *point de fuite* in French. Originally designated only as the *punto centrico* by Alberti, referring of course to the centric vanishing point in frontal perspective. Lateral points, that is, vanishing points in oblique perspective, seem only to have been referred to as the *misure del occhio* or *Augenpunkte* ("eye position") in the technical literature of the Renaissance. Since the science explosion of the seventeenth century, the notion of the vanishing point as a mathematical as well as an artistic function has been more and more appreciated. Hence, we are led to believe today that this phenomenon is an established fact of vision. However, the medieval science of optics taught just the reverse—that the so-called illusion of perspective convergence (i.e., the vanishing point) was a mere *Fata Morgana* and could be disproved by simple geometry. Brunelleschi and Alberti, therefore, had their work cut out for them. They had to show that this strange illusion could actually be recapitulated and predicted by applied geometry. In the beginning they were only concerned that the "centric point" worked with enough uniformity to make their pictures seem convincing in light of the contemporary belief that anything that functioned by mathematical law must be inherently in harmony with God's masterplan.

visual axis (axis visualis and *axis perpendicularis* in medieval optics; also the centric visual ray which Alberti dubbed the "prince of rays"): The single visual ray understood by both extromission and intromission theorists in ancient and medieval optics which conveys the image most clearly and distinctly to the brain.

visual ray: The entity believed by classical and medieval optical scientists either to project from the eye or into it from the seen object. Since

Glossary

Euclid, always understood as traveling in straight lines, hence subject to geometric laws. According to Alhazen, not merely a mathematical line (length but no width) but a finite form having minute breadth.

visual pyramid: Sometimes visual cone. According to ancient and medieval optics, all the visual rays together form such a figure, the apex being the eye, the base the object seen. Hence, the whole force of seeing could be studied and diagramed by application of the same laws which apply to the cone or pyramid in geometry.

visual triangle: Actually the visual cone or pyramid shown in section on a flat piece of paper. Convenient way of diagraming the visual pyramid for explaining the geometric nature of the intersection and the centric ray.

Index

Index

Armillary sphere, 110, 194
Arnheim, Rudolf, 154
Artes liberales, see Quadrivium
Artisan-engineer, 30, 38
Artisan practice in the early Renaissance, 29–30, 37–39, 61
Assisi: Basilica of San Francesco at; importance for early history of perspective, 14, 19, 75
Astrology, 61
Atlas, see Ptolemy: *Geographia*
Atomism in Greek optics, 67
Averröes, 61
Avicenna, 61, 72, 73, 89

Bacon, Roger, 72, 73, 75–77, 78, 84, 88; on the relation of light to God's grace, 74–75; on the relation of geometry to religious pictures, 17–18; his notion of scale as compared to Alberti's, 88; his writings: *De multiplicatio specierum*, 76; *Opus majus*, xv, 16–19, 74–75
Baptistery of Florence: Brunelleschi's perspective picture of, 125, 133, 138–153; as the insignia for the quarter of San Giovanni in Florence, 133, 186n.14
Barberini panels, 165n. 13
Baron, Hans, 92
Bellini, Jacopo: perspective drawing of *Architecture*, 51–54
Bifocal method, 47–49
Bisticci, Vespasiano de', 98
Blasius of Parma, 61–62; *Quaestiones perspectivae*, xv, 62, 77
Boninsegni, Domenico di Lionardo, 98
Bookkeeping: double-entry; invention of in Italy, 38–39
Braccio, 43, 127, 138, 187n.25, 195
Bradwardine, Thomas, 20–21
Brunelleschi, Filippo: education and ambition as artisan-engineer, 27–31, 37–38, 40, 123; friendship with Toscanelli, 61–62; scale drawings of Roman architecture on gridded paper, 120–129; understanding of the vanishing point, 133–138; conception of the distance point, 129–131, 147, 188n.3; first perspective picture of the Baptistery: xvii, 4, 5, 86, 90; Manetti's description, 127–128; Krautheimer-

Panofsky recapitulation, 129–131; White's recapitulation, 143–144, 188n.1, 190n.8; Parronchi's recapitulation, 189n.5; Gioseffi's recapitulation, 191n.9; postulated date of the experiment, xvi, 5, 27–30, 126, 133, 184n.4, 196; optical rationalization for the demonstration, 150–152; second perspective picture of the Palazzo Vecchio as described by Manetti, 128–129; attestation of Brunelleschi as discoverer of perspective: by Filarete, 125, by Manetti, 127; by Vasari, 183n.2; B's interest in mirrors, see Mirror; possibility of the two first perspective pictures surviving in Medici collections, 184n.6
Bruni, Leonardo, 93; "geometric" encomium to Florence, 36

Camera obscura, 89; as different from camera ottica, 89–90, 195
Cassirer, Ernst, 155–157
Cathetus, 135, 136, 195
Catoptrics; see Mirror
Cavalcanti, Giovanni, 114–115
Cennini, Cennino, 39, 82
Centric point, 26, 43, 195; see also Vanishing point
Centric ray, 69, 74, 85–87, 100–101, 195, 200; see also Eye, Visual axis
Chrysoloras, Manuel, 94, 97
Cimabue, 19
Columbus, Christopher, 61, 91, 98; in correspondence with Toscanelli, 120–122
Corbinelli, Antonio, 93, 111
Costruzione legittima, 185n.9, 195; see also Linear perspective
Council of Pisa, Rome, and Constance, 98, 179n.17
Crystallinus, 70, 72, 74, 87–88, 152, 195; see also Galen, Eye
Curvilinear perspective, 186n.20, 192n.3
Cusanus, Nicolaus, 36–37

Dante, 60, 77, 134; verses in *Divine Comedy* on reflecting light rays, 135–136; passage in *Convivio* on moral imprimatur of centric ray, 85–86; on the mirror-like character of the crystallinus, 152

Index

Index

Index